Darling Joan

Happy 29th anniversary and
happy days in the
hunting field. S (r)

22nd January, 2006.

HORSE&HOUND

FOXHUNTING
A CELEBRATION IN PHOTOGRAPHS

Acknowledgements

With grateful thanks to all Masters, Hunt Staff, and especially the many dedicated hunt followers and terrier men without whose help and enthusiasm this book would not have been possible.

Trevor Meeks

First published in Great Britain by André Deutsch in 2005
An imprint of the Carlton Publishing Group
20 Mortimer Street
London W1T 3JW

Horse & Hound is a registered trade mark of IPC Media Limited.
Photographs © IPC Media Limited.
Text and design copyright © Carlton Books Ltd

Printed in Dubai

ISBN 0 23300 164 6

Editorial Manager: Lorna Russell
Art Editor: Emma Wicks
Design: Barbara Zuñiga
Production: Lisa Moore

HORSE&HOUND

FOXHUNTING

A CELEBRATION IN PHOTOGRAPHS

PHOTOGRAPHY BY TREVOR MEEKS
FOREWORD BY NIGEL PEEL
COMMENTARY BY KATE GREEN

ANDRE
DEUTSCH

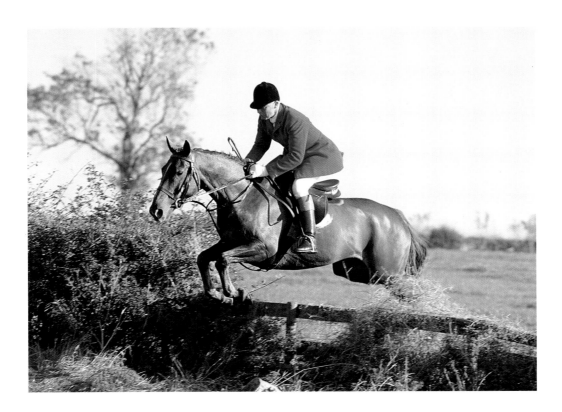

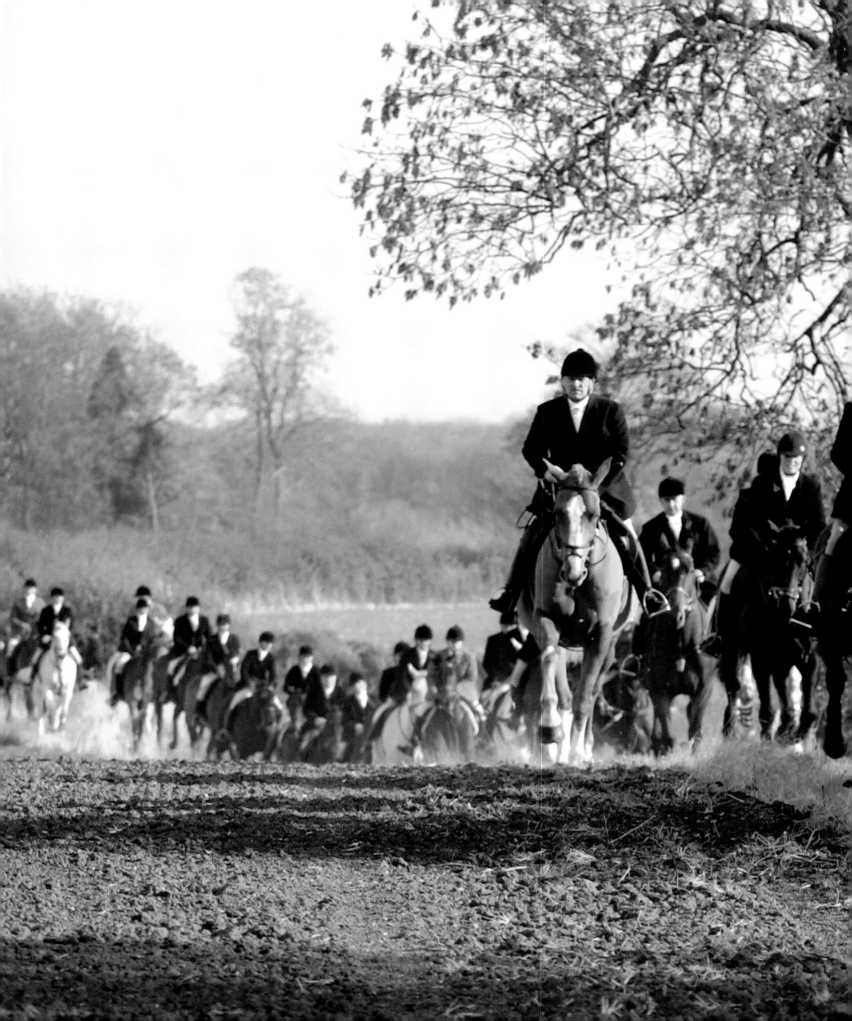

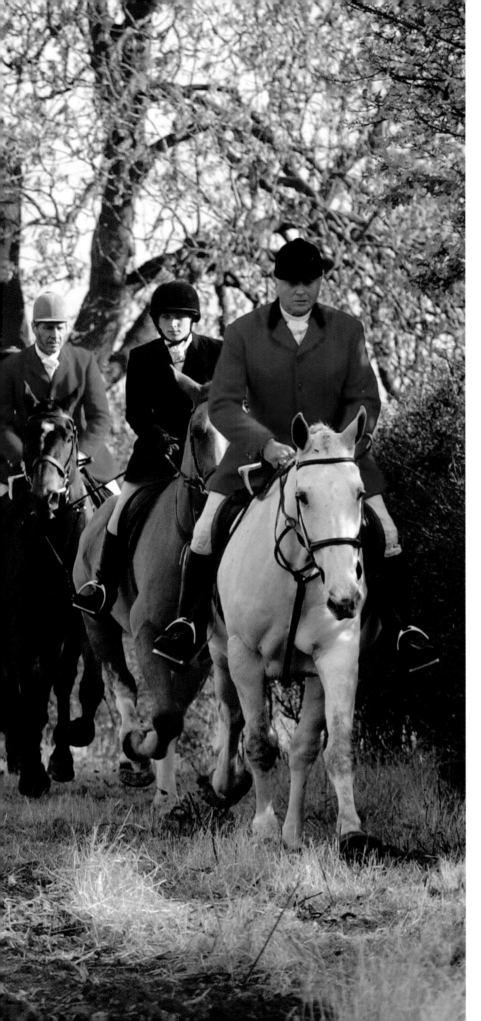

Contents

Foreword by Nigel Peel 6

Introduction 8

1 Hunting and the
Changing Landscape 14

2 Huntsmen and the
Invisible Thread 46

3 The Irish Experience 70

4 A Social Tapestry 86

5 Hounds in Summer 102

6 The Golden Hours 120

LEFT: Skirting the headland of a ploughed field with the Grove and Rufford.

OVER PAGE: The golden light of an early autumn morning with the Burton.

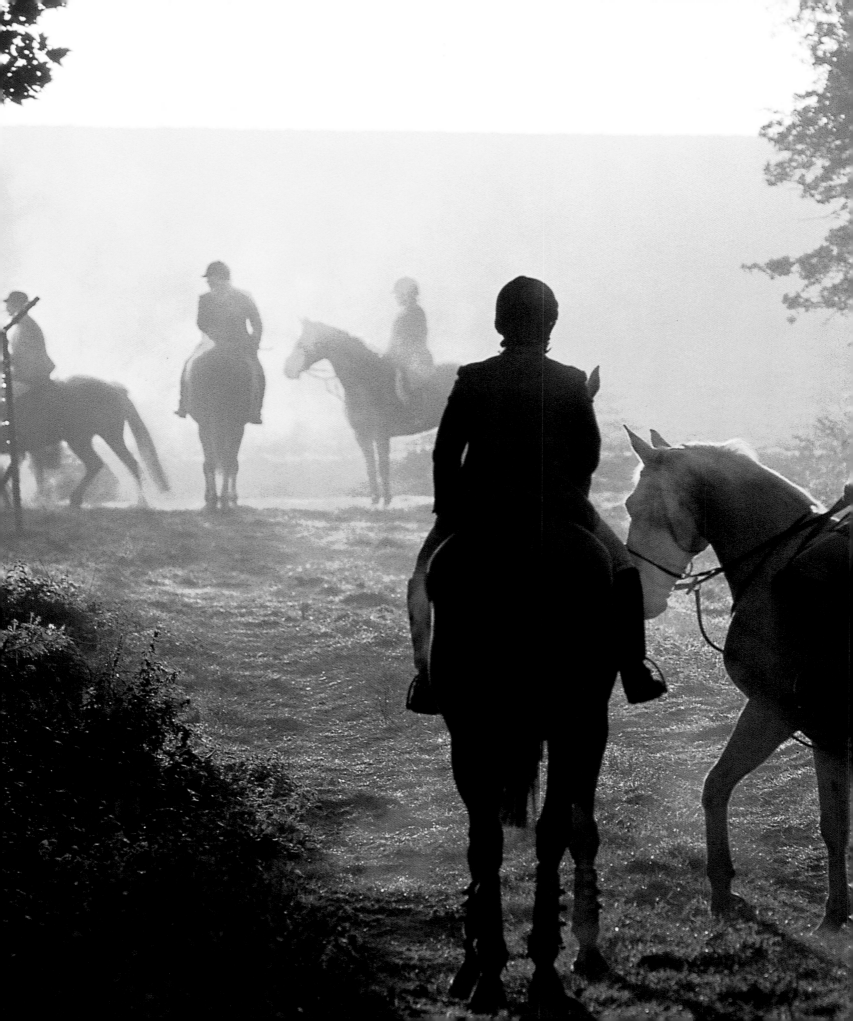

Foreword

This book encapsulates the style and character of Trevor Meeks's work. The life of the sporting photographer is not for the faint-hearted, nor is it a career for the unimaginative or those for whom the changing seasons in rural England are meaningless. The joy. of this work of photographic art, for that is what it is, must surely be that every picture – though hunting related – is totally different. The early mornings of late autumn with their deep rich colours; the dead and dying leaves and the bare branches at the onset of winter; the mud-splattered clothes, sweaty horses and determined hounds; the splash of scarlet and tricolour as the Oakley Hounds and their huntsman cross the snow-covered fields of Bedfordshire – it is all here. The Fells make a dramatic and majestic background to Stanley Mattinson and his famous Coniston Hounds. What history is depicted in these pages.

Hunting has been described as the image of War without its guilt. This is aptly portrayed in the wonderful print of the Heythrop with their long-serving Master, Richard Sumner, at their head looking every bit as keen to get to the hounds as Marshal Blucher was to get to Waterloo. Trevor has also captured the spirit of some of the revered huntsmen of our time. His study of Captain Charlie Barclay with his terrier Blot is a magical portrait of one of the all time greats. The steely face of Martin Letts gives a glimpse of the spirit of this fine huntsman and, needless to say, his hounds had the same outlook on life. Then there is the elegance of Mrs Pope talking to Captain Ian Farquhar, Joint Master of the Beaufort Hunt, the very essence of ducal grandeur!

The summer shows or, as that time of the year is called in hunting parlance, the Silly Season, are not omitted either. Those who know Trevor are well aware that his camera is on duty at all our major agricultural and hound shows. The lens misses nothing as his photograph of Peter Jones, the celebrated Pytchley huntsman and his equally renowned counterpart at the Fernie Bruce Durno, illustrates so succinctly. They are both watching the judging at the Peterborough Royal Foxhound Show. Both wear bowler hats and reading glasses. Their intense gaze misses nothing and I rather suspect that the judges as well as hounds are being scrutinized.

The camera never lies, nor does it rest. Neither does Trevor. I have seen him out with my hounds at crack of dawn, in pouring rain and howling winds – never a complaint. Well, not an audible one! Although on one occasion he did give me an old-fashioned look when the driver of the vehicle I had arranged for him to follow the hounds in told Trevor that he hoped he did not mind being driven by a 90 year old! Charlie Warren and his tank had been the first to advance across the minefield at the start of the Battle of Alamein. Trevor, however, had a safe and happy day and, as always, was never far from the action.

I hope that this book gives you as much pleasure as it has already given me. It is a great treat. Do not forget to read the wise words of the 'Fox's Phrophecy' quoted in part on page 10. Likewise, the dun pony with NO BAN clipped onto its bottom is the one to follow for this book must not become a record of a bygone age, but rather a spur to encourage us forward to victory so – Forrard On.

Nigel Peel
CONDICOTE

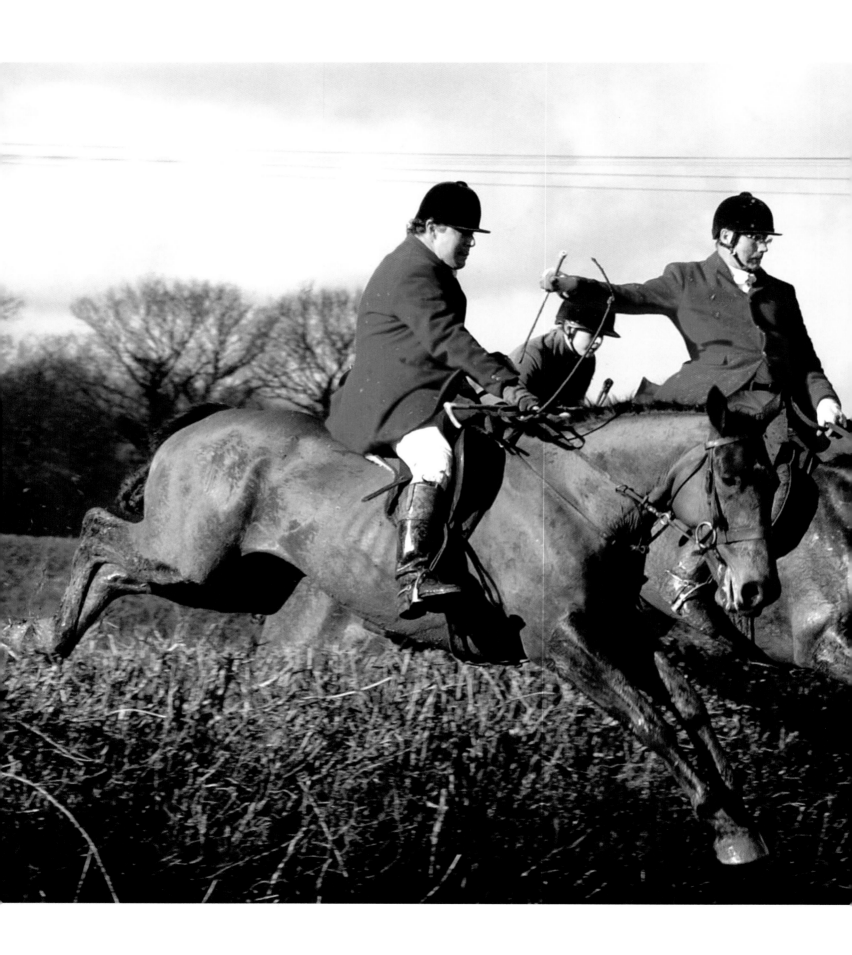

Introduction

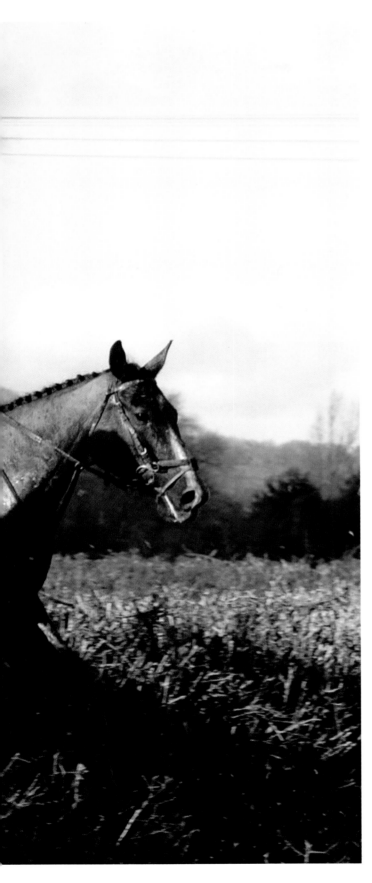

'Believe me, there is no colour like red – no sport like 'unting.'

Mr Jorrocks

THERE IS NO MORE EVOCATIVE SIGHT in the British countryside than that of hounds and hunting. For centuries, the colourful image of a pack of Foxhounds – whether streaming across a field; meeting in the town centre on Boxing Day; or surrounded by children at a county show – has been as intrinsic to the rural community as lambing or harvest time, and has inspired painters and writers throughout the centuries.

Foxhunting not only provides recreation through a unifying and democratic social structure in rural areas devoid of more urban forms of entertainment, but also fulfils the less glamorous functions of pest control and flesh collection, which support the farming industry. Hunting plays an integral part in conservation through the preservation and maintenance by hunt supporters of coverts (woodland), which provide sanctuary for wildlife, and in retaining the balance of the food chain by helping to control the fox population. Hunting underpins the economy of Britain's prolific equestrian industry — a surprising number of people keep a horse purely to hunt — because a single day's hunting is a triumph of organisation that will have provided employment, whether directly or indirectly, to thousands.

However, for such a seemingly beneficial activity, hunting arouses ferocious passion, whether people are for or against it, and it has been hunting's own image – mistaken but so difficult to shift – as a bloodthirsty hobby of the rich and upper class that has often clouded the issue. Hunting can inspire more emotional and aggressive debate than politics or religion. MPs from all parties have risked their careers to defend it; people who do not hunt themselves have marched in support of it, because they do not see why the right to hunt should be summarily removed, and many of the movers and shakers who have expounded the greatest energy in preserving hunting and its traditions neither ride nor have the spare time actually to go hunting.

The generosity and desire of so many people to maintain traditional foxhunting has seen it survive the deprivation of two World Wars, recessions, outbreaks of foot-and-mouth disease and relentless political activity. Increasingly, hunting people have had to grasp the significance of PR — unfortunately not always with unqualified success — and, in addition to the many other skills he has to acquire, the professional huntsman has reluctantly been forced to become a political animal.

LEFT: Sir Richard Hardy and John Studd take on the serious hedge country of the Blackmore & Sparkford Vale.

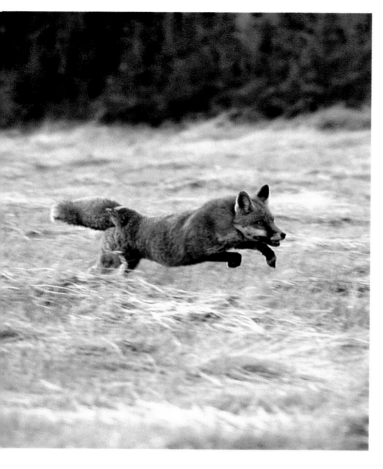

ABOVE: A healthy fox bounds away from covert — the Hunting Act will do nothing for his lot.

Hunting's argument is that a ban does nothing whatsoever to improve the fox's lot; indiscriminate culling is already taking effect and many recognise that a change in the law will be necessary. In 1882 the extraordinarily far-sighted Victorian writer DW Nash gave a fox a voice in his poem 'The Fox's Prophecy'. More than a century later, it still arguably presents the best case for foxhunting's survival:

'Yet think not, huntsman, I rejoice
To see the end so near;
Nor think the sound of horn and hound
To me a sound of fear...

'Too well I know, by wisdom taught,
The existence of my race
O'er all wide England's green domain,
Is bound up with the Chase.

'Better in early youth and strength
The race for life to run,
Than poisoned like the noxious rat,
Or slain by felon gun...

'The huntsman turned, he spurred his steed,
And to the cry he sped;
And, when he thought upon that fox,
Said naught, but shook his head.'

The talking fox's words proved horribly prescient in 2005 when the world of foxhunting changed dramatically, but we hope not forever. After more than 700 hours of parliamentary debate, the day to which few hunting people had really faced up actually arrived. The might of the rarely-used Parliament Act was invoked by Tony Blair's Labour Government and the Hunting Act came into effect on 18 February 2005.

And, on 19 February, foxhunting's hardest battle yet commenced: to find ways of hunting legally so the fox population can be controlled and preserved, and the valued traditions of the British countryside might be saved. The fight goes on — through the courts and through politics — to overturn the ban. Despite reaching the lowest ebb, there is still huge will and energy to ensure that hounds will continue to give great pleasure to people from all walks of life for many years to come.

The pictures in this book, all taken before the Hunting Act by *Horse & Hound*'s staff photographer Trevor Meeks, himself a late convert to the joys of hunting, capture exactly why the energetic fight for its preservation have been so worthwhile and why foxhunting does matter.

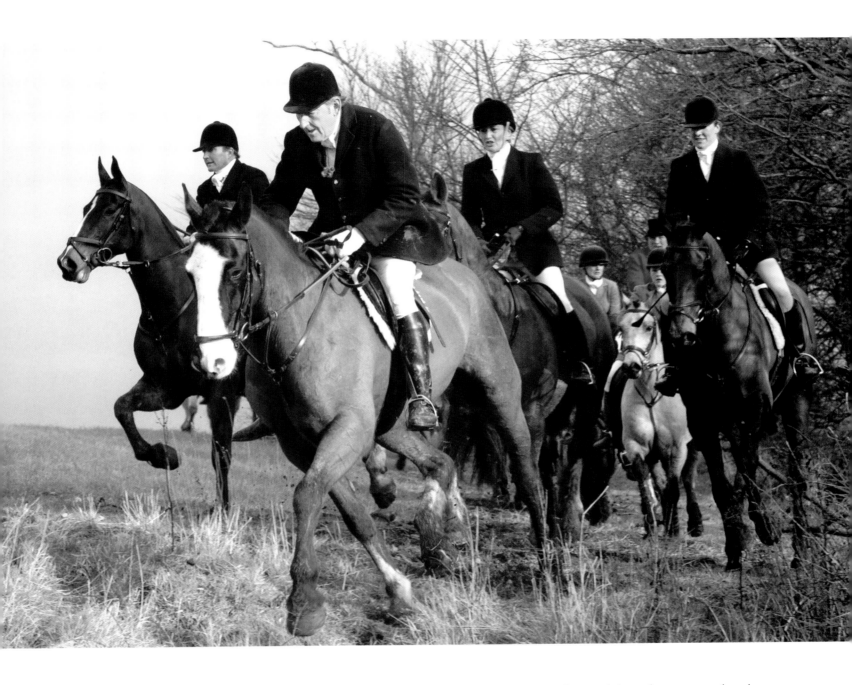

ABOVE: The Bedale field, headed by Willie White.

OVER PAGE: George Adams, huntsman, takes the Fitzwilliam hounds out on foot when conditions were too snowy to ride.

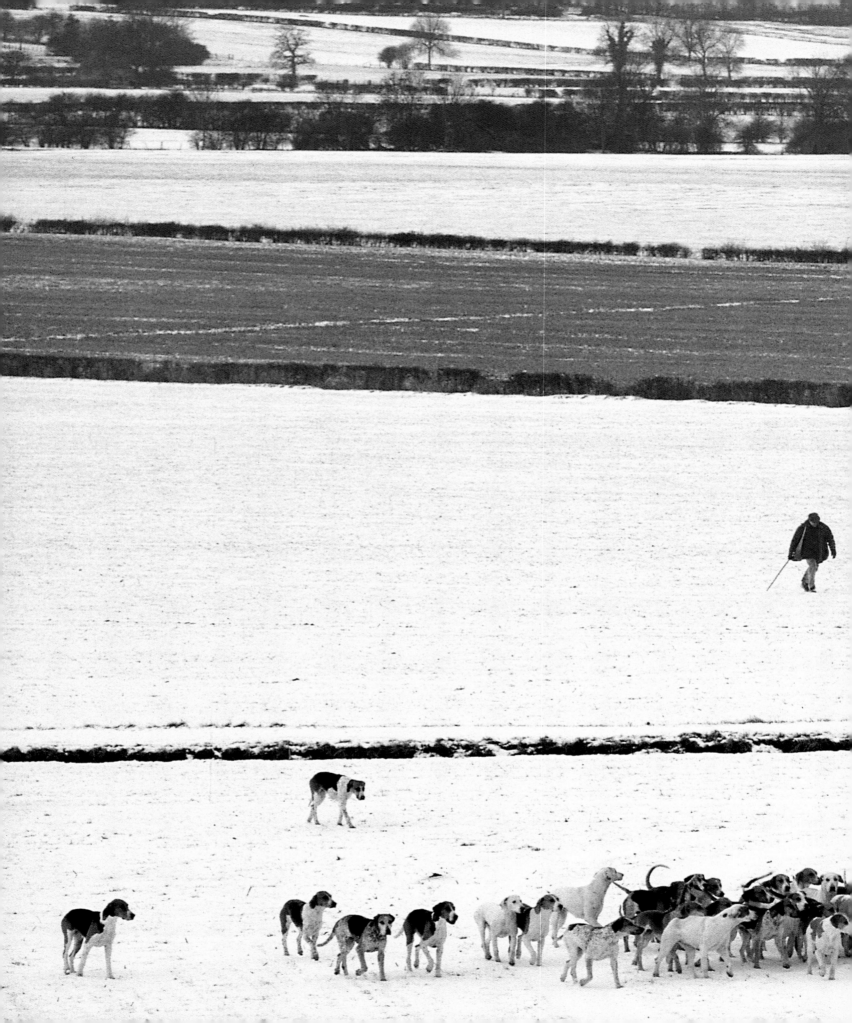

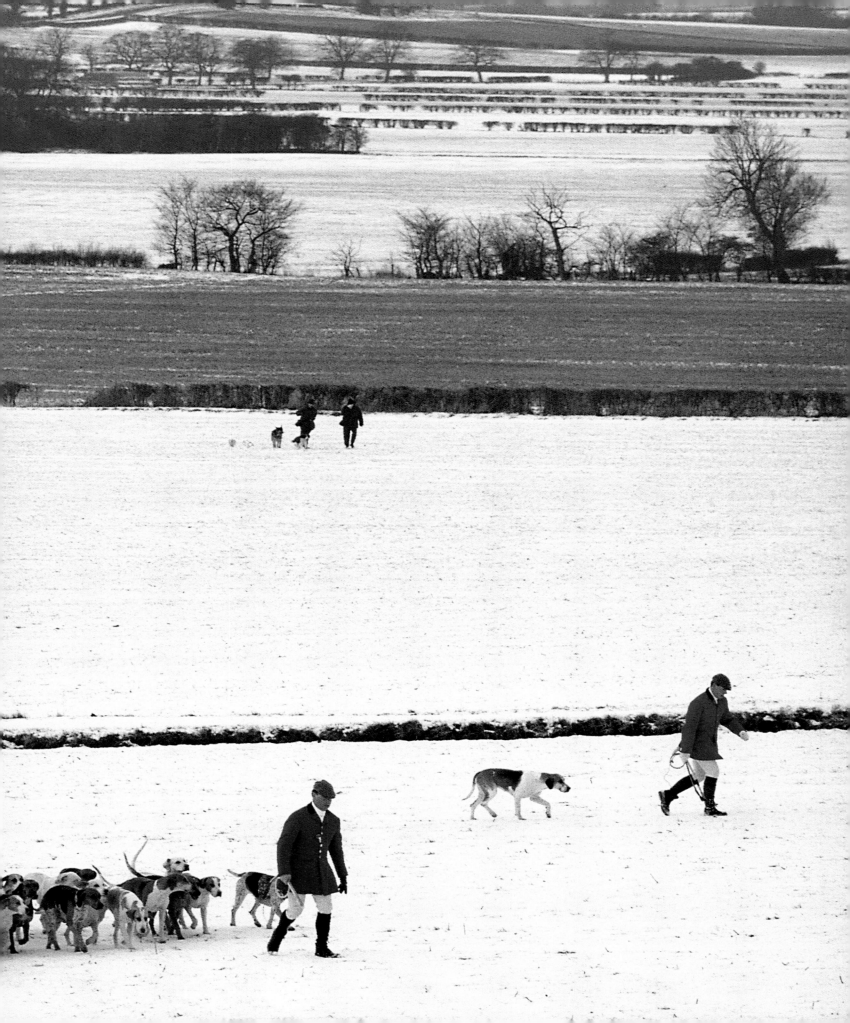

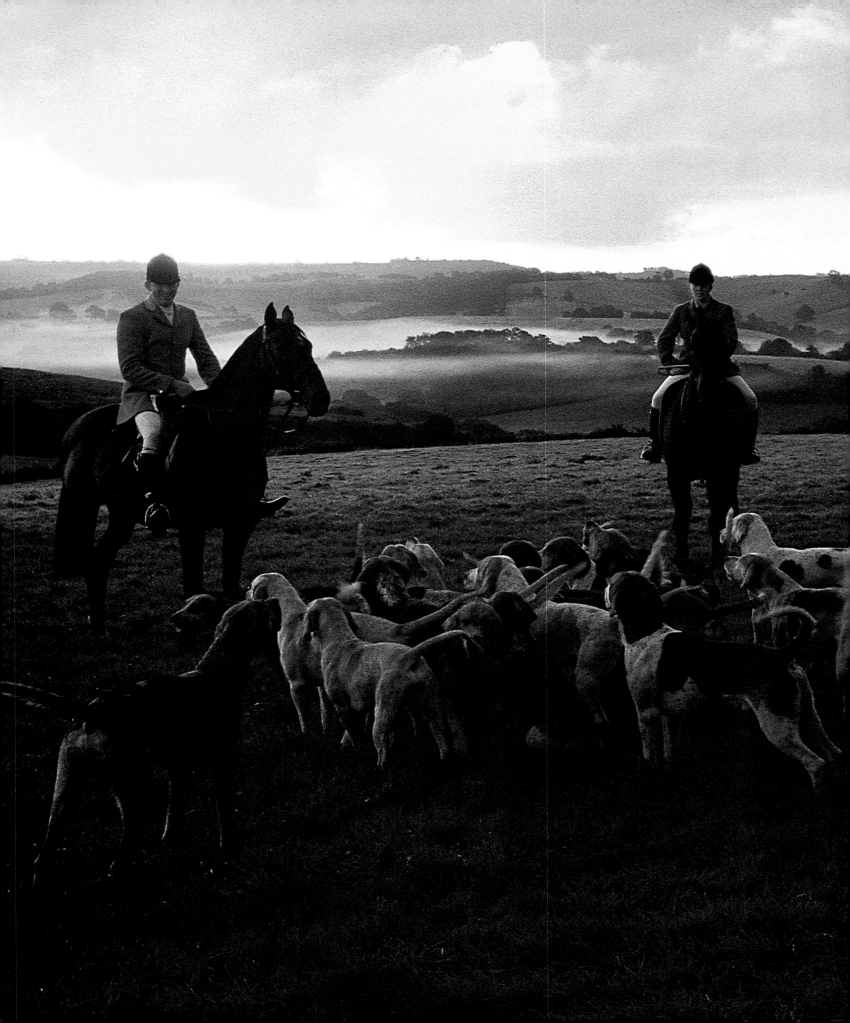

1 Hunting and the Changing Landscape

'Come, I'll show you a country that none can surpass,
For a flyer to cross like a bird on the wing,
We have acres of woodland and oceans of grass,
We have game in the autumn and cubs in the spring,
We have scores of good fellows hang out in the shire
But the best of them all is the Galloping Squire.'

From 'The Galloping Squire', GJ White-Melville

PASSION FOR FOXHUNTING is as strong among the small packs of the steep Welsh valleys as it is in the Vale of Belvoir's lush grass and jumping country, which is perhaps why the hunting fraternity has generally been able to maintain a united defence on the political stage. Yet styles and flavours of hunting countries differ enormously. Terrain, soil, farming patterns — especially the increase in arable farming — population and urbanisation will have an enormous effect on the way a hunt operates and therefore its character. Jumping doesn't have to be the be-all and end-all — the wild, steep moorland areas are just as challenging to cross and offer the purist the thrill of watching hounds work unaided.

Hunting countries vary from the expensive — Leicestershire, with its 'oceans of grass' and inviting, beautifully-laid hedges — to the boggy West Country moorlands of Exmoor, Dartmoor and Bodmin, and the even wilder Welsh and northern Border countries where dozens of small packs of hounds vanish into steep-sided valleys. From the flat Somerset 'levels', split by awesome, gaping rhines (wide, water-filled ditches), to the Cotswold stone walls; the giant blackthorn hedges of Dorset to the flat, plough country of East Anglia and the well-maintained jumping countries of the Midlands, the common denominator is enthusiasm. This is coupled with a desire to make foxhunting fit in the landscape, no matter how it is shaped.

Today, Leicestershire, with its springy grassland, is touted by many as the most sought-after — and popularised – hunting area of England. But 300 years ago it was the south-east that was regarded as prime hunting country, accessible to London and beloved by royalty – and also to RS Surtees' great character Mr Jorrocks. There are still huge pockets of wonderfully rural countryside with great jumping in the south-east, but the accessibility to cities, which once made it so appealing to kings, has also become its ruination. The region suffers from the inevitable urbanisation, pressure from anti-hunting factions and the predominance of big estates given over to shooting.

However, politics isn't the only threat to the tradition of the Chase. There are many, less-publicised problems that threaten the future of hunting, even if the ban were revoked. Urbanisation, bringing with it intolerance and misunderstanding, is a major issue. There is the increase in arable farming, where care must be taken not to damage crops in the wet winter; the rise in game shooting — and its economic value, and the predominance of Forestry Commission land in parts of Wales and the Fells, where hunting licences were revoked with the Hunting Act.

All these factors mean that a single day's hunting can require military-style planning to ensure that hounds blend with the landscape's many other demands. Planning and co-operation are the key demands of 21st century hunting, and every hunt goes to great lengths to ensure it achieves harmony and tolerance in the countryside.

LEFT: Pink early morning light with the Seavington.

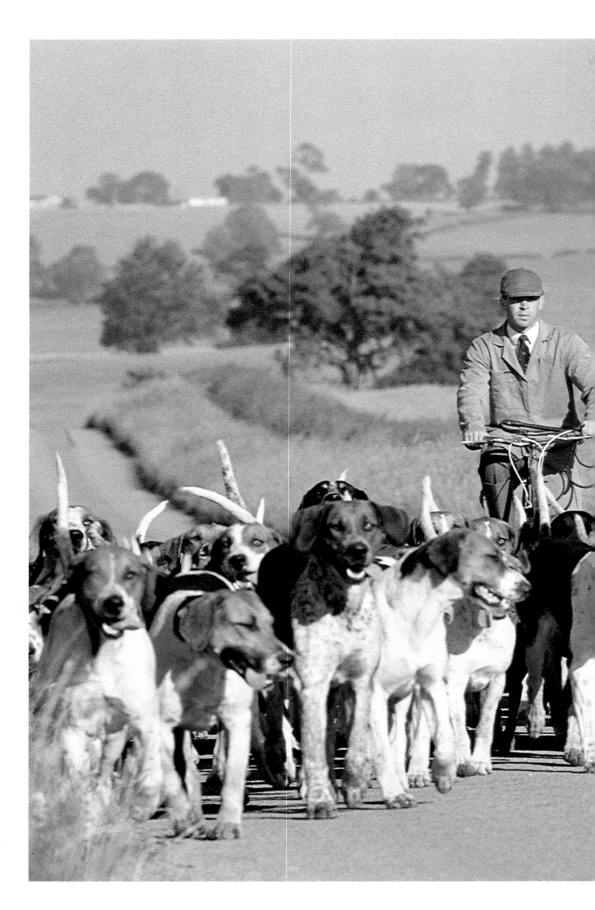

RIGHT: Bruce Durno, legendary huntsman of the Fernie for 31 years, hound exercising on a summer's morning.

OVER PAGE: Chris Bowld, huntsman of the Blackmore & Sparkford Vale since 1985, leads hounds away from the opening meet at Sherborne Castle.

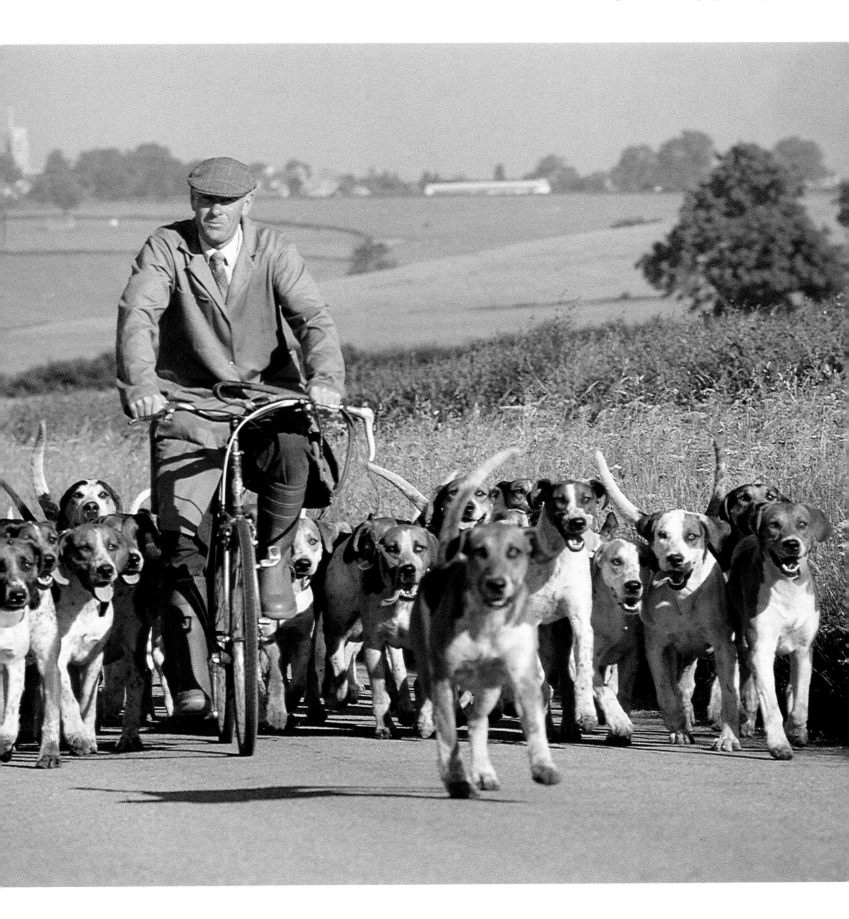

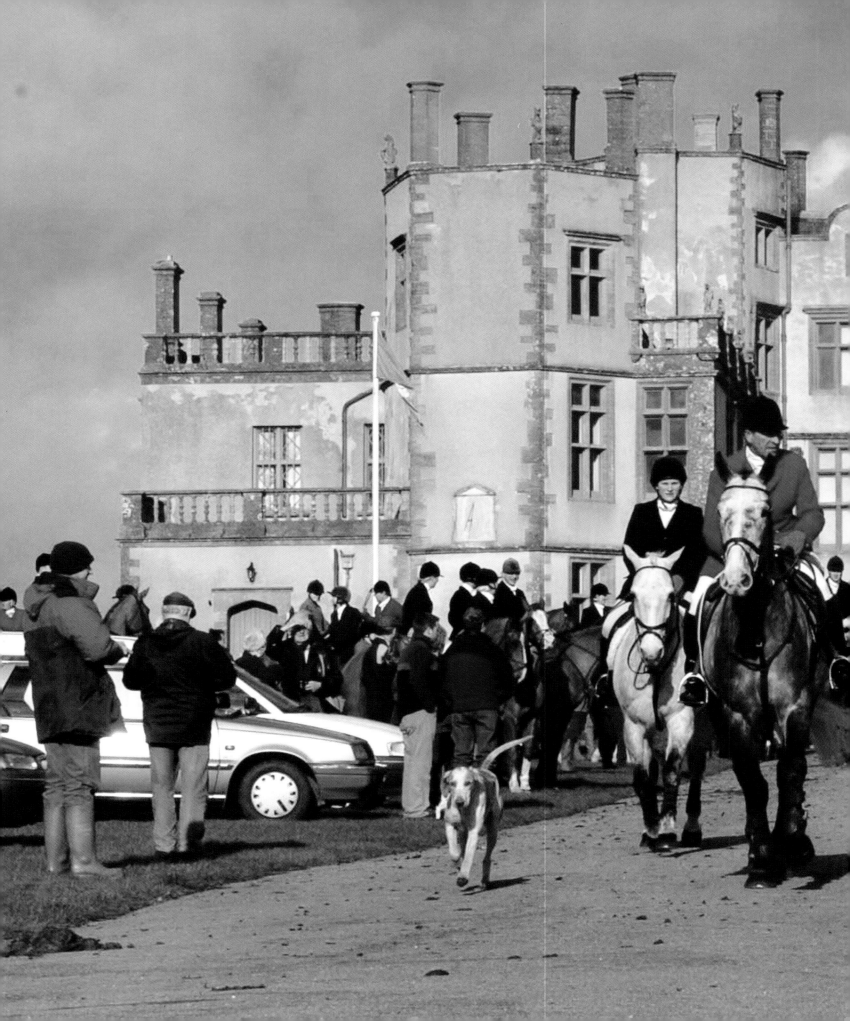

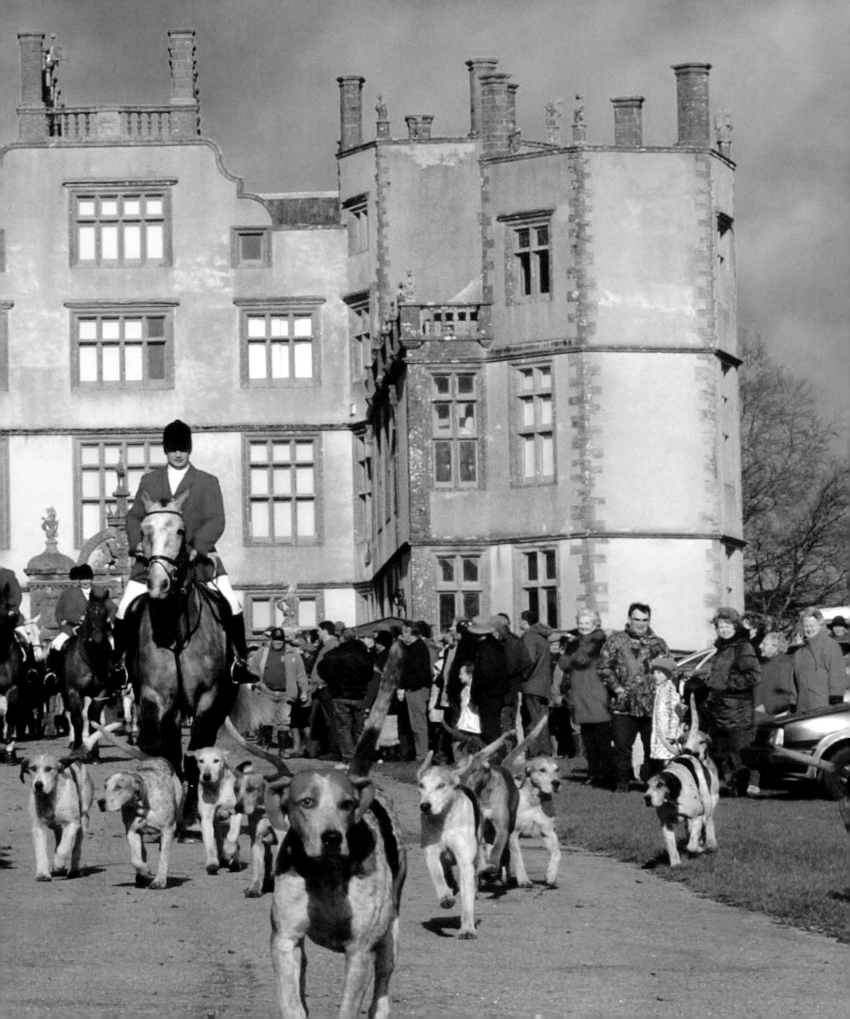

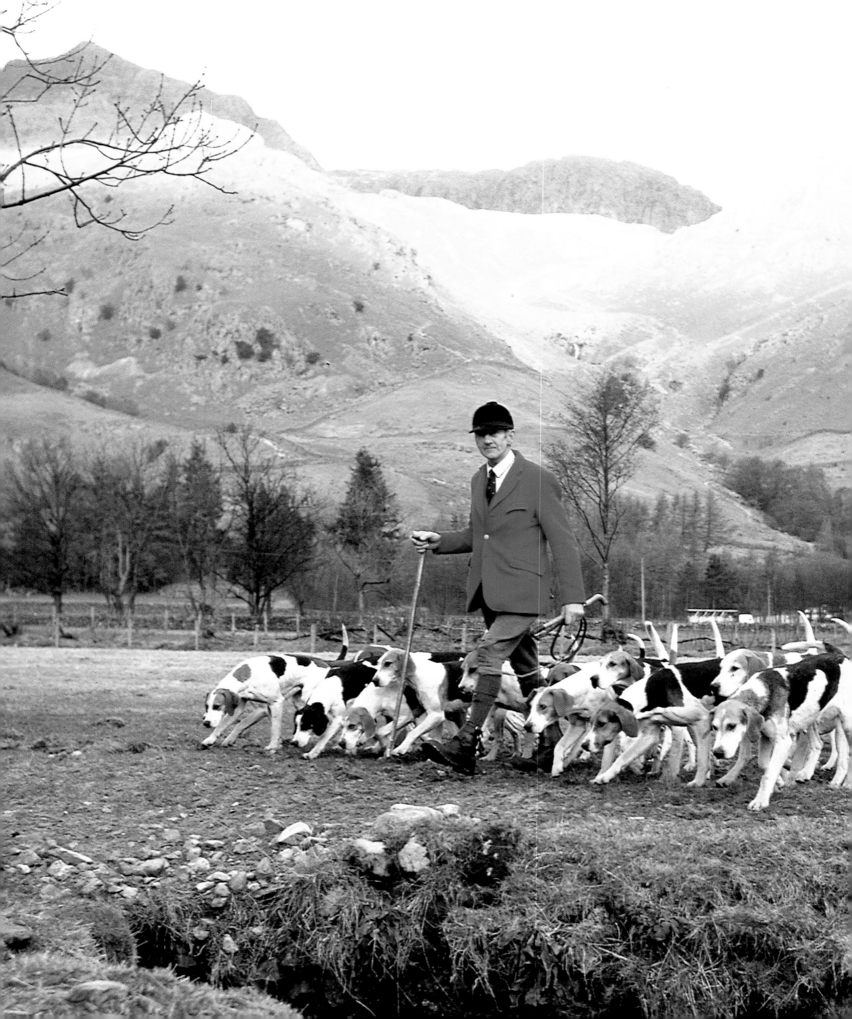

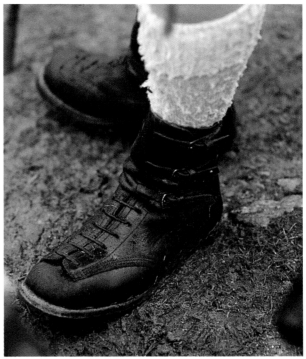

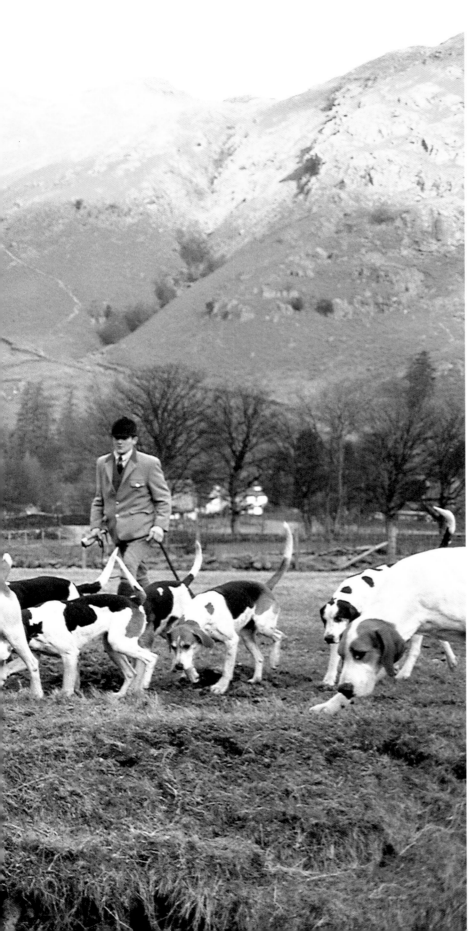

ABOVE: These boots were made for walking... Hunt staff in the Fells are a different breed and have to be enormously fit to stay in touch with hounds in a stunning, but sometimes merciless, landscape.

LEFT: Stan Mattinson, former huntsman, with the Coniston hounds, a Fell pack formed in 1825 to keep foxes down in a prolific sheep-farming area. The spectacular backdrop shows why it is impossible to keep with hounds. Here, more than anywhere, the huntsman's control of and relationship with his hounds is paramount.

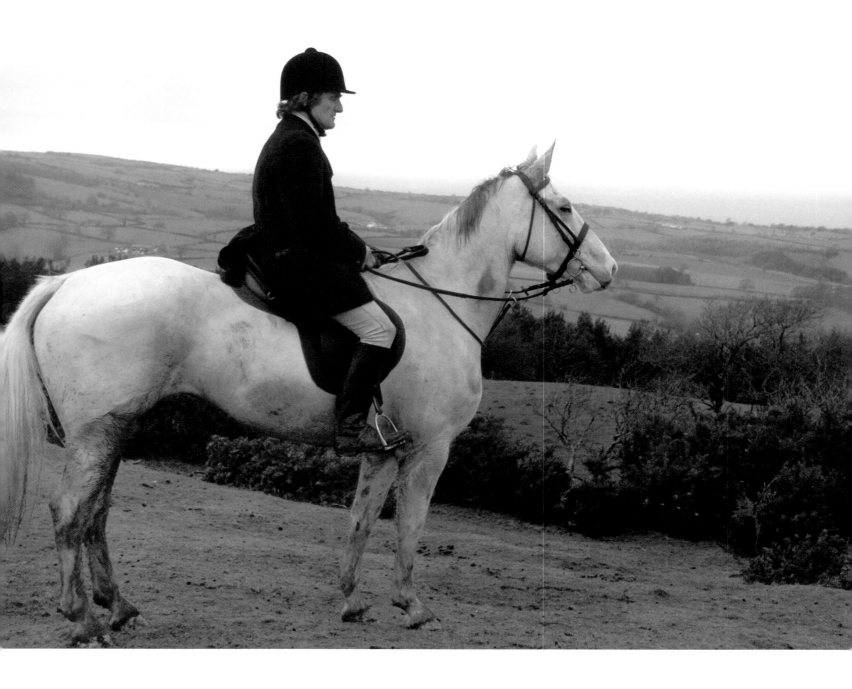

ABOVE: Hunting farmer Bob Parry overlooking
Colwyn Bay in the Flint & Denbigh's unspoilt North
Wales country.

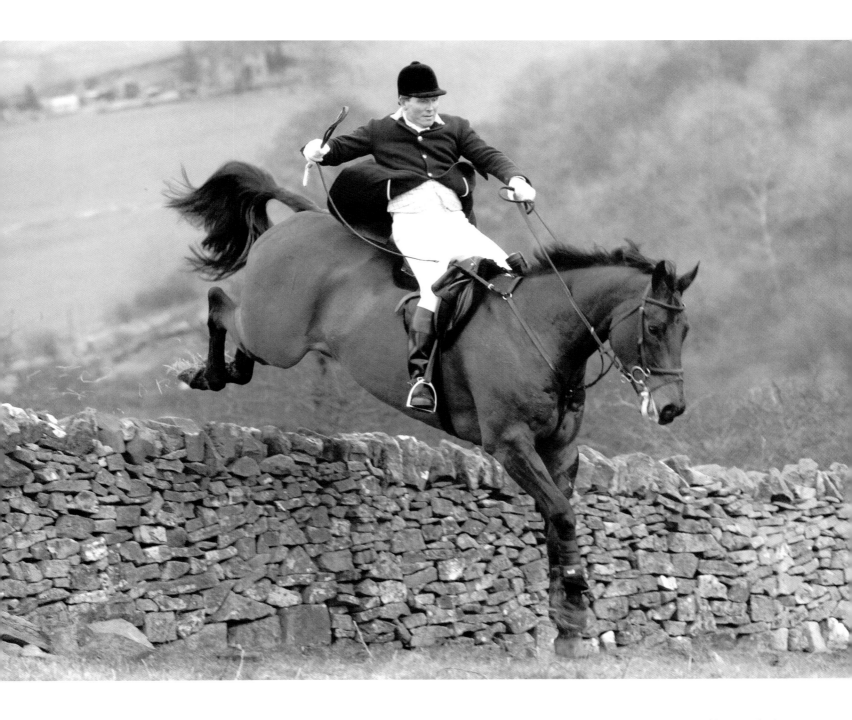

ABOVE: David Machin clears a stone wall, typical of the Staffordshire Moorland country. This pack was only formed (privately) in 1980, originally to hunt hares. Unusually, it has a female huntsman, Elaine Barker, whose husband David was formerly huntsman of the Meynell & South Staffs.

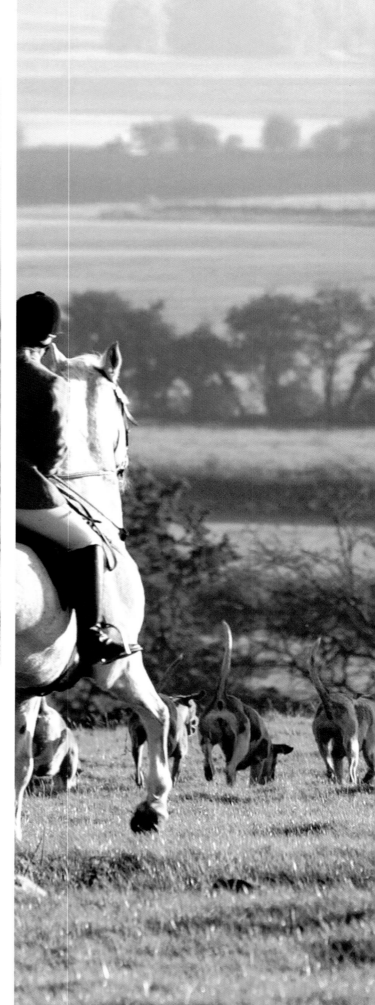

ABOVE: A holloa — one of the most evocative, spine-tingling sounds — from a Quorn foot-follower.

LEFT: Charles Gundry, joint-master and amateur huntsman, with the Middleton hounds on an autumn morning. He is the latest generation of his family to hunt hounds, following his father Robin and grandfather Gerald.

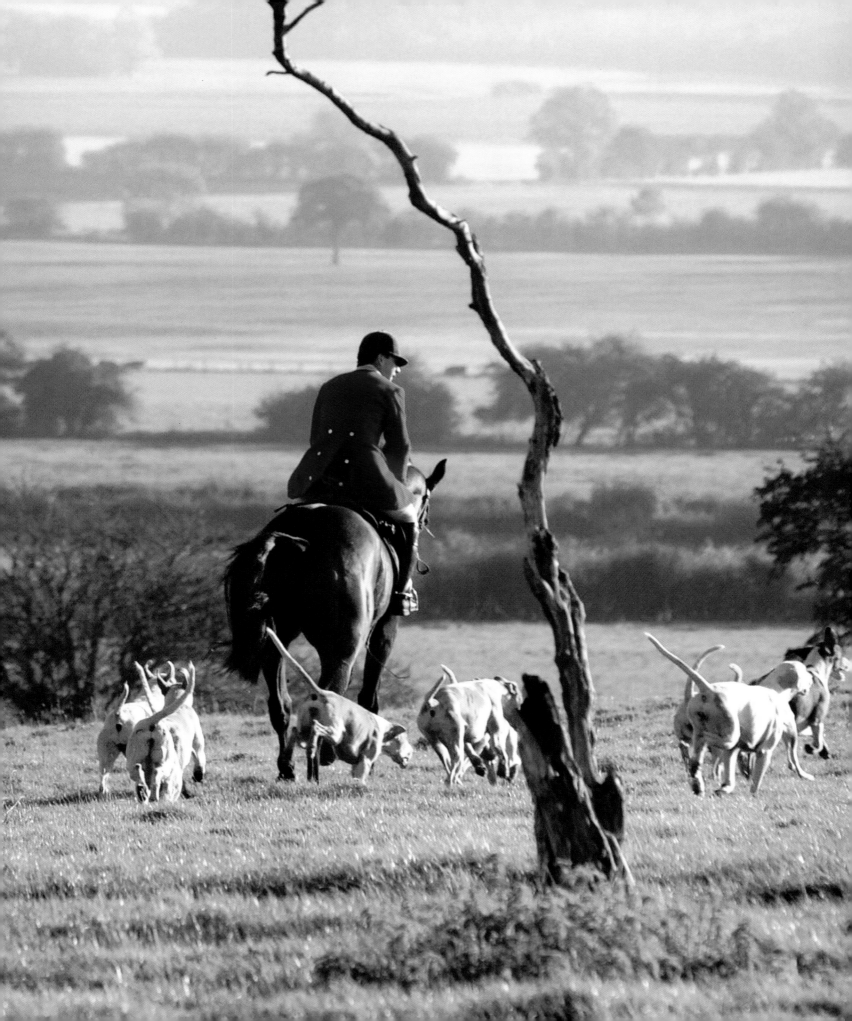

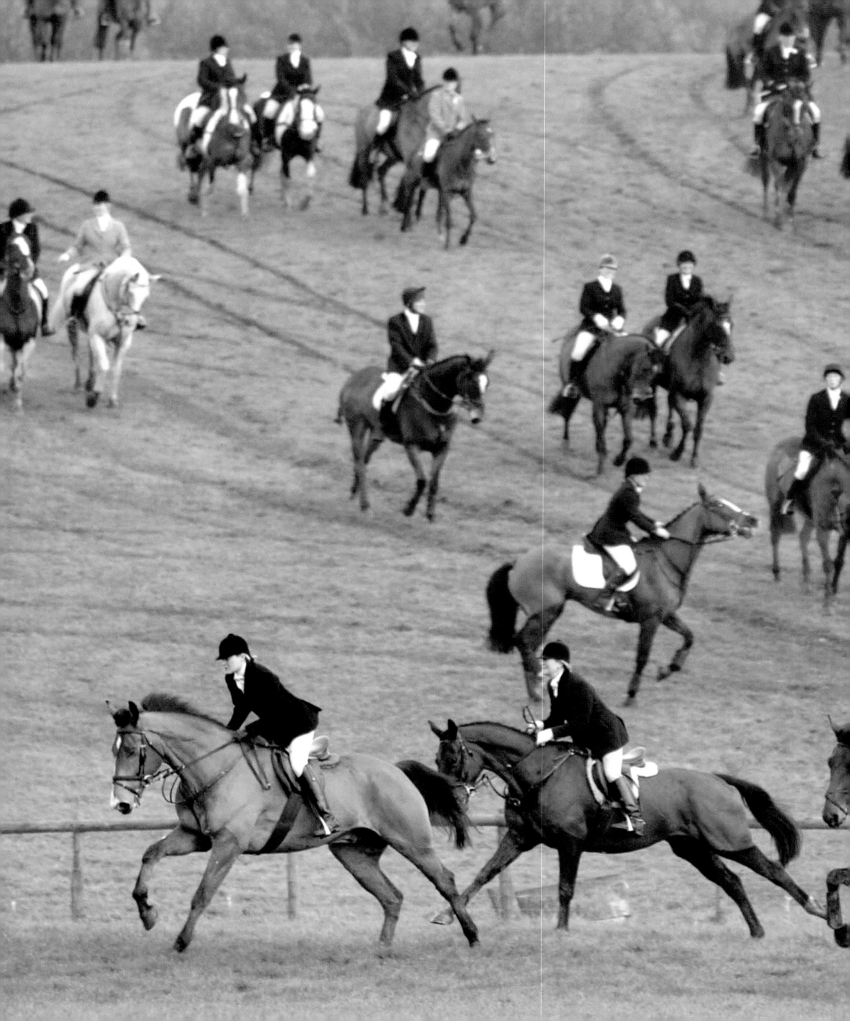

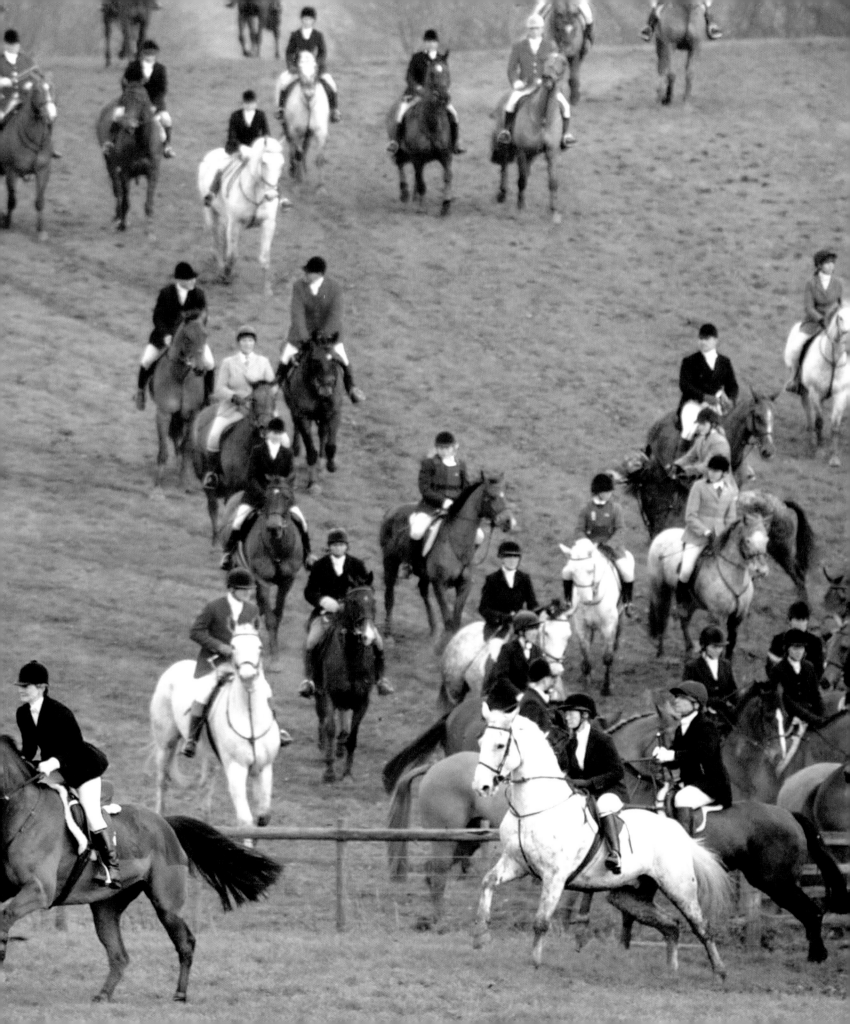

RIGHT: Pink sky in the morning — autumn hunting with the Seavington.

PREVIOUS PAGE: Probably the most famous pack in the world — a large Quorn Saturday field queues for a gateway. The 19th century hunting correspondent Nimrod (Charles Apperley) described this as 'the most perfect hunting country in England' and it still has to maintain a waiting list for subscribers.

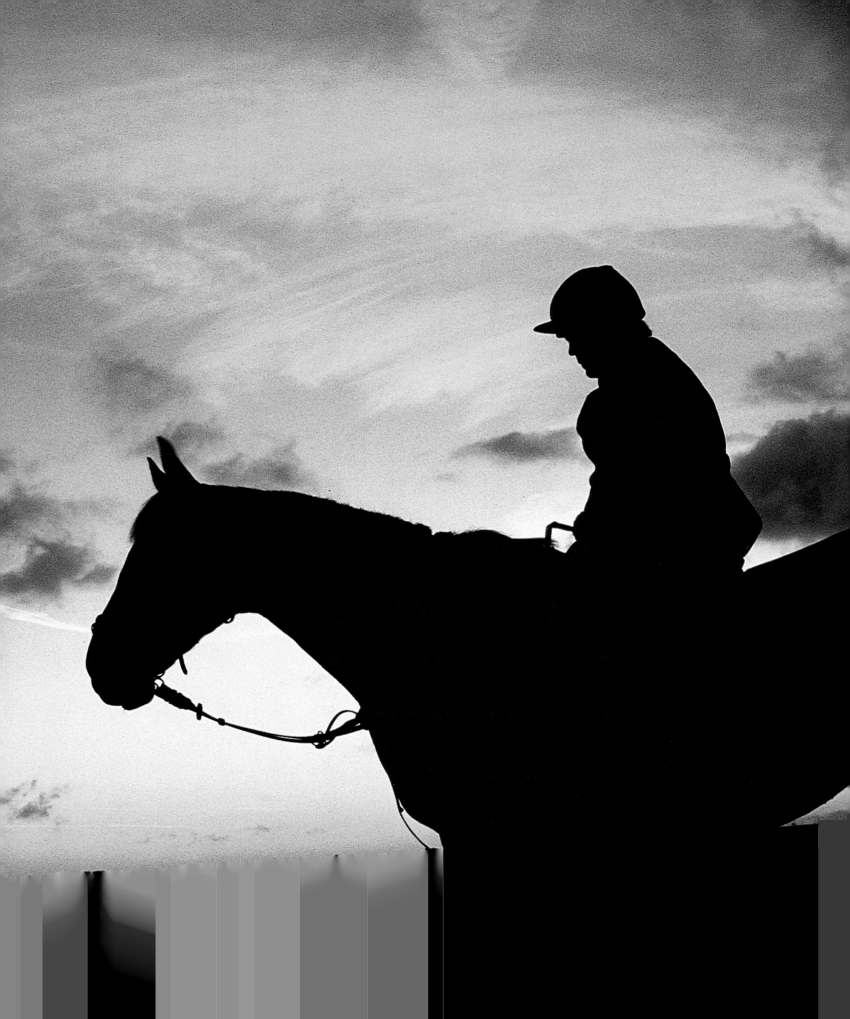

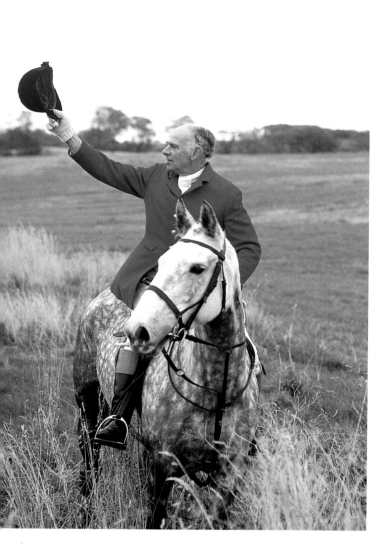

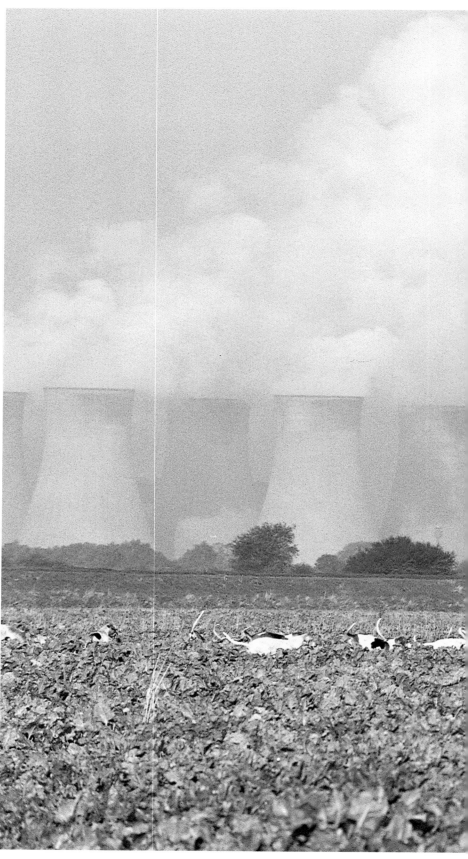

ABOVE: Peter Neilson, joint-master of the Duke of Buccleuch's, holloas a fox away.

RIGHT: One of the longest-serving hunt staff, Jim Lang, huntsman of the Burton since 1967.

OVER PAGE: Cheshire followers crossing the Shady Oak Bridge over the Shropshire Union Canal.

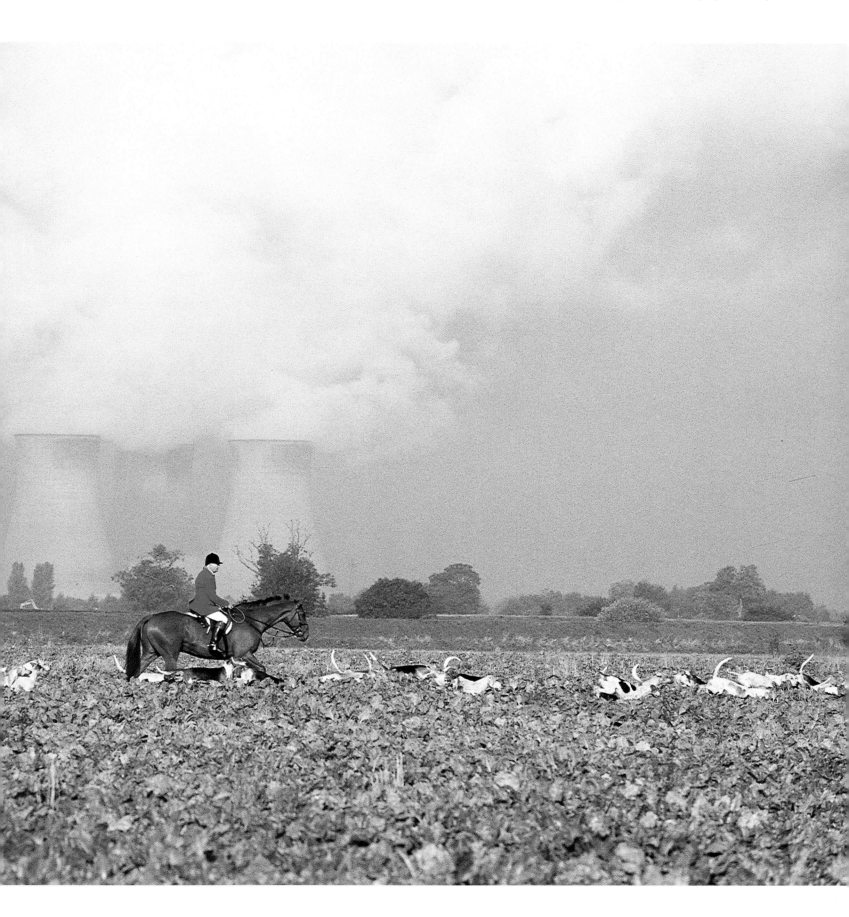

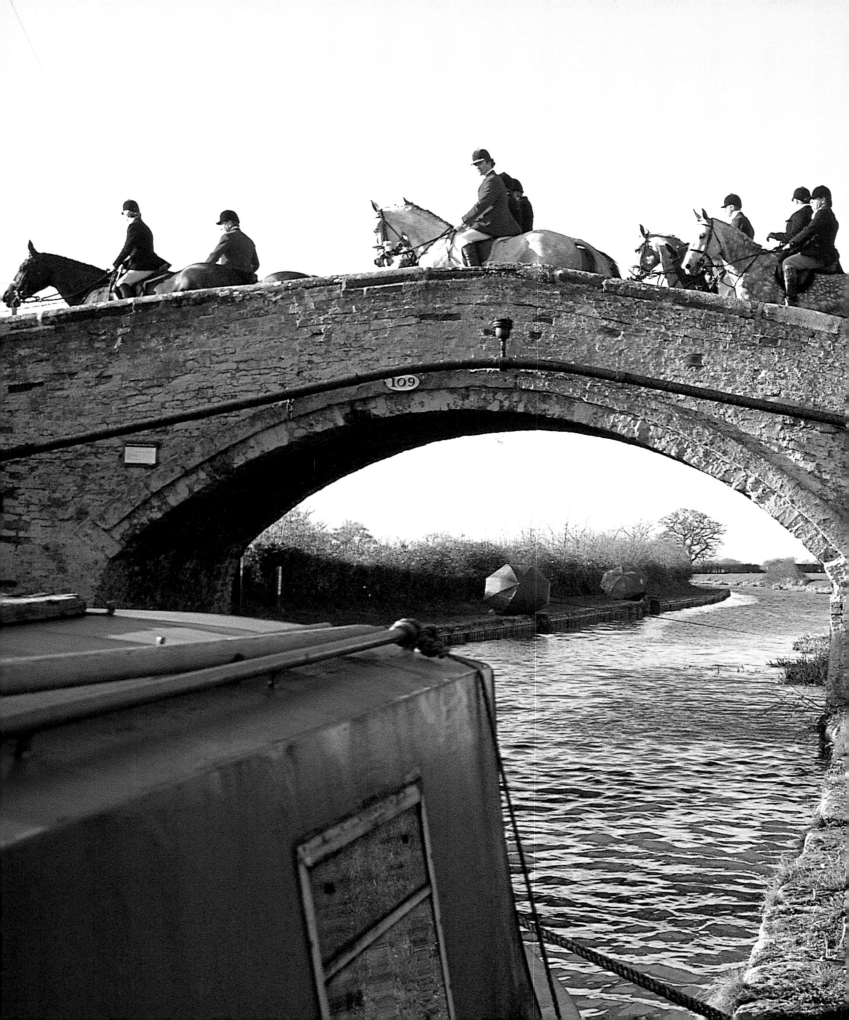

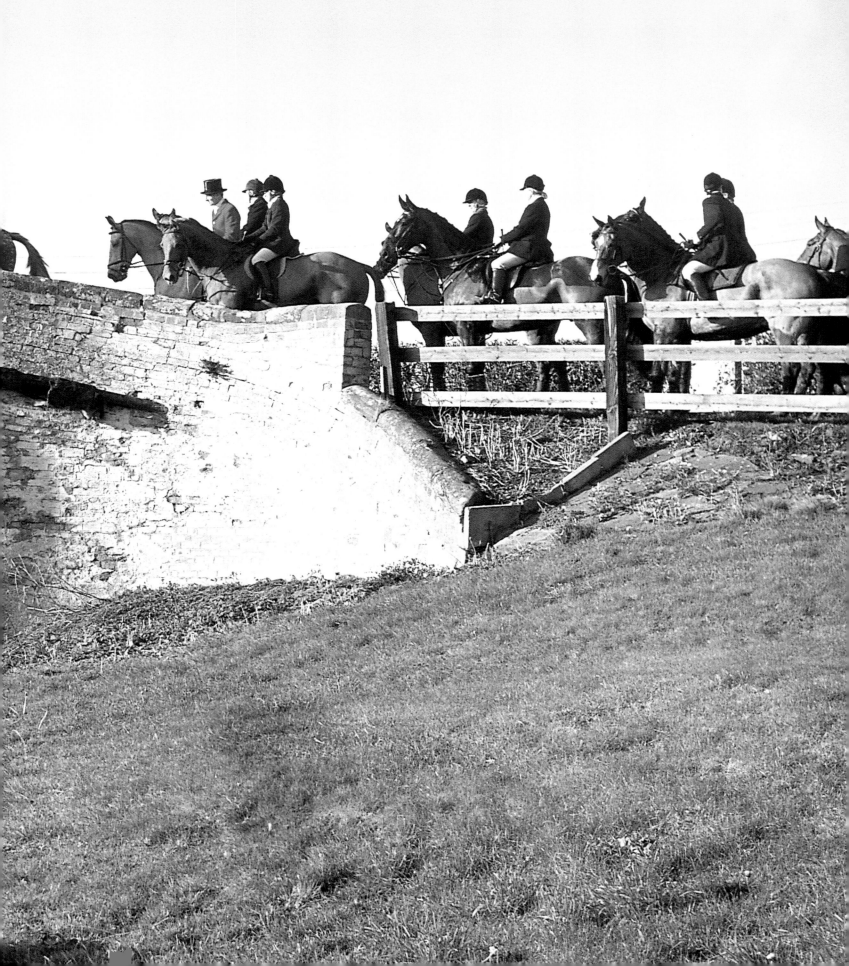

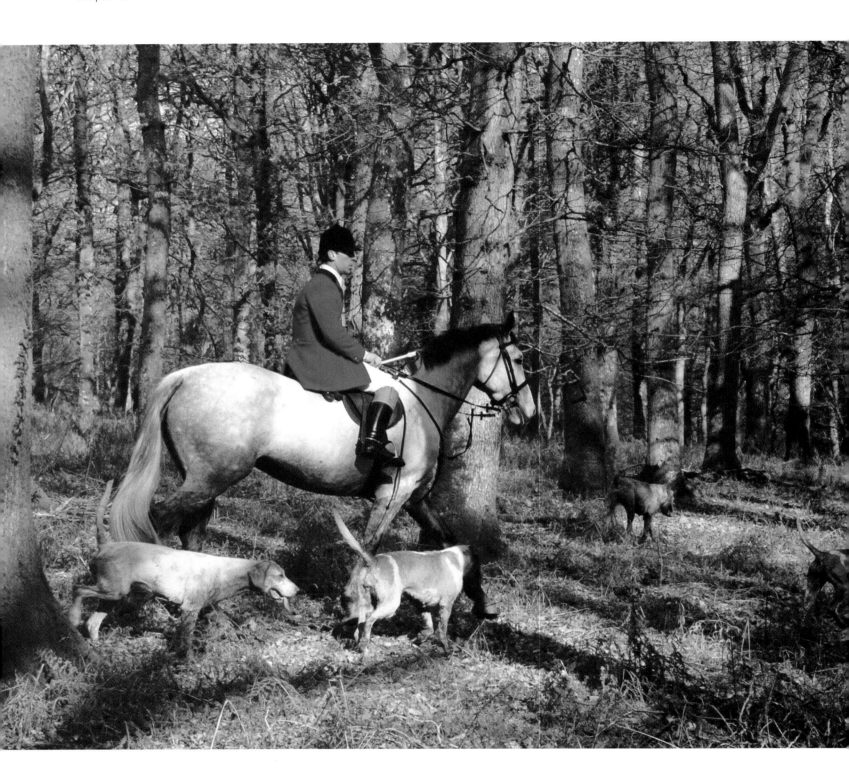

ABOVE: Michael Woodhouse, who has succeeded his father Paul as huntsman of the New Forest, pictured in the mellow light of the ancient woodland.

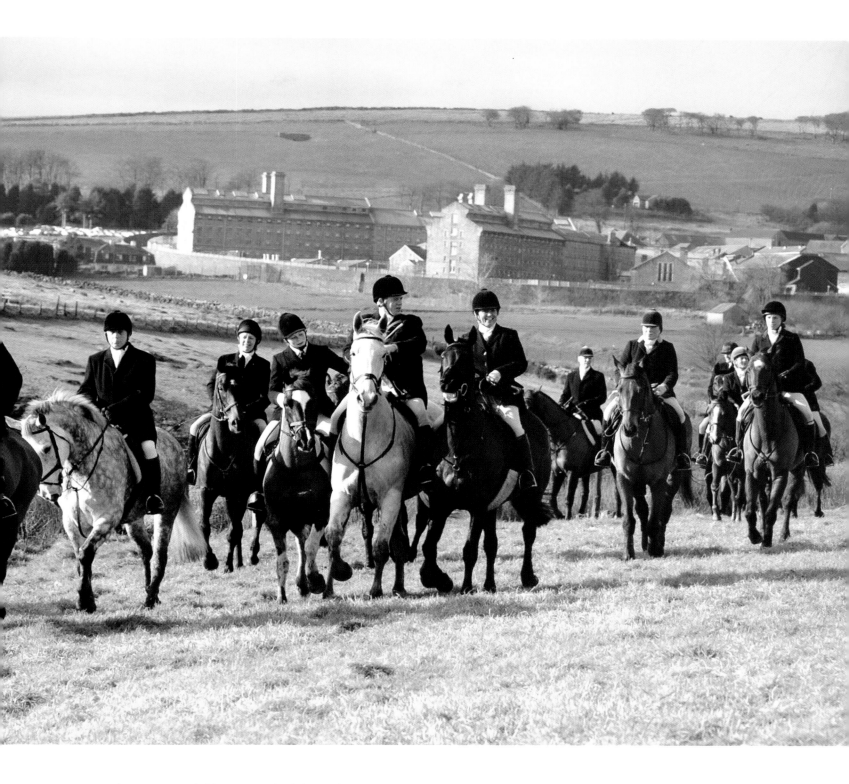

ABOVE: The Dartmoor field against a backdrop of the notorious prison, which looks unusually benign in the November sunshine.

OVER PAGE: A pause for the Fernie field while a gate is shut, ensuring the sheep don't escape. Field master Philip Cowen, whose father Joe has been master since 1972, is pictured right (scarlet coat).

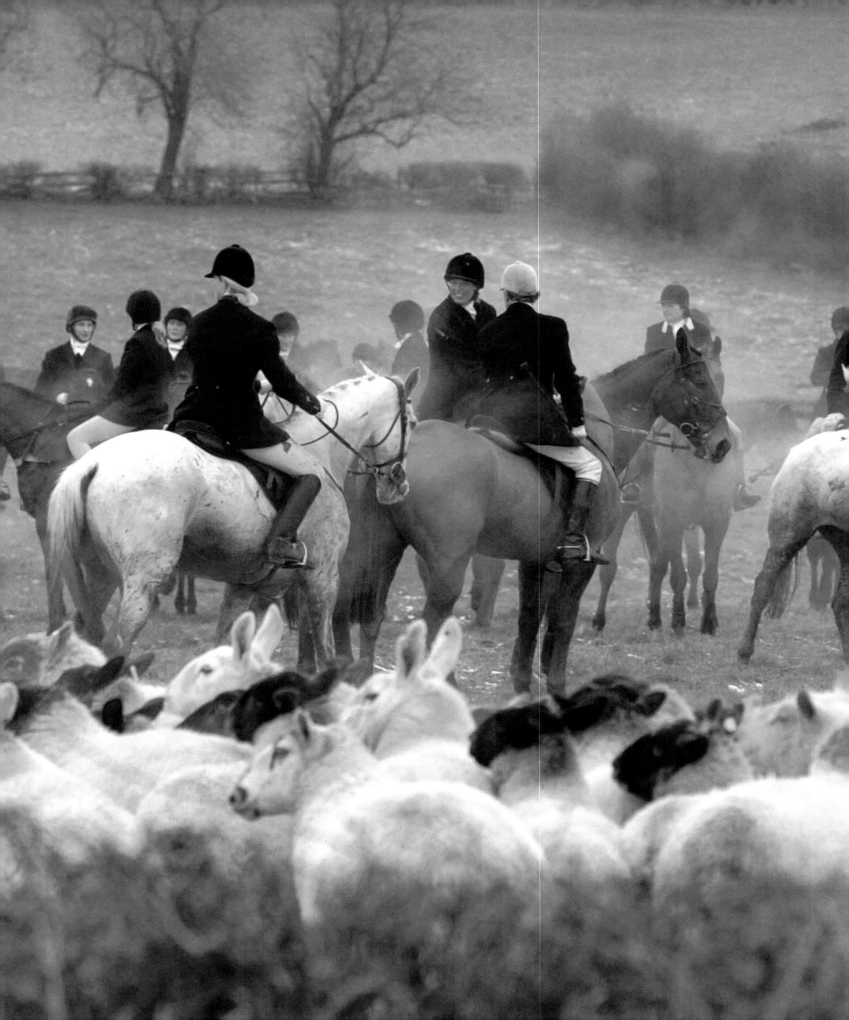

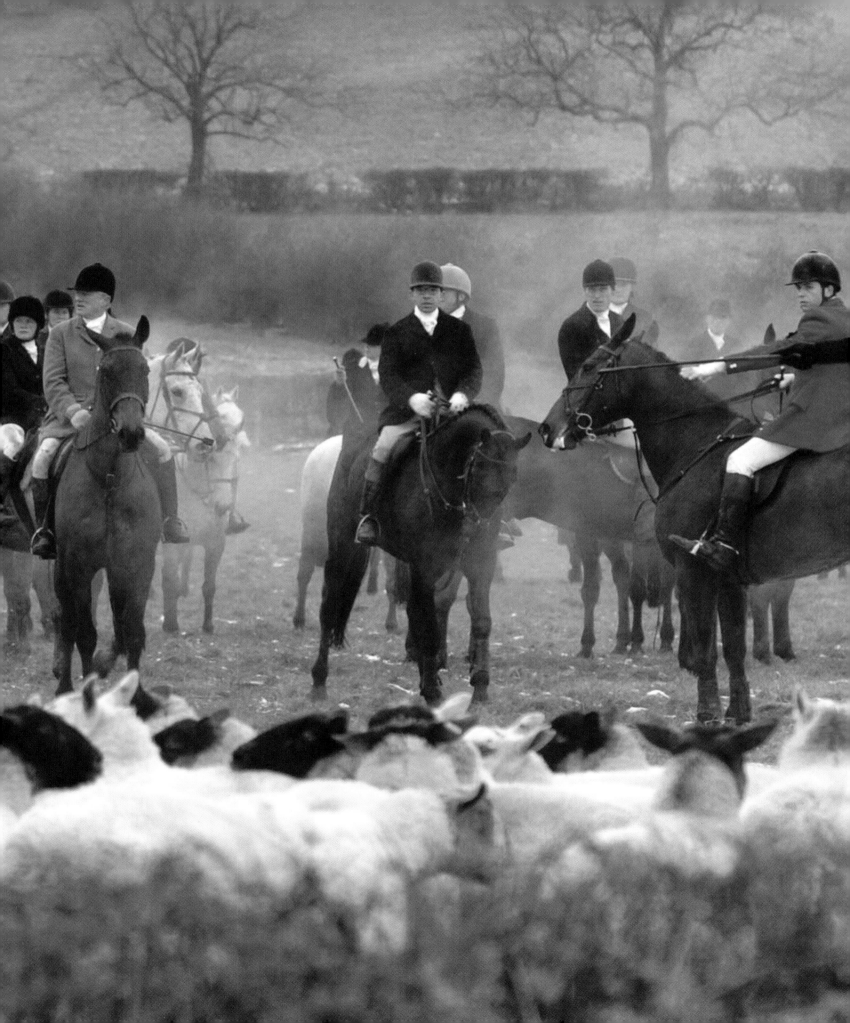

RIGHT: Michael Holt enjoying the blissful peace of point duty on a bracken-covered hillside with the Sinnington.

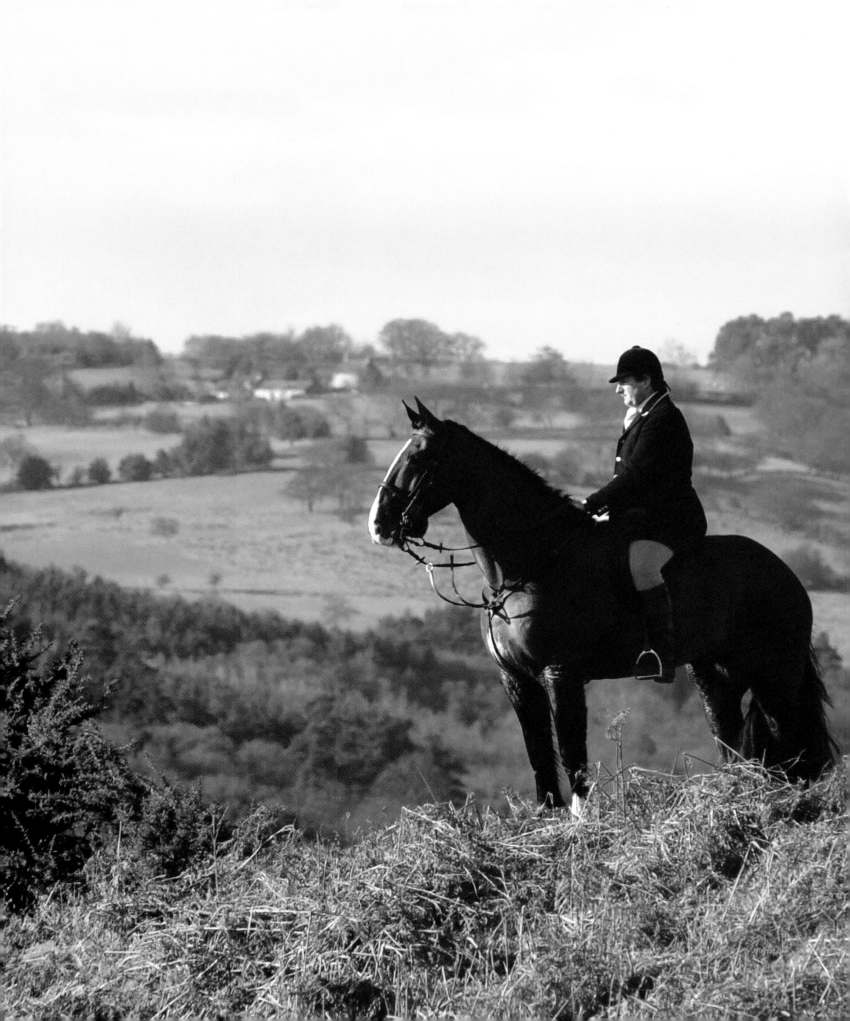

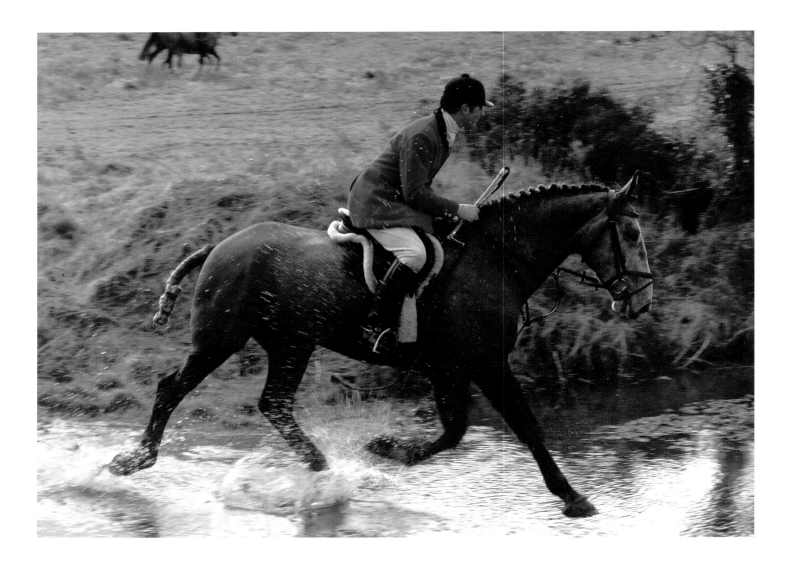

ABOVE: Matthew Penrose, amateur whipper-in to the Bedale.

RIGHT: Scottish Border pack the Duke of Buccleuch's hounds, led by their joint-master and huntsman since 1989, Trevor Adams, who has provided strong leadership at the sharp end of hunting politics. Scotland saw a hunting ban before England, but Scottish packs — all of which have survived — are allowed to use the whole pack to flush out foxes rather than just a couple of hounds.

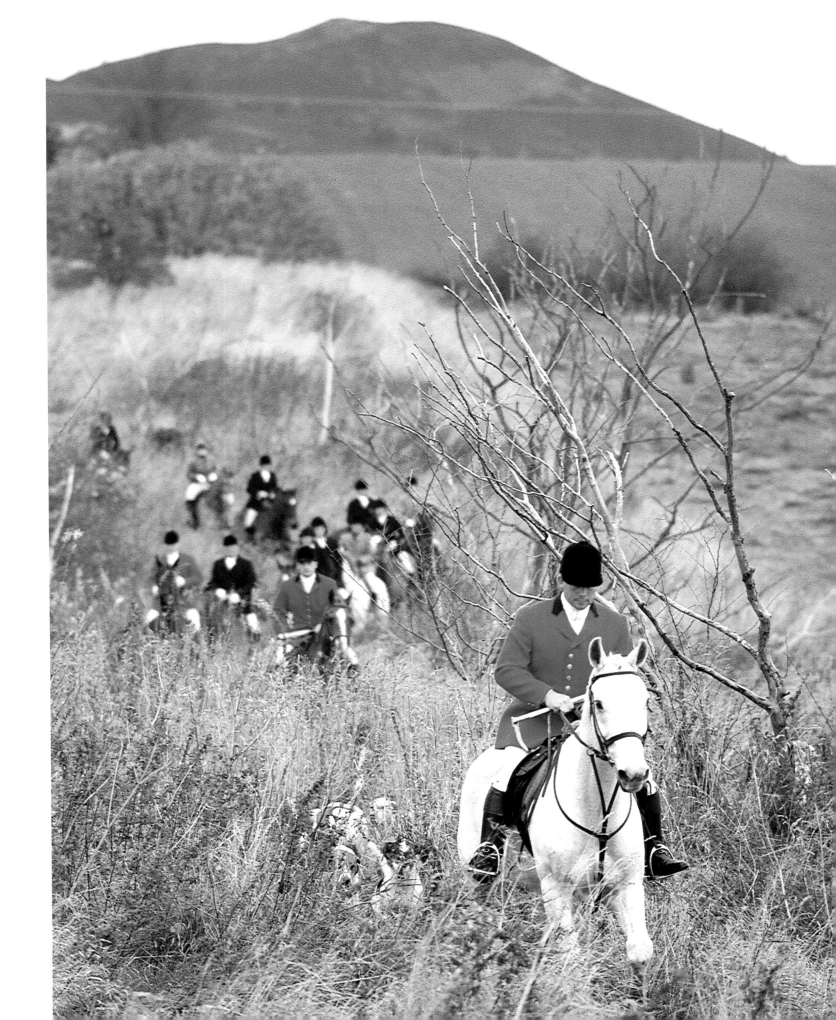

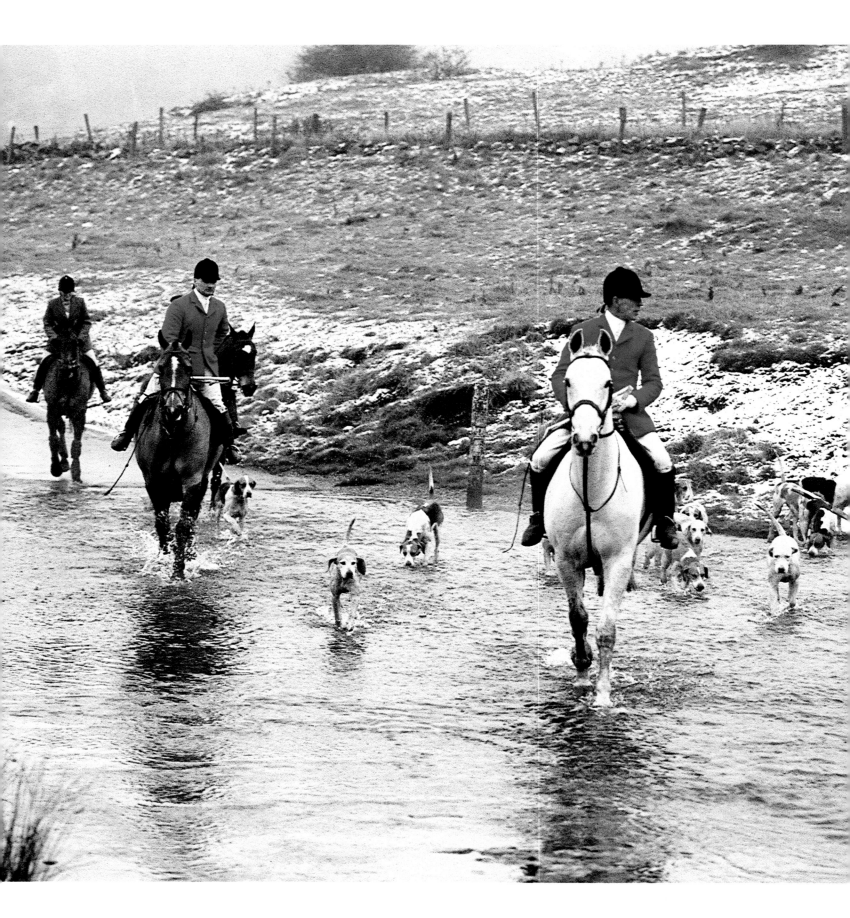

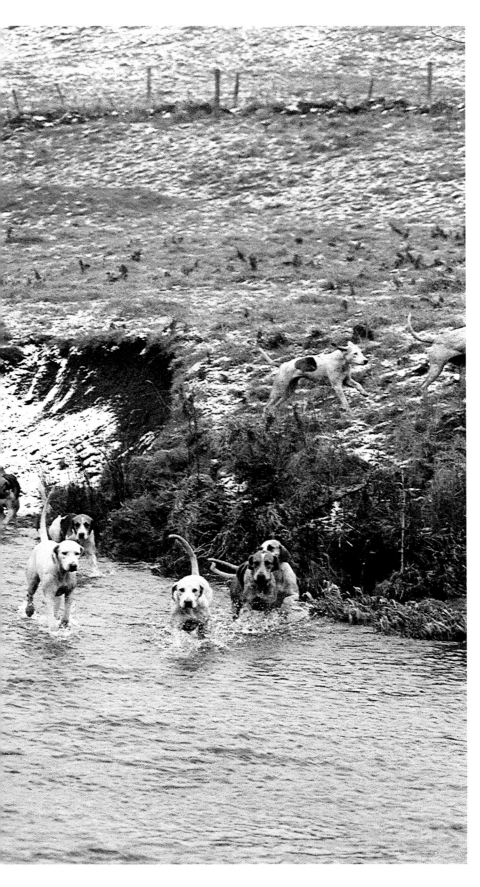

LEFT: David Barker, legendary huntsman and crack horseman — he represented Britain in show jumping at the 1960 Olympics — crosses the River Dove with the Meynell & South Staffs hounds and whipper-in Robert Haworth.

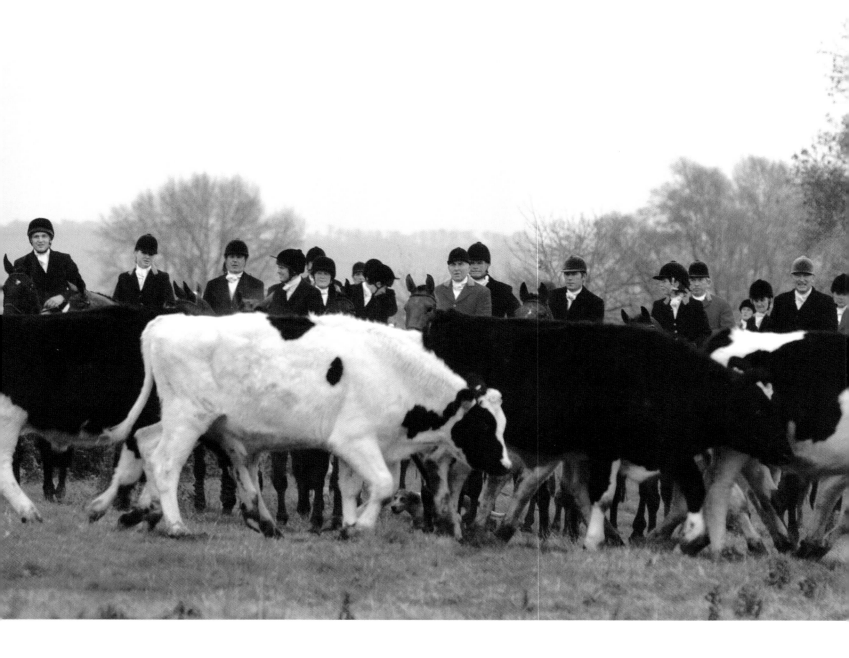

ABOVE: The Vale of Aylesbury with Garth & South Berks field quietly negotiates a herd of cows. Never before has it been more crucial for hunting people to maintain the goodwill of farmers, without whose generosity it would be impossible to continue.

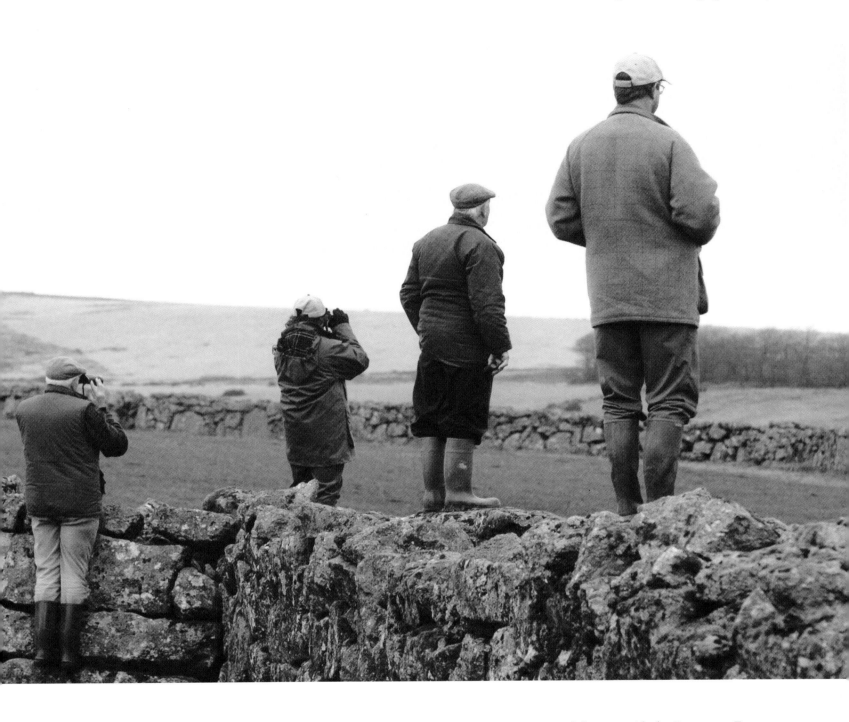

ABOVE: Foot-followers with the Dartmoor. Foot sloggers — often the backbone of hunting — are among the hardest hit by the Hunting Act, which has seriously curtailed that quintesssential country pursuit of watching hounds work.

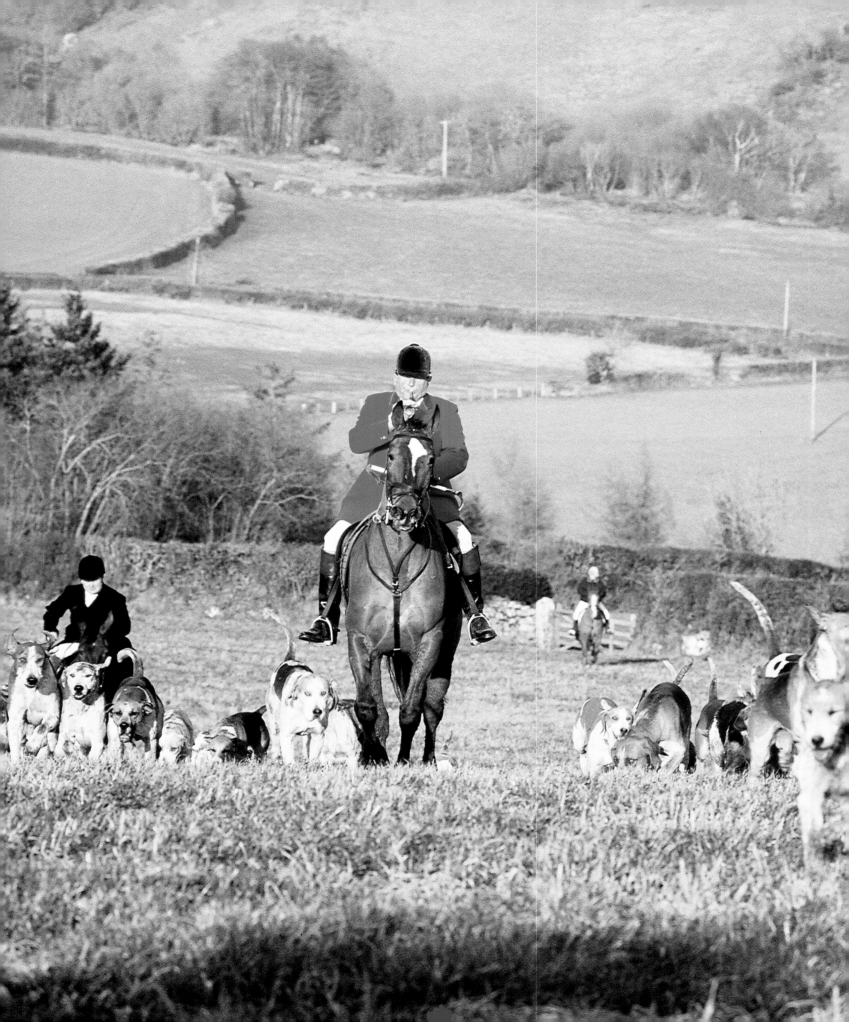

2 Huntsmen and the 'invisible thread'

'I lay down no law for the guidance of a huntsman. The art must be in himself.'

from 'Hold hard! Hounds please!' by Yoi-over

'I F YOU WANT TO SHOOT MY HOUNDS, you'll have to shoot me first.' So said several professional huntsmen in the wake of the Hunting Act. A huntsman's relationship with his hounds is everything: no matter how good a horseman he is or how much he might enjoy the ride, he will put his hounds' well-being above anything else, because it is this relationship, ultimately, on which the success of the day hinges.

To see hounds instinctively flood towards their huntsman when they see him, looking trustingly for guidance or 'singing' in excitement because they love him, is a moving sight. Hounds should respect, trust and obey him, but not be afraid of him.

'The huntsman, Robin Dawe, looked round,
He sometimes called a favourite hound,
Gently, to see the creature turn,
Look happy up and wag his stern…'

John Masefield

When a huntsman has a true rapport with his hounds, the whole pack will move after him as one, no matter how often he changes direction. From a distance, a properly united pack will look as though a pocket handkerchief – or 'an old woman's shawl' – would cover them. The instinctively talented huntsman has total, but discreet, command of his hounds, hence the expression 'the invisible thread', used to describe the perfect relationship. Hounds may be fields away, or on the other side of a valley, yet the huntsman is still in control.

LEFT: Bernard Parker, one of the longest-serving 20th century huntsmen, with the Mid Devon hounds. He retired from hunt service in 1999, having been with the Mid Devon since 1958

Although the many organisational elements of a day's hunting may be taken care of by the masters, committee and other hunt staff, responsibility for a successful outcome lies with the huntsman. He must entertain followers yet maintain the trust of his hounds; he must be in control of them, mindful that they are not a public nuisance. In addition to knowing his hounds and the hunting country, being physically fit and able to ride well enough to stay with hounds and ahead of the field, today's huntsman must also be a showman, with personality, presence and political 'nous'.

The professional huntsman usually lives at the kennels, the nucleus of the hunt and the place where all public enquiries are directed. He therefore needs to be able to interact with the general public, and explain hunting to interested, but perhaps ambivalent — or even hostile — onlookers. He has to develop the trust and friendship of farmers and landowners, and he must now be capable of articulating a political view to the press, although sometimes the huntsman's simple sincerity and passion for what he does is the most effective response.

In short, the professional huntsman needs huge reserves of diplomacy. A job in hunting is known as being in 'hunt service' and old-fashioned, respectful good manners are expected at all times — he is expected to keep his exasperation to himself. Whereas unpaid officials have the freedom to roar their displeasure at a member of the field who has got in the way, or shout back when provoked by antis, the professional huntsman must grit his teeth and rise above open irritation.

For many years now, hunt staff have been forced to live under the dismal threat of the Hunting Act, which could eventually destroy their livelihoods, leaving them bereft of jobs, homes, income and way of life. This is obviously stressful enough, but it is the effect the Act may have on their hounds, and the dread of confusing and disappointing them through forcing them to change the way they have been bred, which has undoubtedly caused the most anguish.

Once, being paid to hunt hounds was perceived as a dream job. Now it is a profession of compromise that faces an uncertain future, meaning those special skills may be lost.

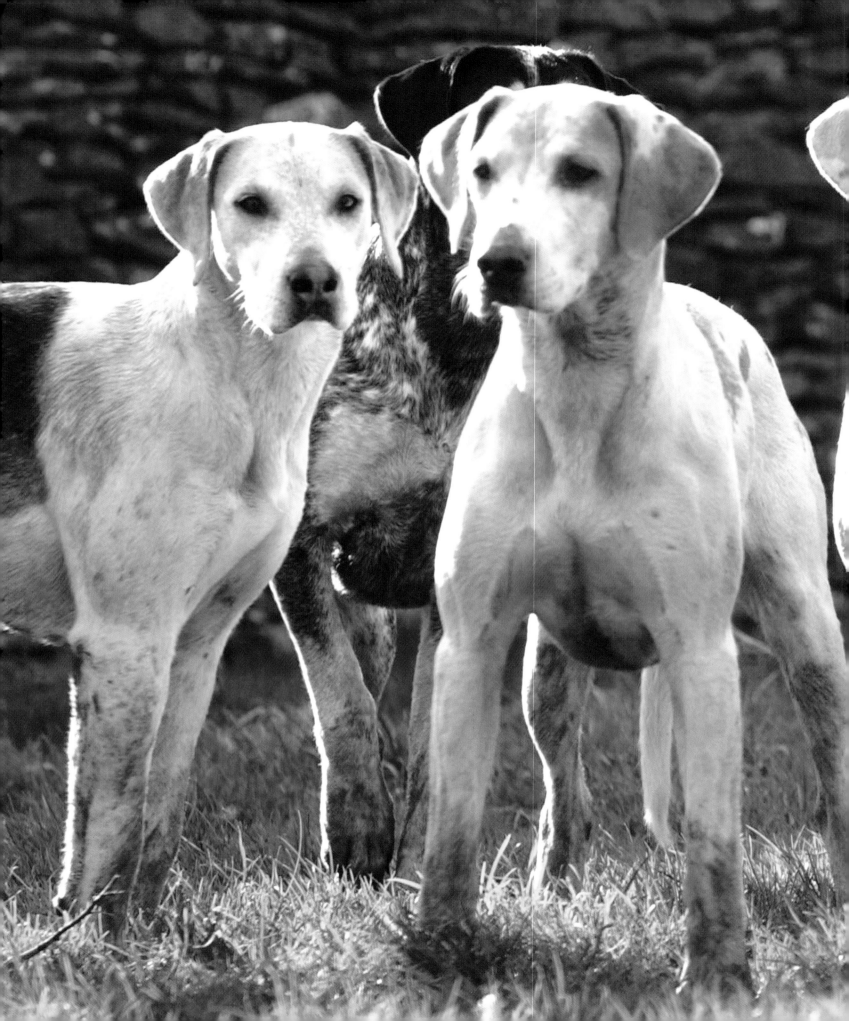

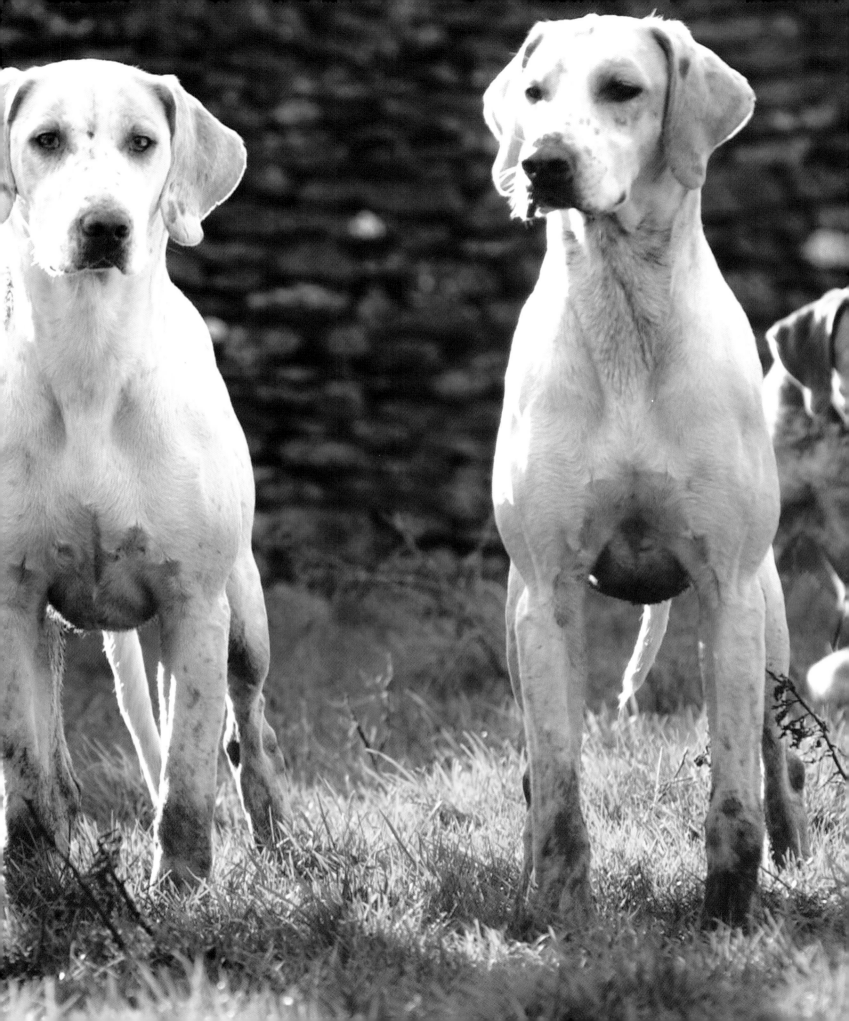

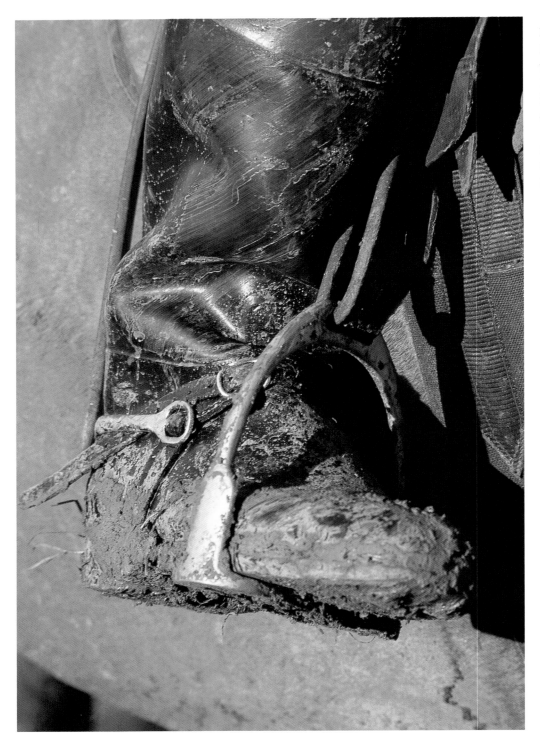

PREVIOUS PAGE: The Duke of Beaufort's hounds, the property of the Dukes of Beaufort since the 17th century and kennelled at Badminton, considered the 'home of foxhunting'.

RIGHT: Fitzwilliam huntsman George Adams blows for his hounds.

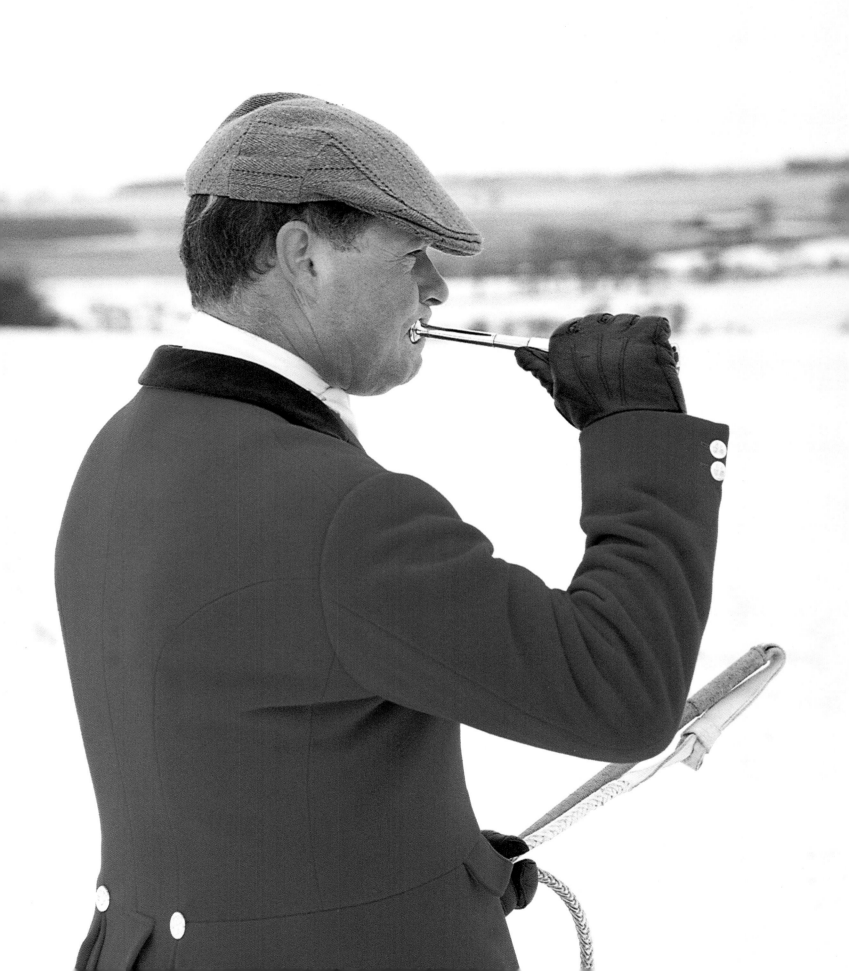

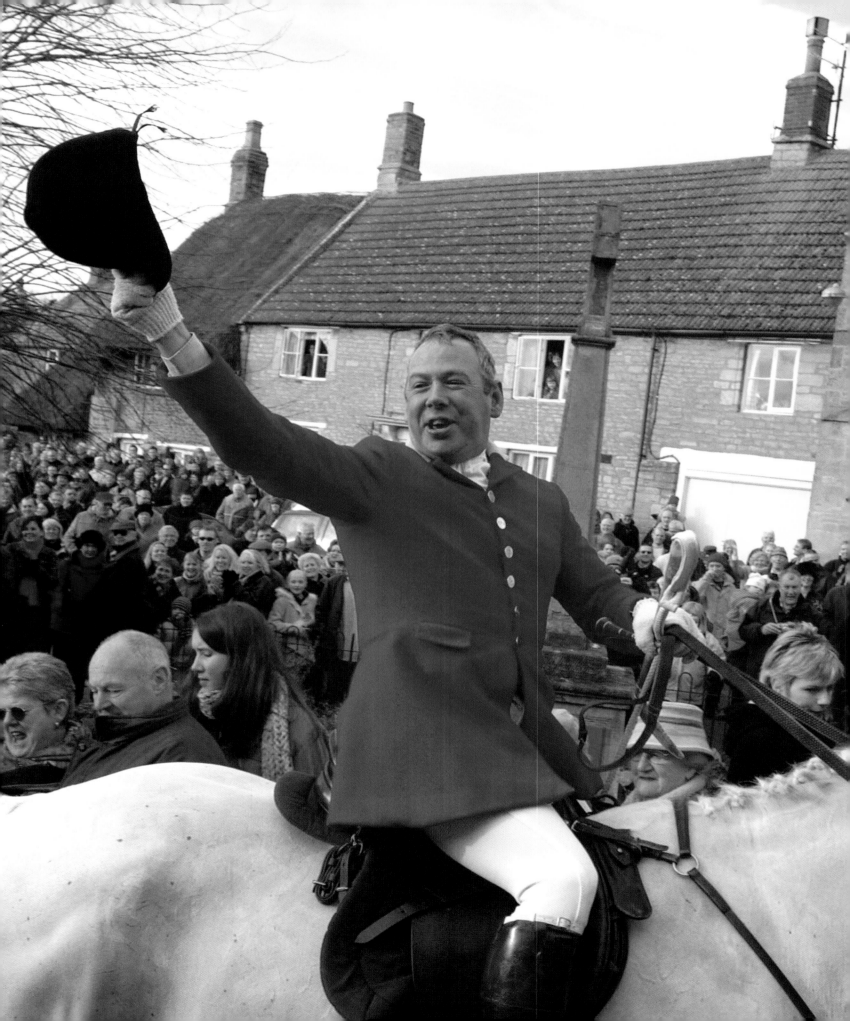

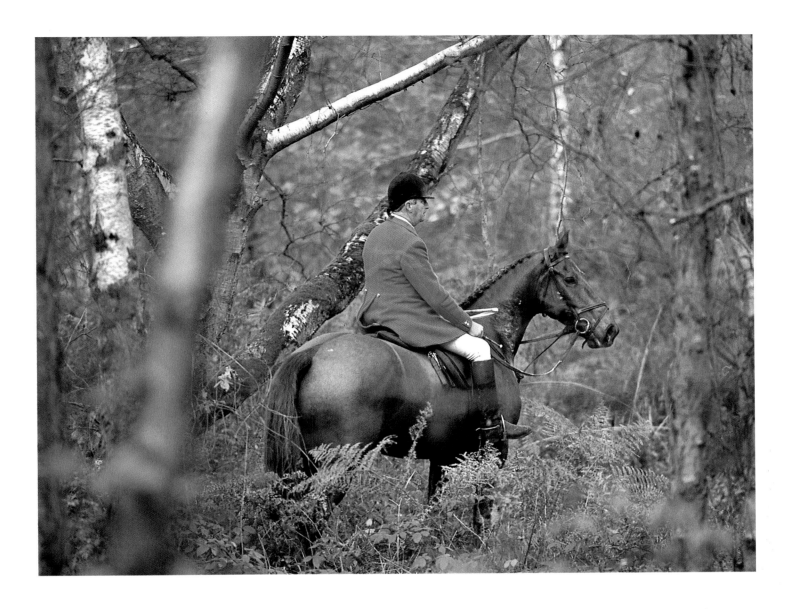

ABOVE: Sidney Bailey, hugely respected huntsman of the VWH who retired at the end of the 2005 season after more than 40 years in hunt service.

LEFT: Tim Taylor, huntsman of the Woodland Pytchley, acknowledges a supportive crowd at the Boxing Day meet in Brigstock.

OVER PAGE Former Essex & Suffolk huntsman Steve Swann exercising hounds in summer.

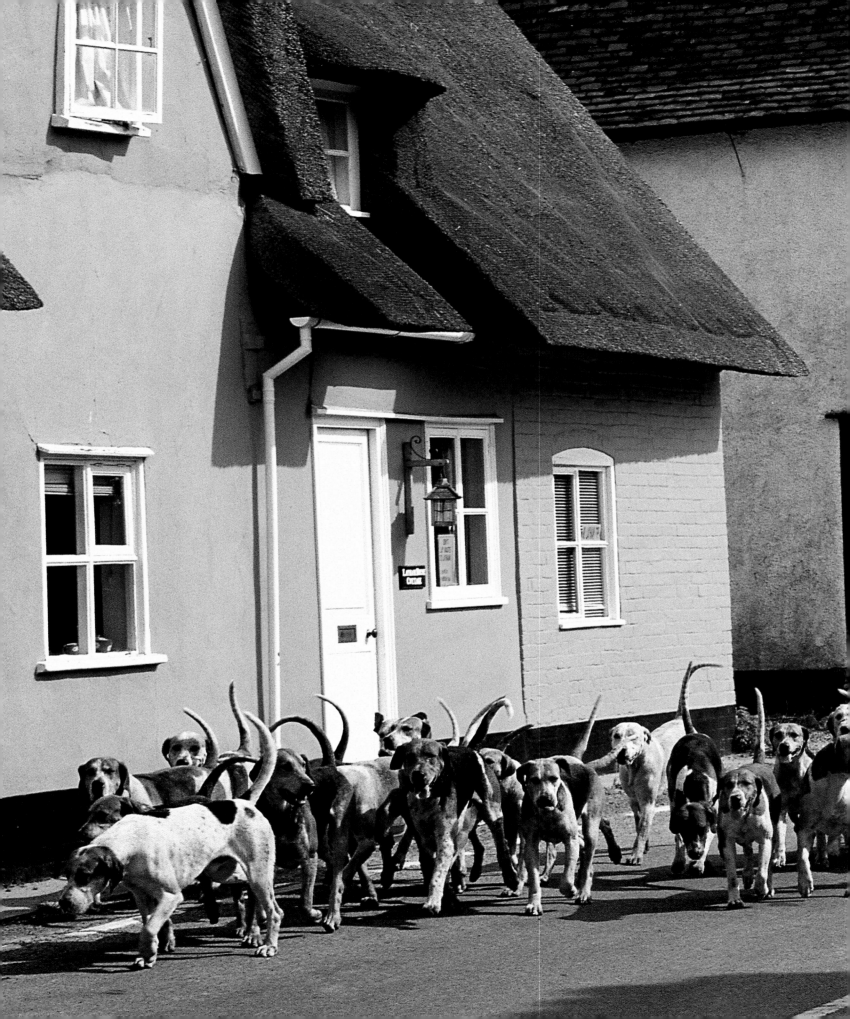

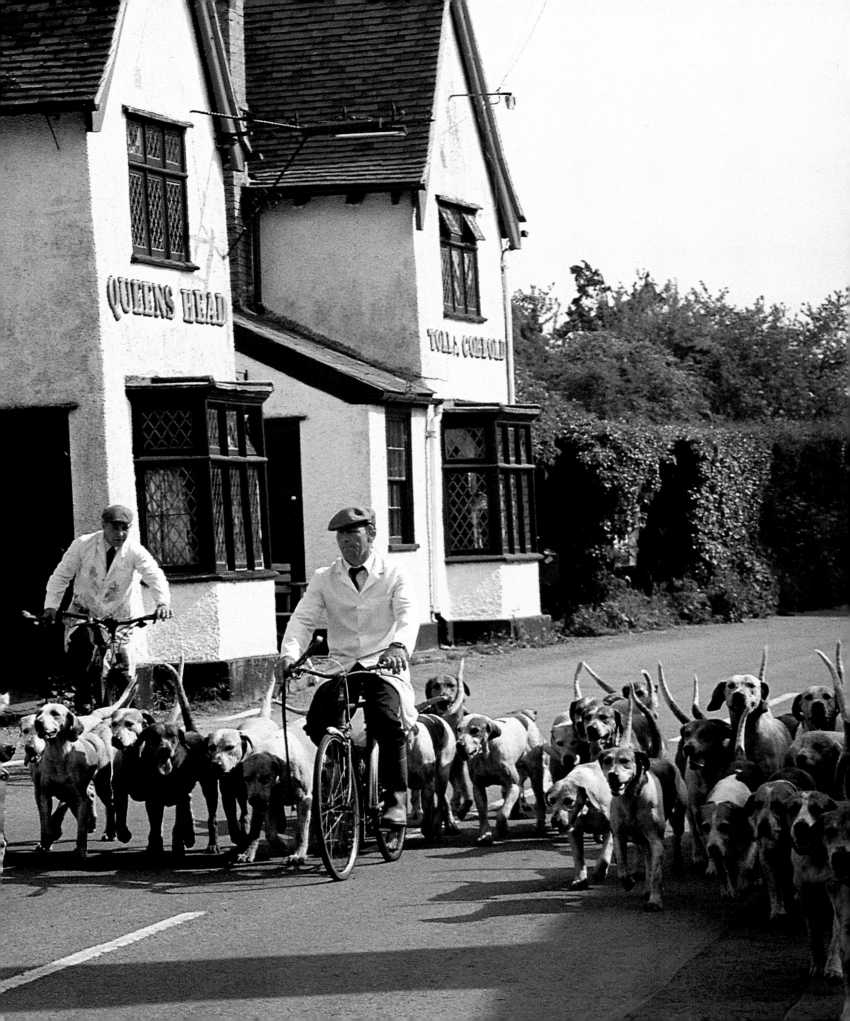

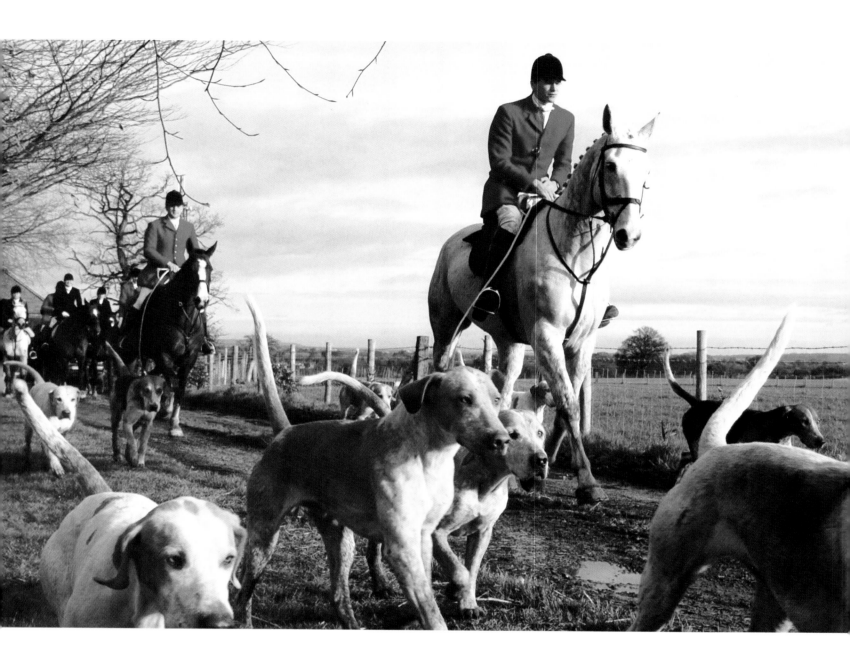

ABOVE: Otis Ferry, young joint-master and huntsman of the South Shropshire. As the son of a rock star, he attracts massive media attention for his passionate commitment to fighting hunting's cause.

RIGHT: The late Capt Charlie Barclay (and dog Blot), a much-loved and respected third generation master and huntsman of the Puckeridge for 45 years, whose children have continued the mastership tradition.

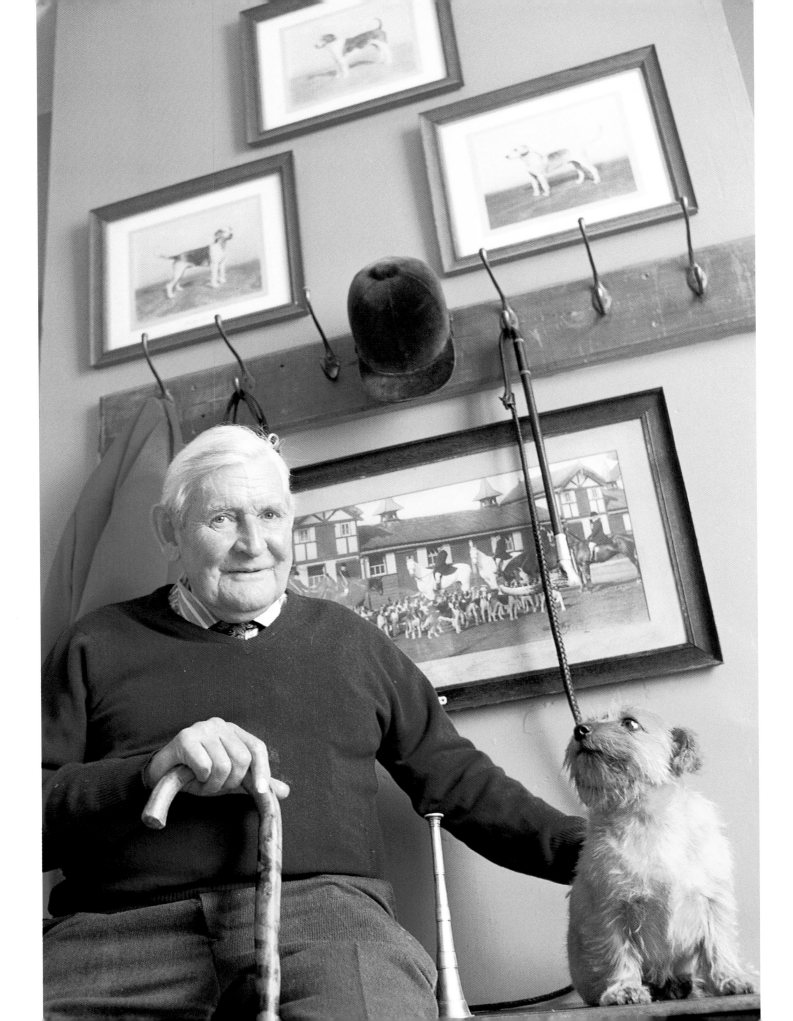

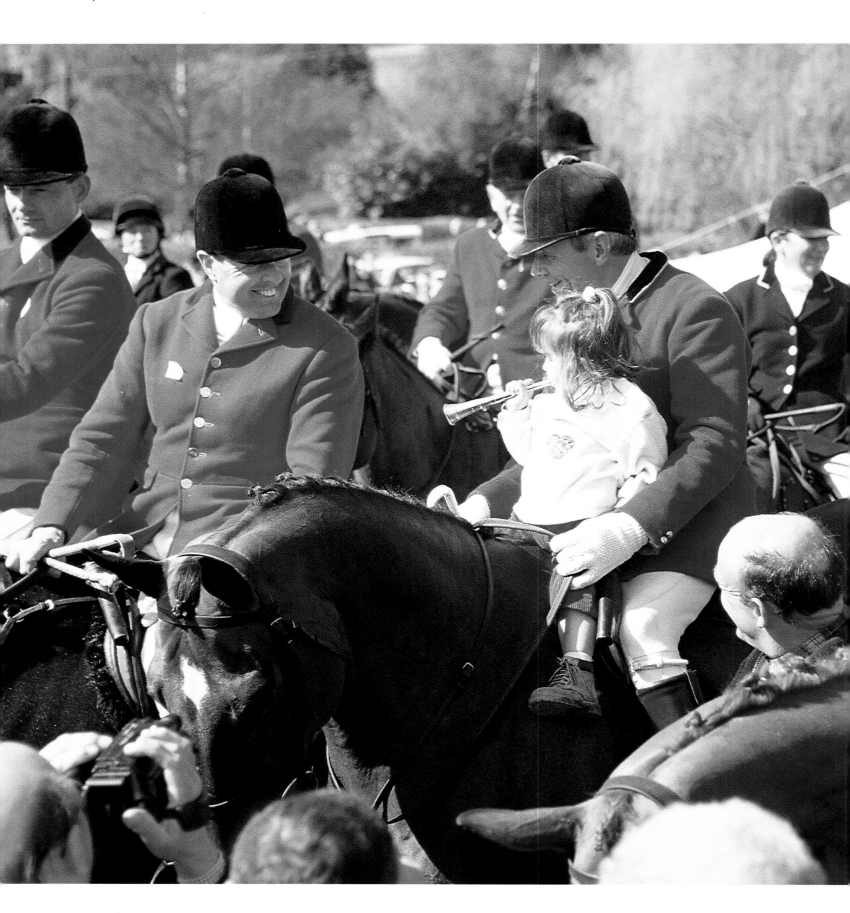

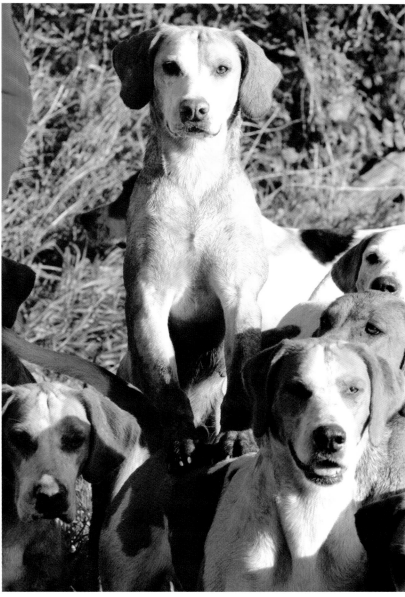

LEFT: Visiting huntsmen pay tribute to the West Kent's long-standing huntsman Stan Luckhurst, pictured at his last meet in office in 1999, with his god-daughter Victoria on his lap. The West Kent has since amalgamated with the Old Surrey & Burstow.

OVER PAGE: Anthony Adams, former huntsman of the Heythrop for 17 seasons from 1988, with his hounds at the end of the day above the typical Cotswold village of Bourton-on-the-Hill.

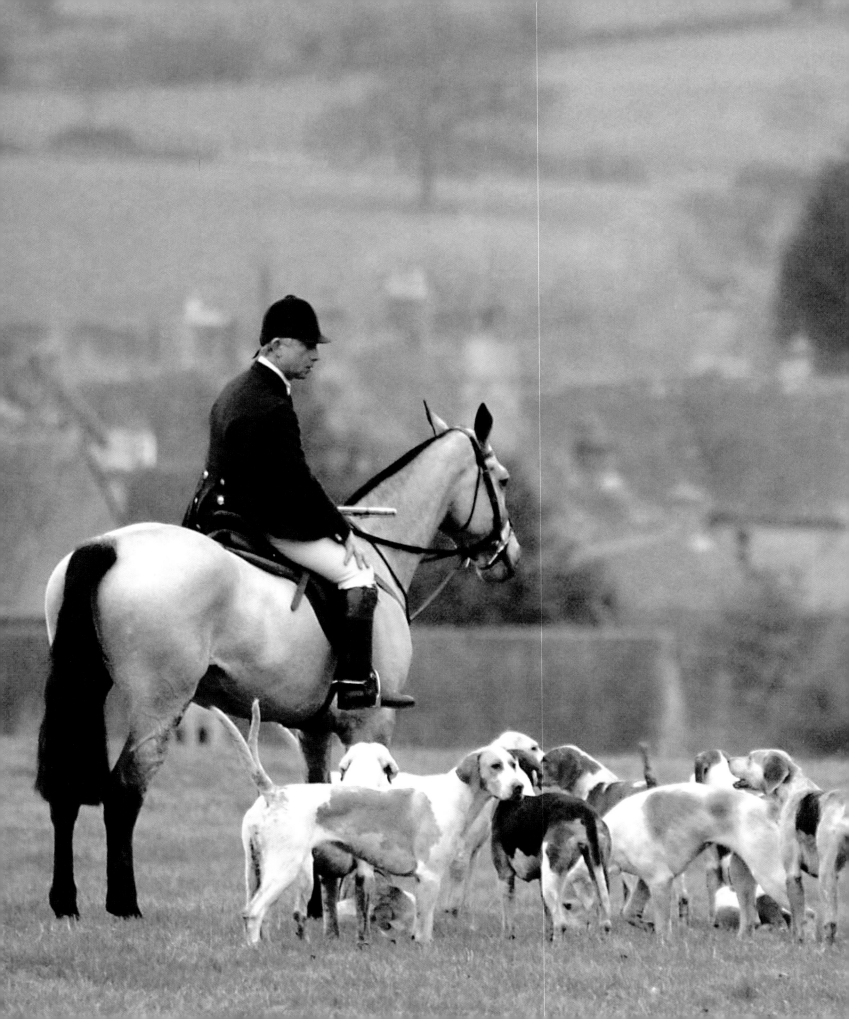

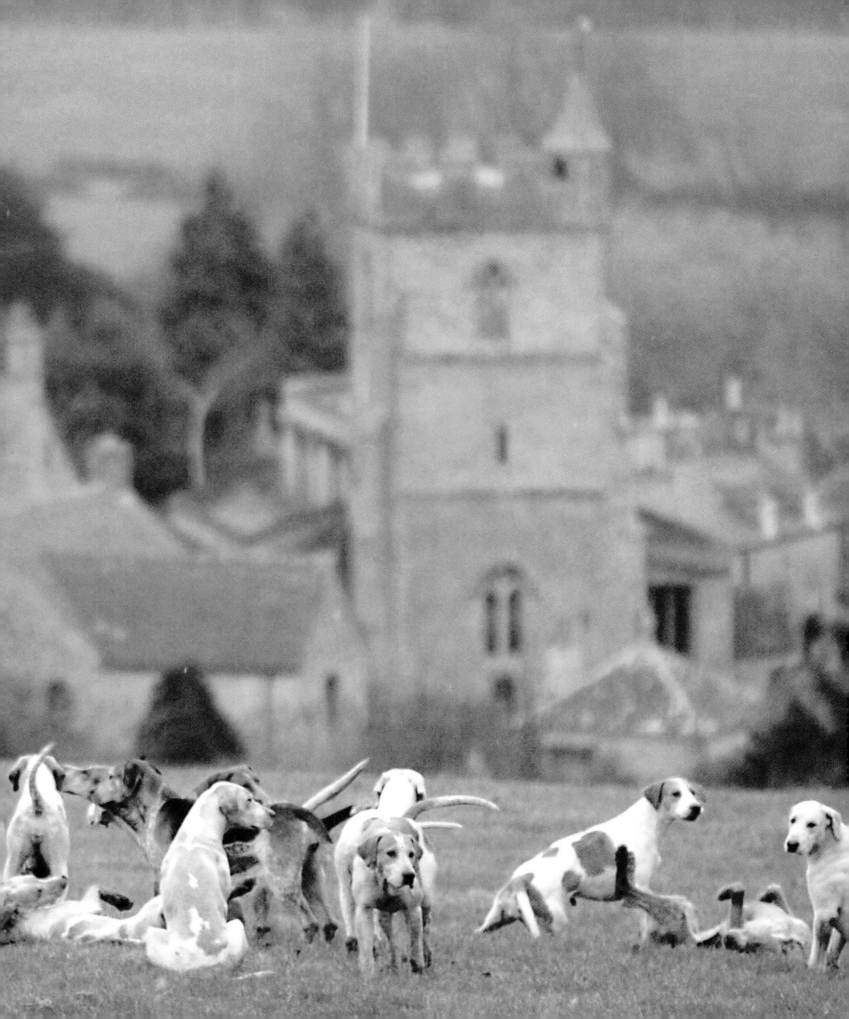

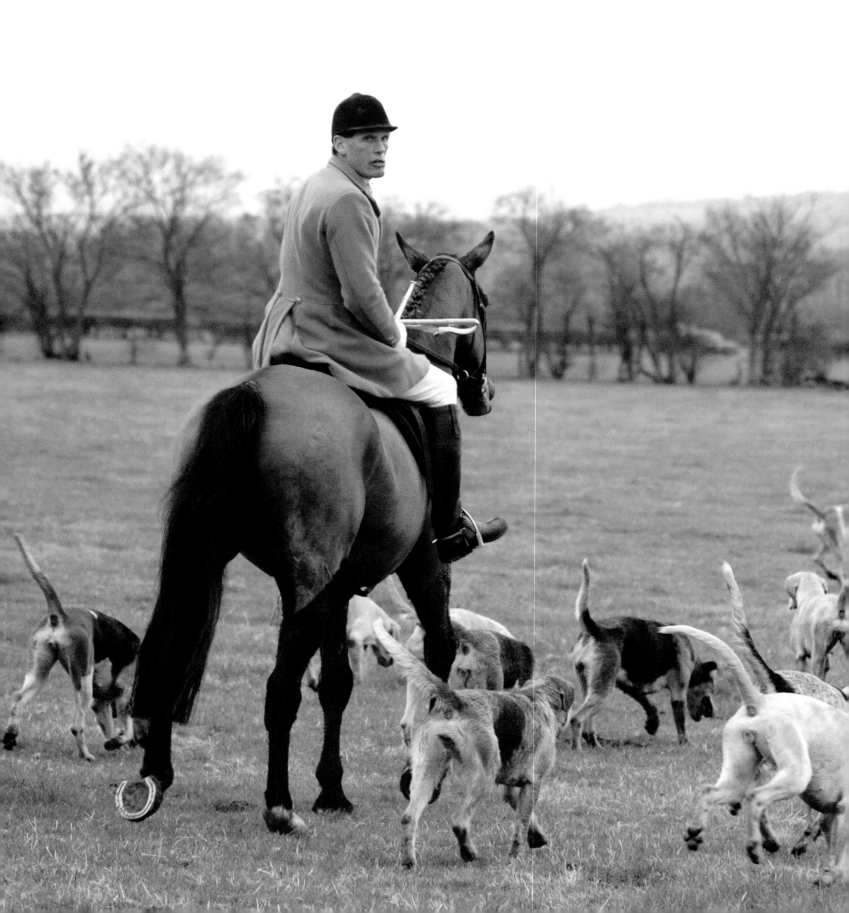

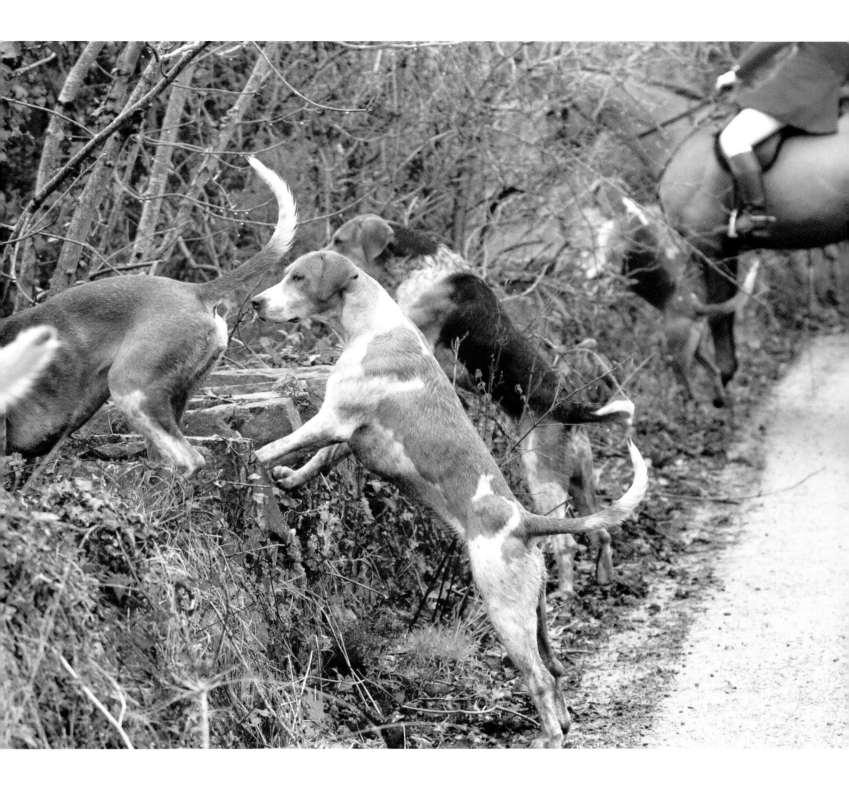

LEFT: Alan Hill, formerly a successful amateur jockey, now joint-master and huntsman of the Vale of Aylesbury with Garth & South Berks.

ABOVE: The Flint & Denbigh hounds being put in to draw at covertside. Used to working as a pack, the post-ban practice of flushing out foxes with a couple of hounds can be a confusing experience.

RIGHT: Jo Foster, point-to-point jockey and whipper-
in, and Richard Lloyd, huntsman, of the Pendle
Forest & Craven.

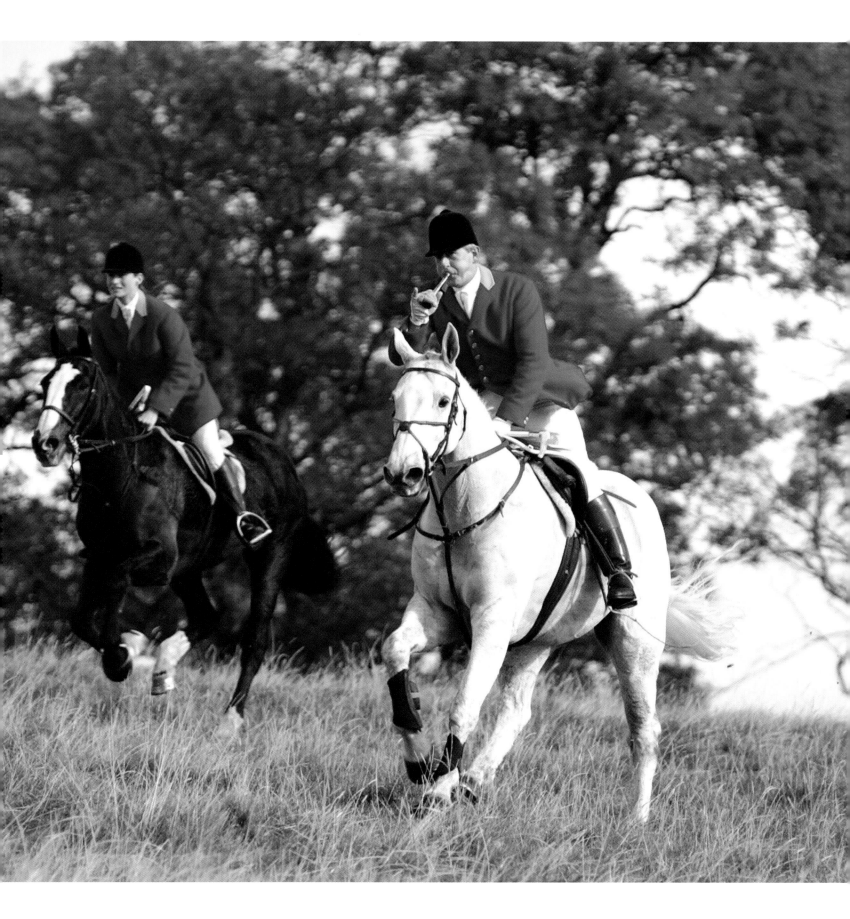

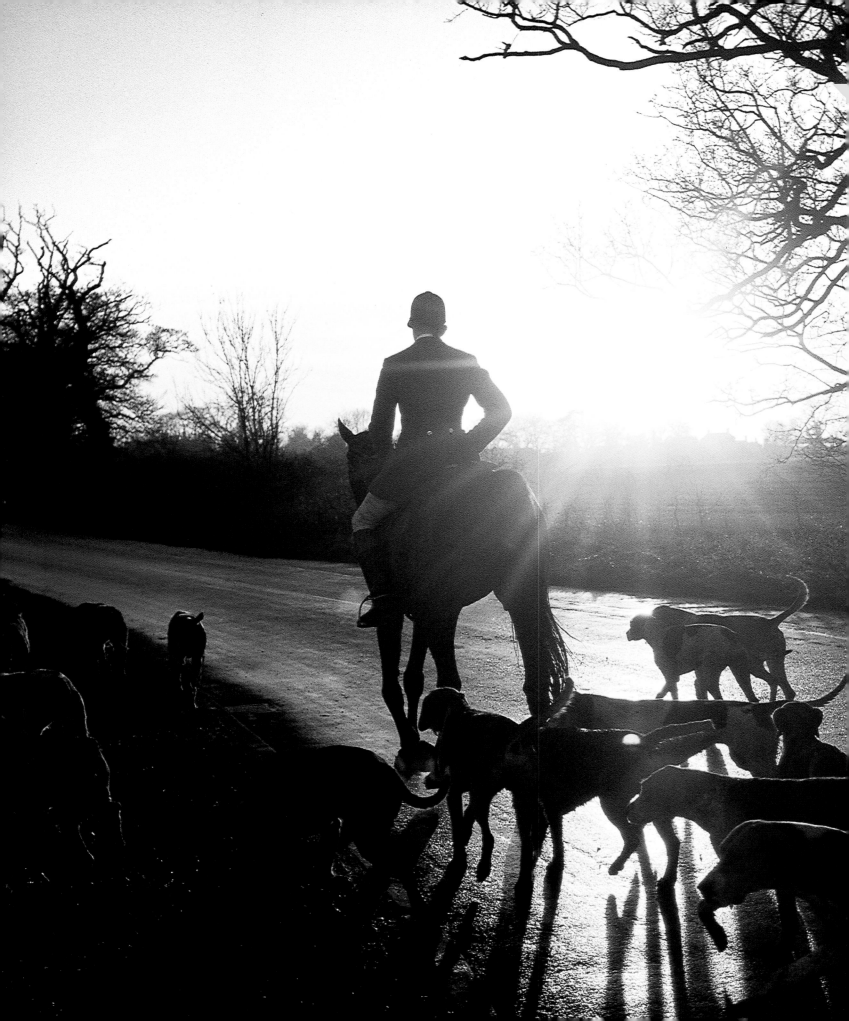

LEFT: Alone with hounds at the
end of the day — Martin Bluck,
former huntsman of the Blankney.

67

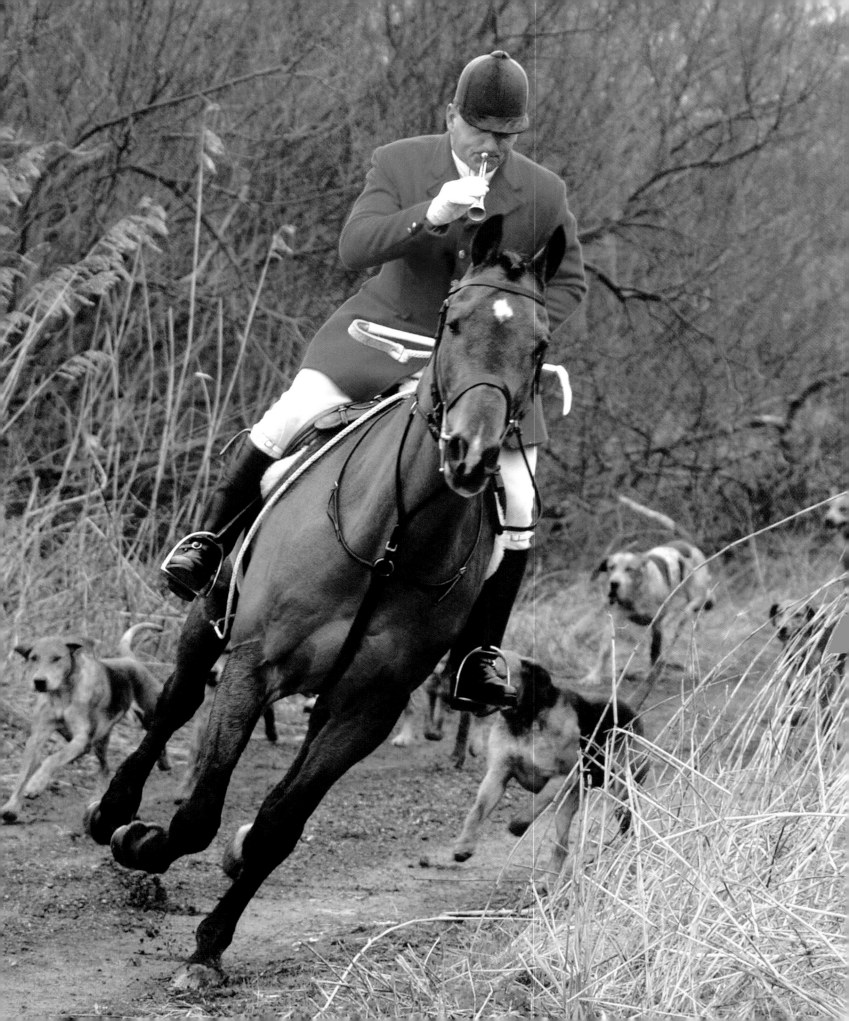

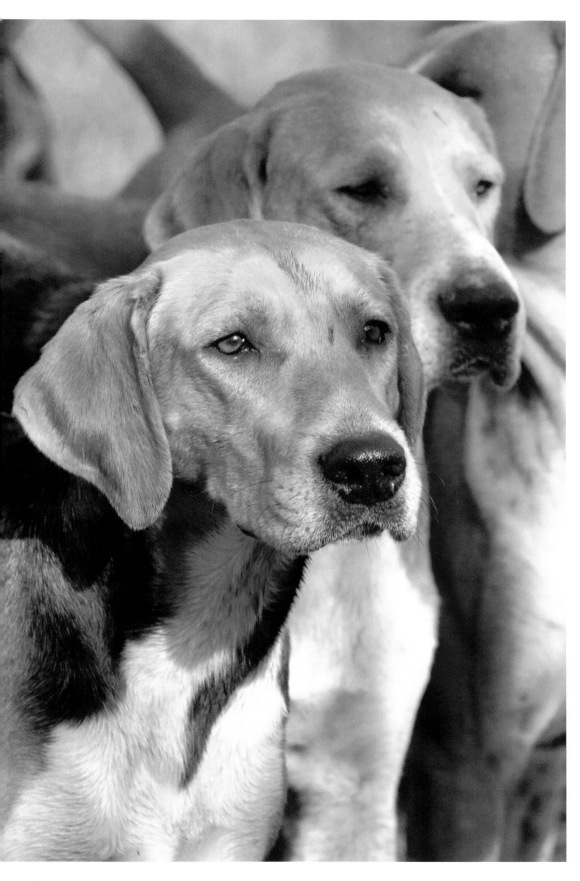

FAR LEFT: Sean Hutchinson, huntsman of the Suffolk, blows *Gone Away*.

LEFT: The Belvoir hounds, historically-bred Old English Foxhounds with traditional lines tracing back to the 18th century.

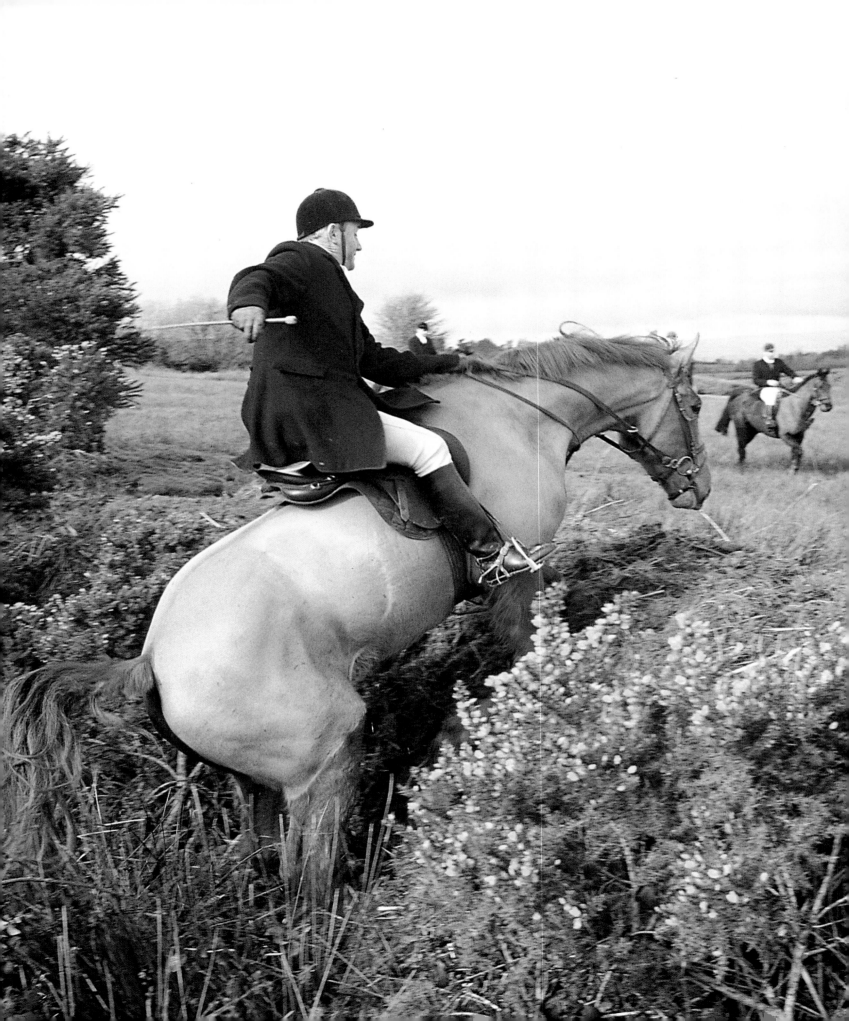

3 The Irish Experience

'My first is the point of an Irishman's tale,
My second's a tail of its own to disclose,
But I warn you in time lest your courage should fail,
If you're troubled with either the shakes or the slows,
That the longer you look at my whole in the vale,
The bigger, and blacker, and bitterer it grows!'

'The Bullfinch' by *GJ Whyte-Melville*

HUNTING IN IRELAND REMAINS JOYFULLY untouched by politics, a sporting Utopia where an enlightened government actually regards it as an asset. That is not to say there isn't the odd skirmish from anti factions but, overall, hunting is considered part of the Irish way of life and an integral contributor to the economy.

But before the disenchanted English head across the Irish Sea in droves to recapture the bliss of hunting unfettered by politics and law, there is an issue of capacity. While Irish hunting feeds off visitors for economics – especially from America – it cannot physically cater for unlimited fields. Indeed, in some hunting countries even the locals are limited as to how many days they are allowed.

One day's hunting may cover literally dozens of small farms, which cannot sustain the intrusion, particularly during a typically damp Irish winter. Developments in arable farming and the presence of big stud farms will curtail hunting further, and, while Ireland is mainly free from huge and busy roads dissecting the countryside, the spread of Dublin and other cities is beginning to eat into hunting countries and hounds are less welcome on the edge of the suburbs.

Despite this, Irish hunting countries tend to be less manufactured than in England; gates may not open and hedges may not be laid. Stories abound of swimming in rivers,

LEFT: Negotiating a typical gorse-covered bank with the Duhallow.

jumping off railway bridges and over iron bedsteads used to plug the gaps in hedges. Different areas have their trademark obstacles: the tiny walled fields of Galway, where it's possible to jump 30 walls in a mile; the huge ditches of Wexford, coupled with 'razor' banks — so narrow that the horse cannot fit front and hind feet on all at once and has to touch down as lightly as a cat — and the giant banks and ditches of Limerick and Cork. In Tipperary, the speciality is thorn-covered banks where the horse has to jump into undergrowth and may have to thread his way along the bank before he can find a spot to jump off.

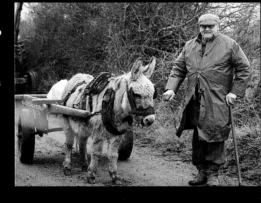

The Irish hunter is therefore a unique horse. Many are expected to learn as they go along from the age of three and, consequently, develop a unique agility — a crucial 'fifth leg' — coupled with a calm brain. The Irish hunter looks before he leaps, jumping very slowly and deliberately so that he has time to see exactly where to put his feet on landing.

However, a knock-on effect of the Hunting Act has been to dent the Irish horse industry, where breeders and dealers are largely dependent on shifting hunter stock across the Irish Sea. Many felt the draught before the ink had even dried on the Hunting Act. This lack of demand could, in turn, cause a shift away from producing the traditional Irish hunter, which is already losing ground to the sport horse or even warmblood.

But while ccmmercial pressures have caught up with some aspects of Irish hunting, the flamboyant flavour of turn-of-the-(19th) century foxhunting, as immortalised by Somerville & Ross's *The Irish RM*, thankfully really does still exist in Ireland where it's possible to hunt seven days a week — wearing a mac and gumboots if you wish —and fit in going to mass.

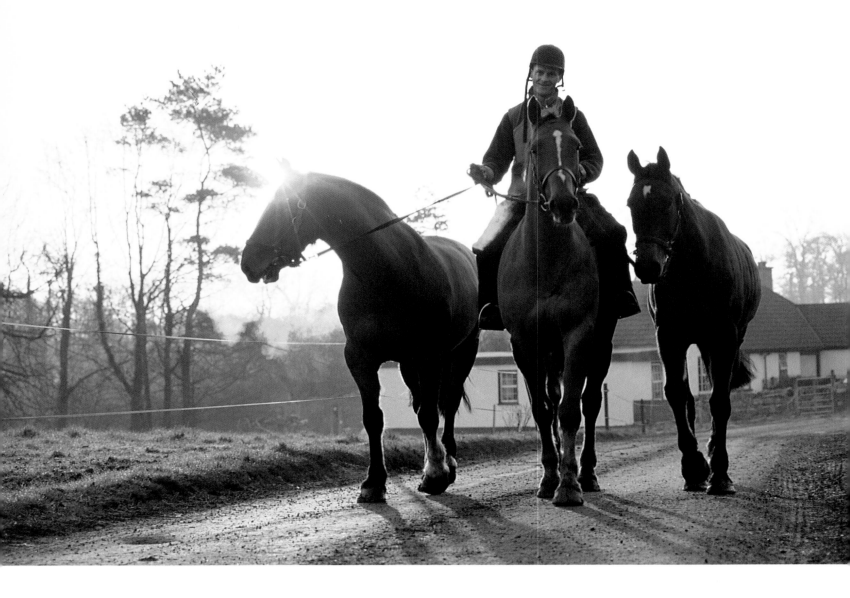

ABOVE: Hunt horses being exercised from the Limerick kennels — in England, many grooms face uncertainty in their employment.

PREVIOUS PAGE: Tom McGrath, plus donkey and cart, follows the Kilkenny hounds en route from shopping.

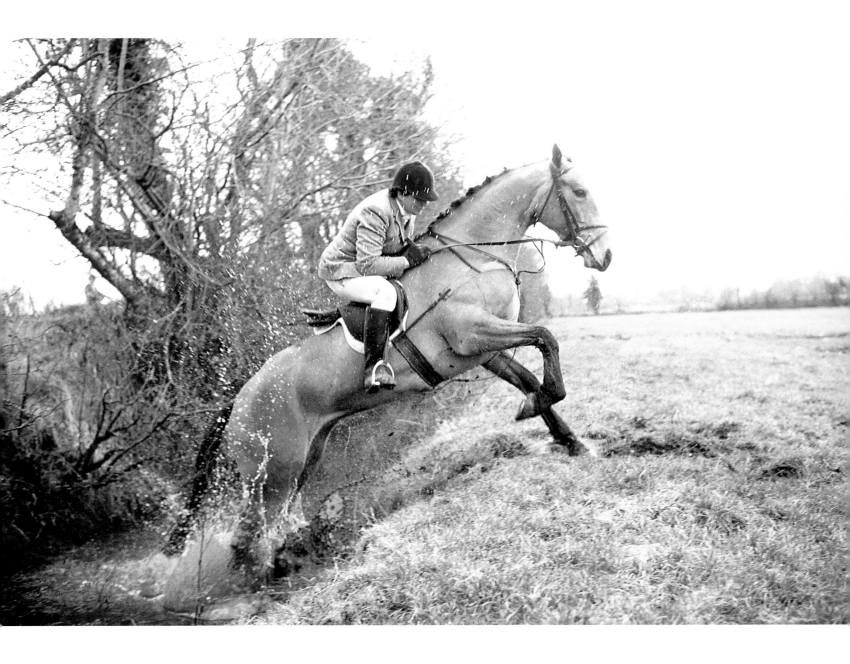

ABOVE: A typical Co Tipperary obstacle. This
sensible Irish hunter has scrambled down the bank,
crossed the stream and popped out on to *terra firma*,
all in the calmest of manners.

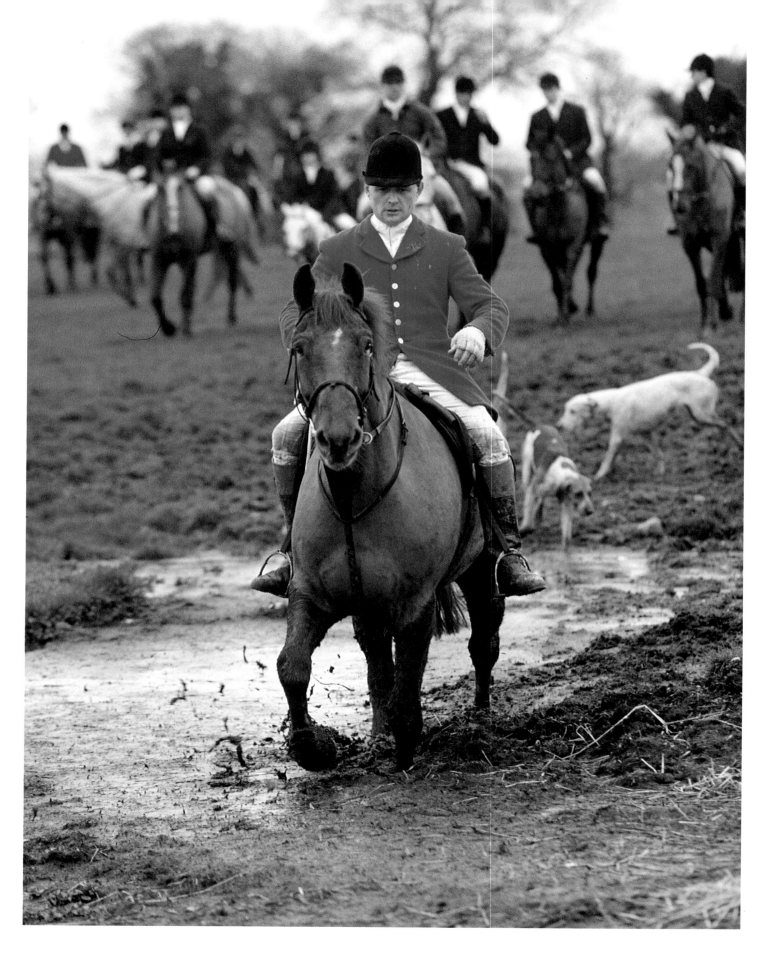

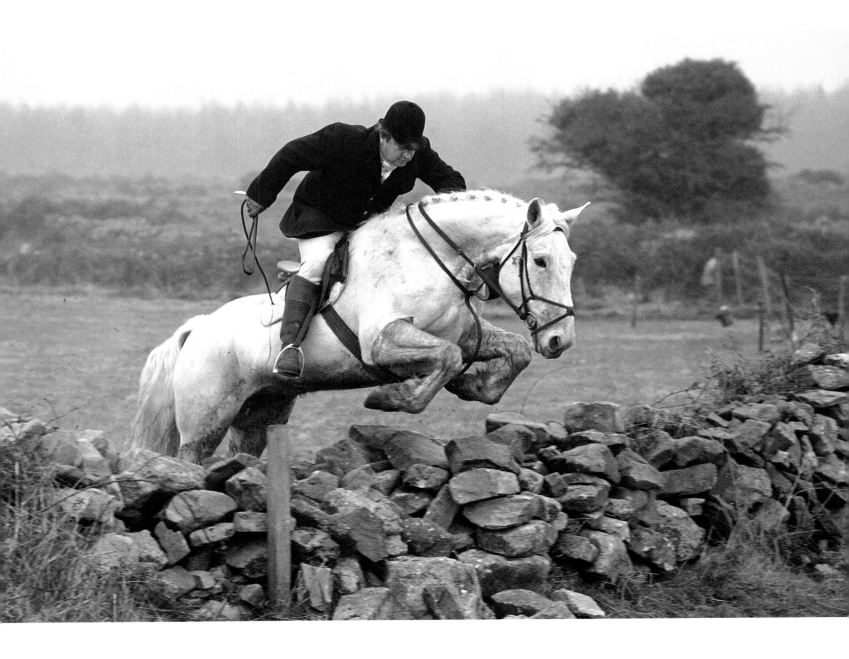

LEFT: Simon Probin, huntsman, with the Tipperary.

ABOVE: Pat Lochlan clears a stone wall in the Kilkenny country, one of the Irish packs most popular with overseas visitors.

OVER PAGE: Hugh Robards, former master and huntsman of the Co Limerick, a formidable horseman about whom the Whyte Melville words 'A rider unequalled — a sportsman complete, a rum one to follow, a bad one to beat' could have been written.

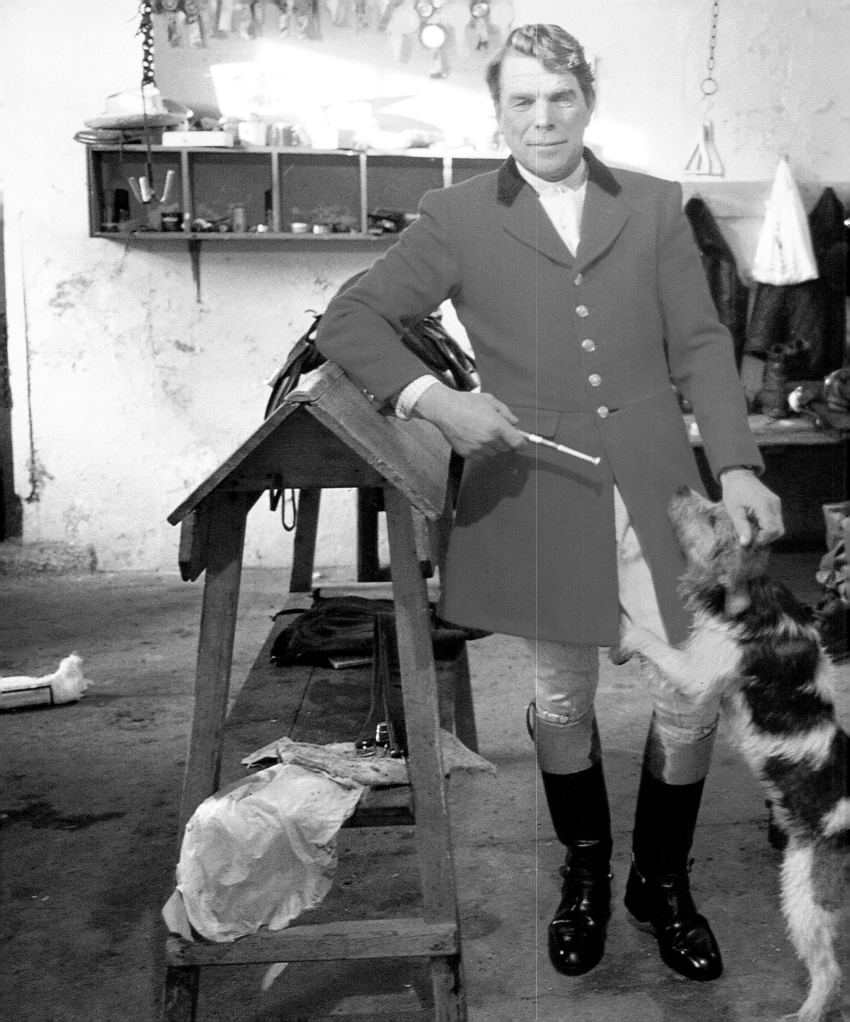

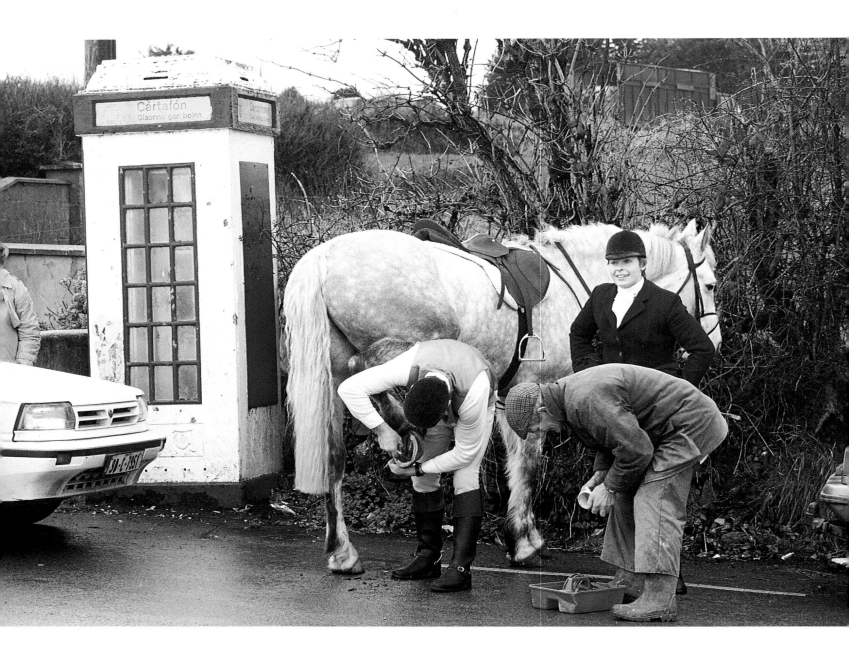

ABOVE: Emergency shoeing repairs midway through
the day.

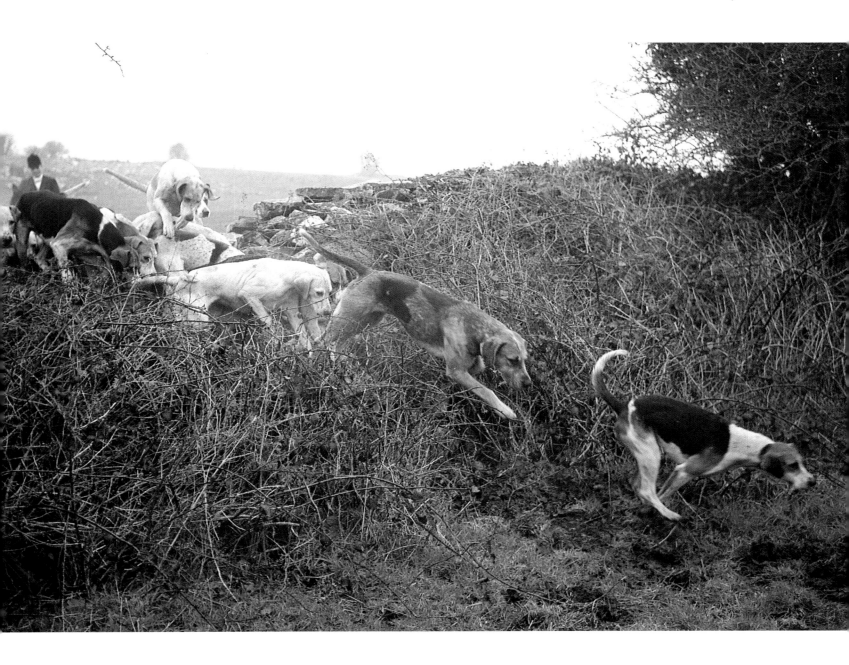

ABOVE: The Kilkenny hounds in full flight over a typically bramble-covered wall.

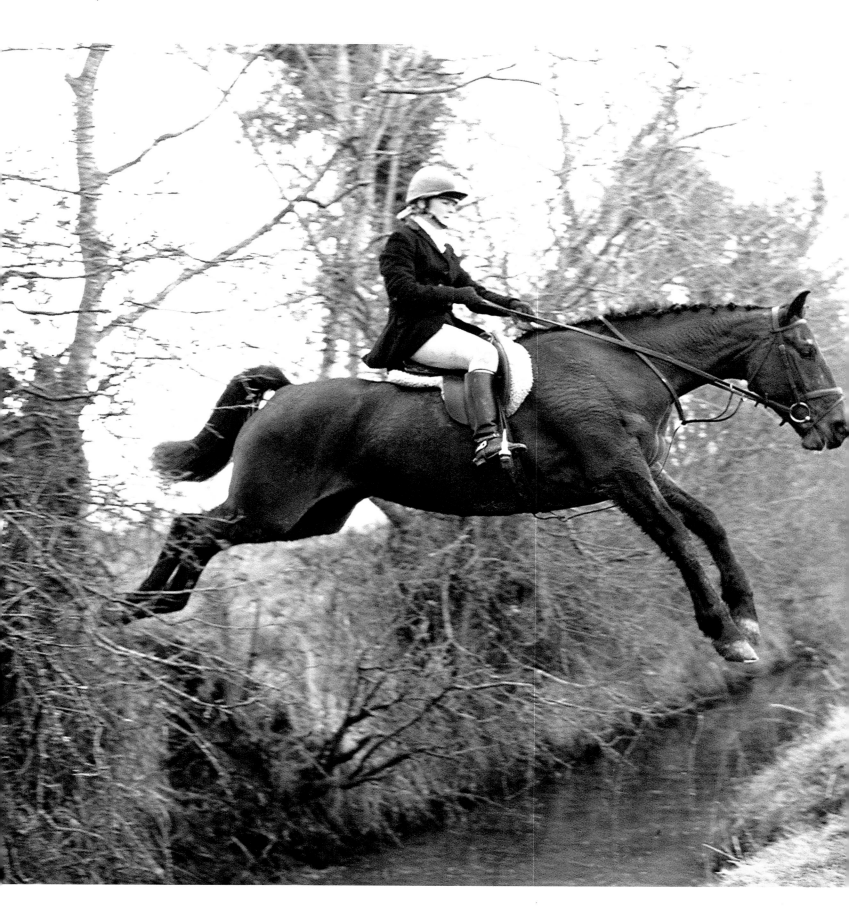

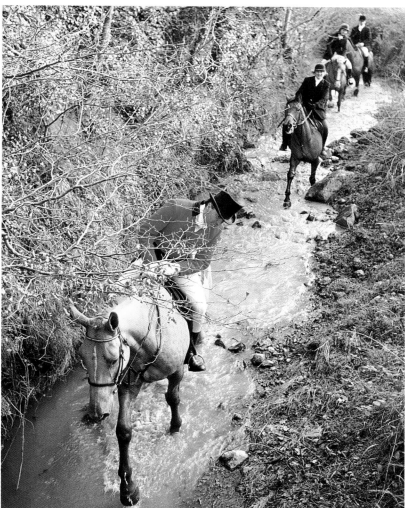

ABOVE: Washing off at the end of the day.

LEFT: A Tipperary bank and ditch taken with flair. The rider is sitting beautifully still and in balance, just behind the horse's movement so as to be prepared for a stumble on landing, and has given the horse the freedom of his head and neck to enable him to make a slow, careful jump.

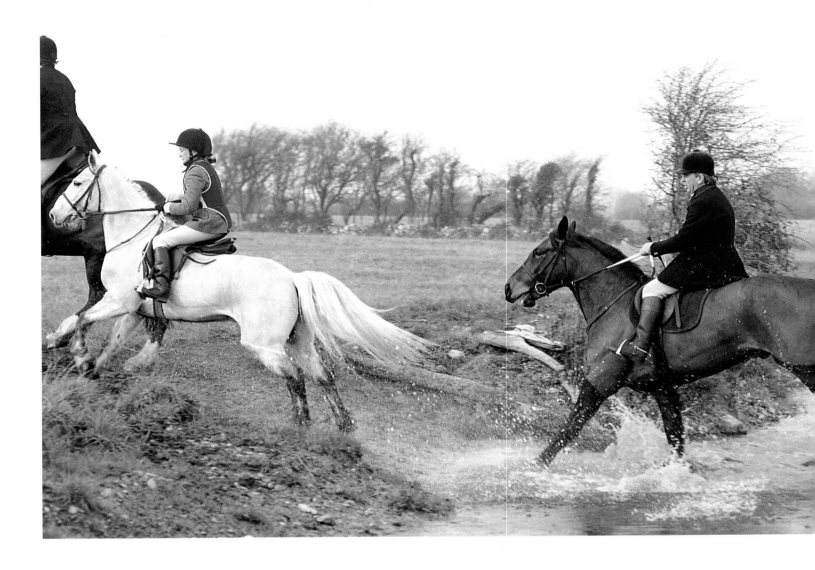

ABOVE: Landlord of Ireland's most famous hunting hotel, the Dunraven Arms in Co Limerick, Bryan Murphy and daughter.

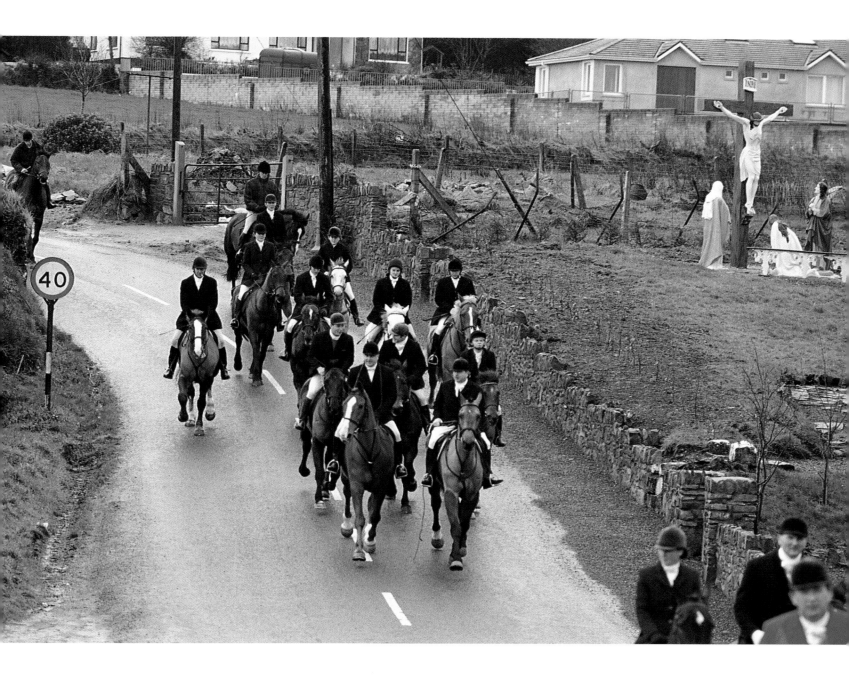

ABOVE: The field rides past a shrine in a Co Cork village.

OVER PAGE: Michael Buckley, huntsman, with the Duhallow hounds, one of the oldest packs in Ireland.

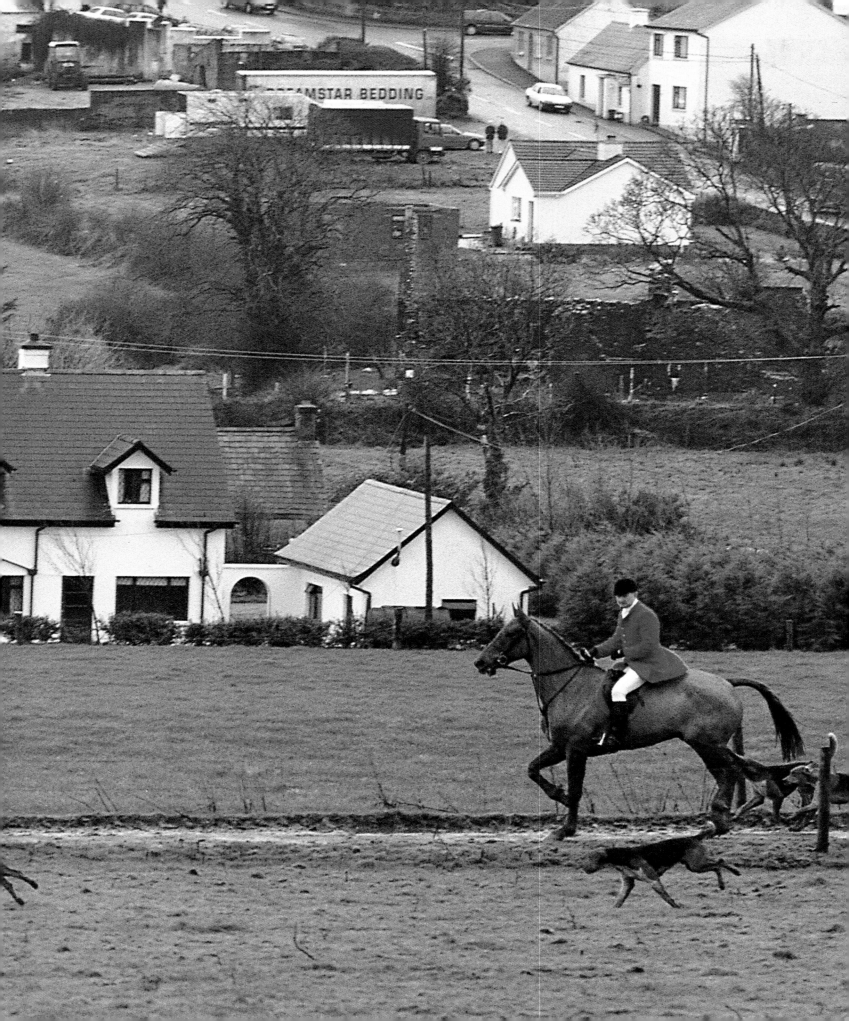

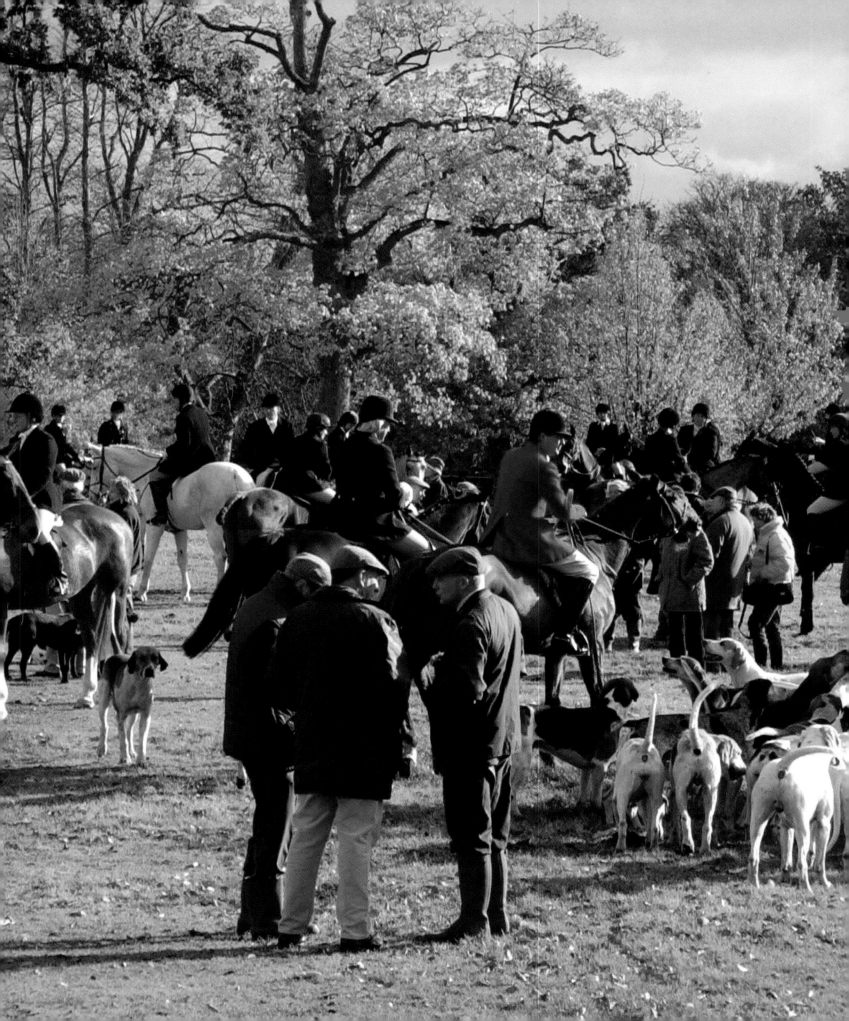

4 A Social Tapestry

'Here's a health to every sportsman, Be he stableman or lord, If his heart be true, I care not what His pocket may afford;
And may he ever pleasantly each gallant sport pursue If he takes his liquor fairly, and his fences fairly too.'

A Hunting song, by Adam Lindsay Gordon

IN THE MORE RURAL PARTS of England and Wales, hunting is the thread that binds social life together. In some areas it goes a step further and forms the linchpin of the economy. Exmoor, where it is estimated hunting contributes millions to the local economy, has long been dependent on early autumn and late spring visitors flocking to the moor, staying in hotels, hiring horses and seeking hunting after the season has ended up country. The Fells in autumn, too, have been a Mecca for true hunting people wanting to watch hounds work in the most spectacular scenery and meet in pubs to sing evocative hunting songs in the evening.

Few packs can survive purely on hunt subscriptions – which vary from thousands in the more 'fashionable' packs to a hundred or so pounds among smaller set-ups – or by money put in by masters. Thus cash has to be raised in other ways to pay for extras like a new vehicle, more modern buildings at kennels or a new horse.

This is where the hunt supporters come into their own, many of whom do not actually ride to hounds – a lot of the most dogged fund-raisers are actually foot-followers – but enjoy supporting the hounds through fund-raising activities. Almost all packs run an annual hunt ball and point-to-point; other fund-raising activities traditionally include hunter trials, horse shows, team chasing, terrier shows, sheepdog trials, whist drives, hunt suppers and film shows, and the modern-day safari supper.

The will of hunting people to organise their own fun while simultaneously raising money is infinitesimal — witness the thousands galvanised into demonstrations and marches. It is this energy, often expended by people who have never jumped a fence in their life, that makes foxhunting such an inclusive occupation.

BELOW: A Belvoir hunt supporter with the hound puppy he walked.

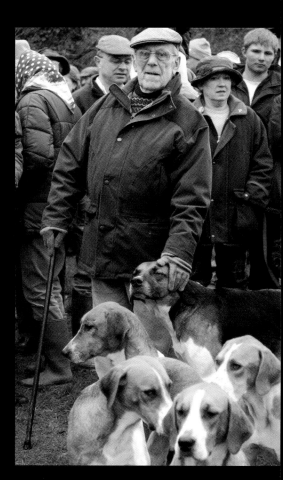

LEFT: The Thurlow opening meet.

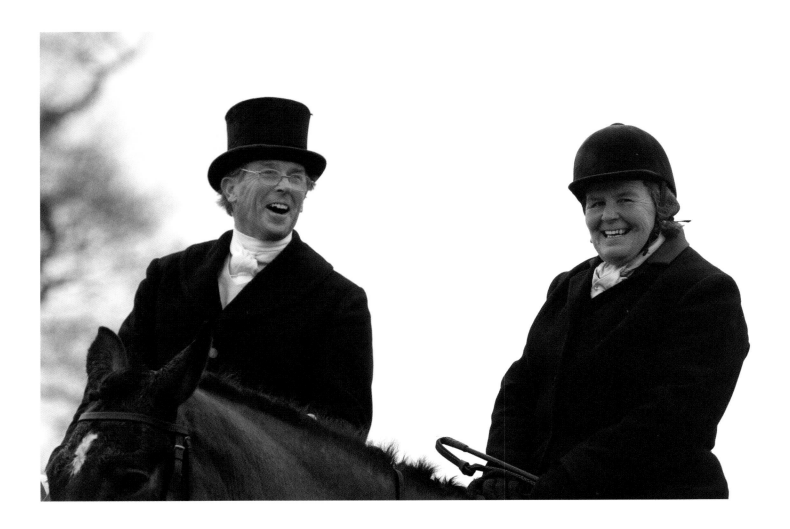

ABOVE: Members of the Meynell & South Staffs,
clearly in good spirits!

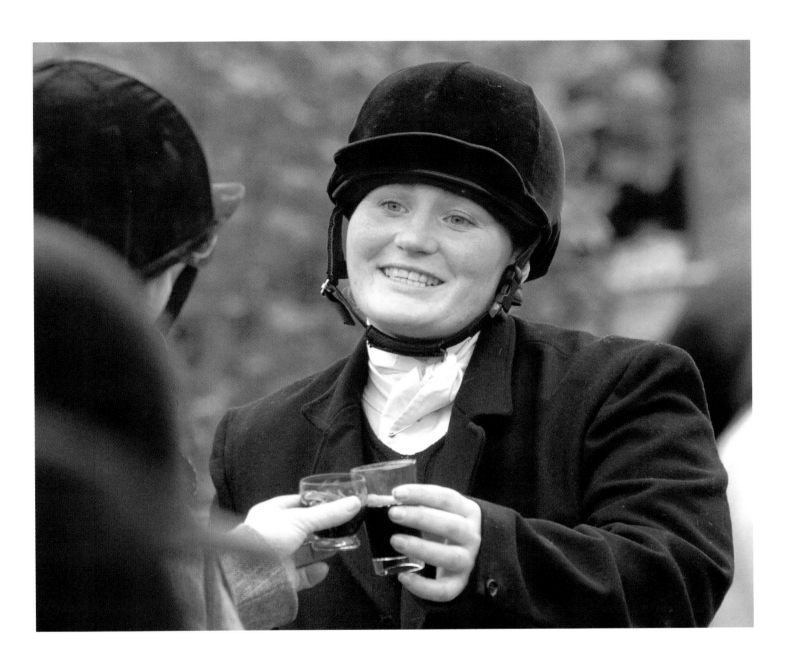

ABOVE: Marion Hughes shares a toast at the Golden Valley on the Welsh border.

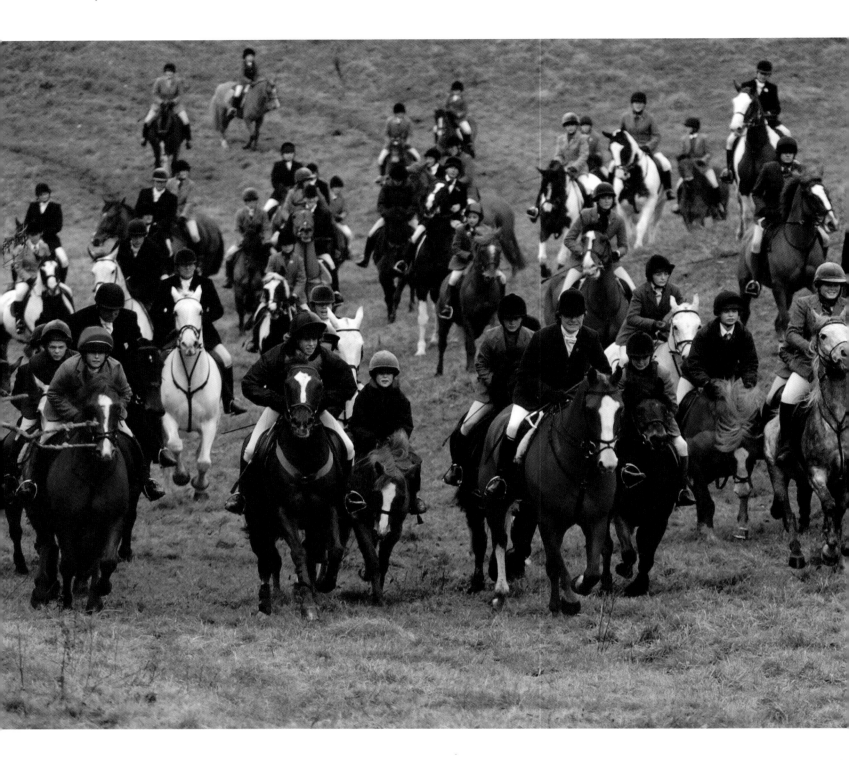

ABOVE: Joint-master Tessa Jackson leads a large and enthusiastic field away from the Cattistock children's meet, a day specially geared to teaching children about hunting, the countryside and horsemanship.

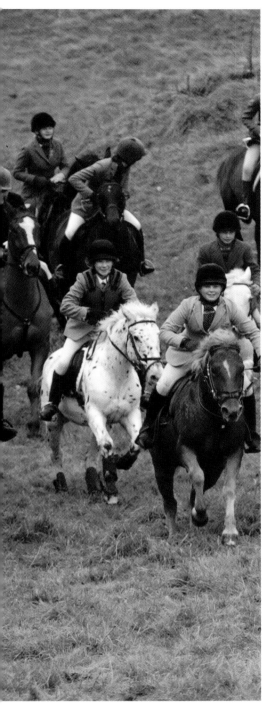

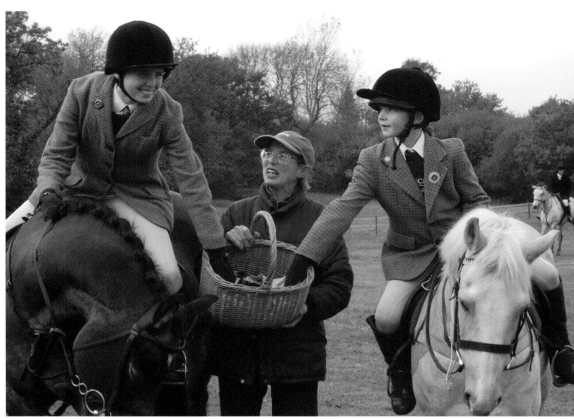

ABOVE: Handing out chocolate bars at a Pony Club meet in the Christmas holidays.

OVER PAGE: A sight to bring a lump to the throat: with the Hunting Act just months away, crowds gather around hunt staff from the Cotswold, North Cotswold and Berkeley — in the distinctive gold livery — at the Countryside Race Day at Cheltenham, a massive annual gathering of hunting folk.

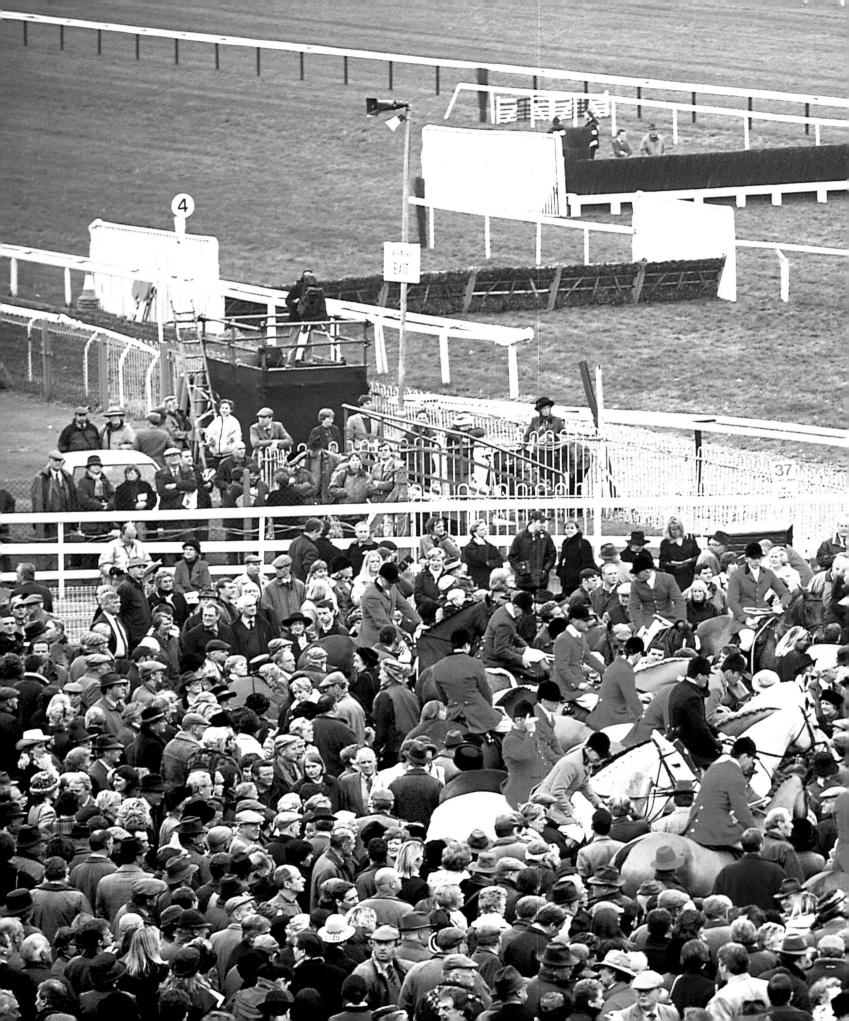

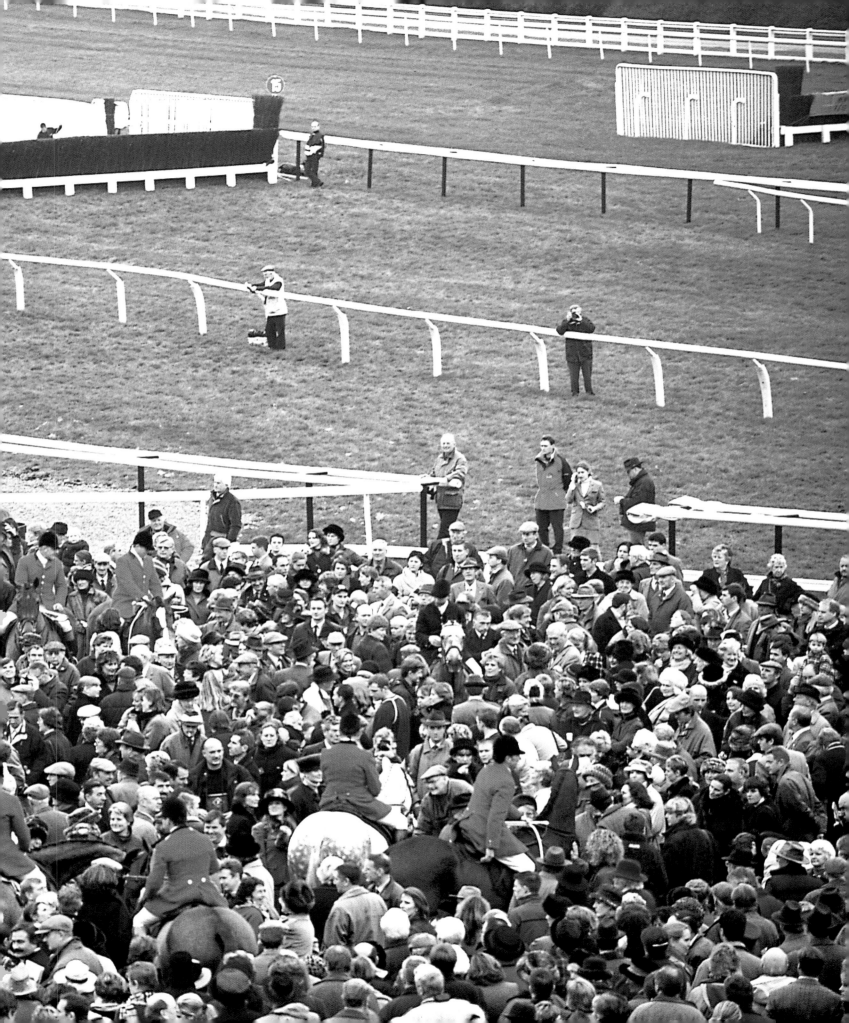

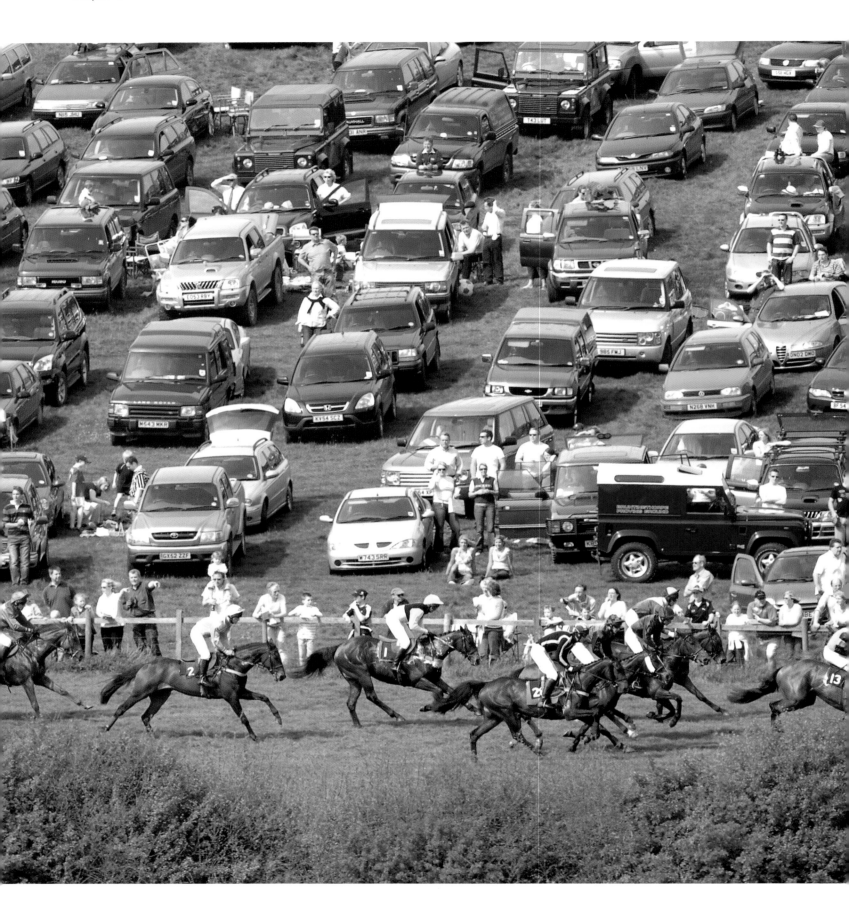

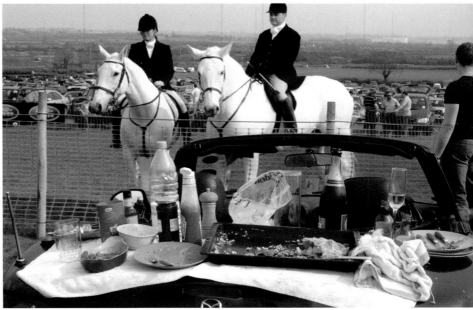

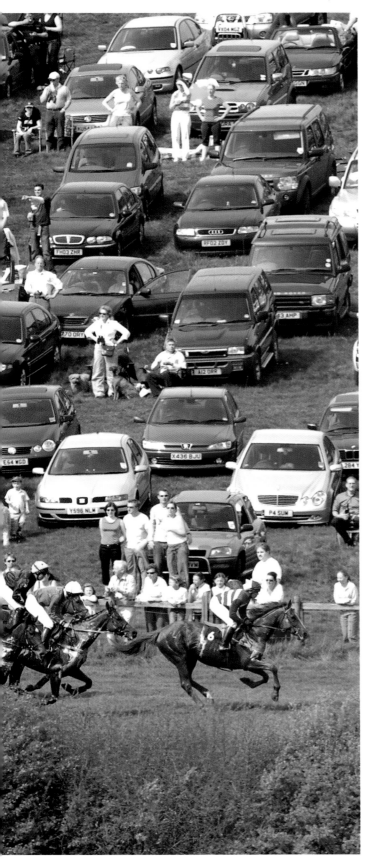

Another major social tradition, the point-to-point, organised by hunt supporters to raise funds and provide a launch pad for National Hunt racing.

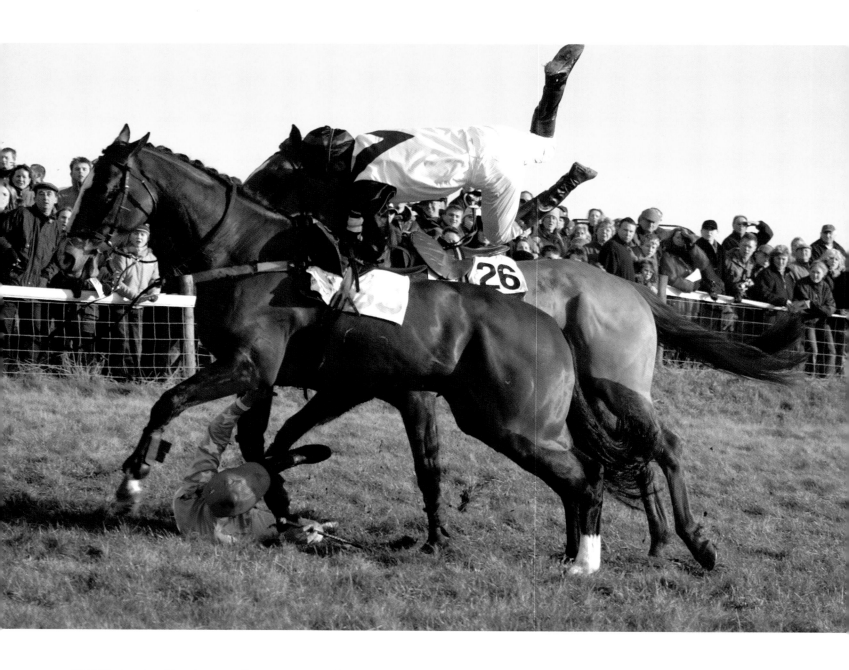

ABOVE: A pair of involuntary dismounts at a point-to-point meeting at Barbury Castle.

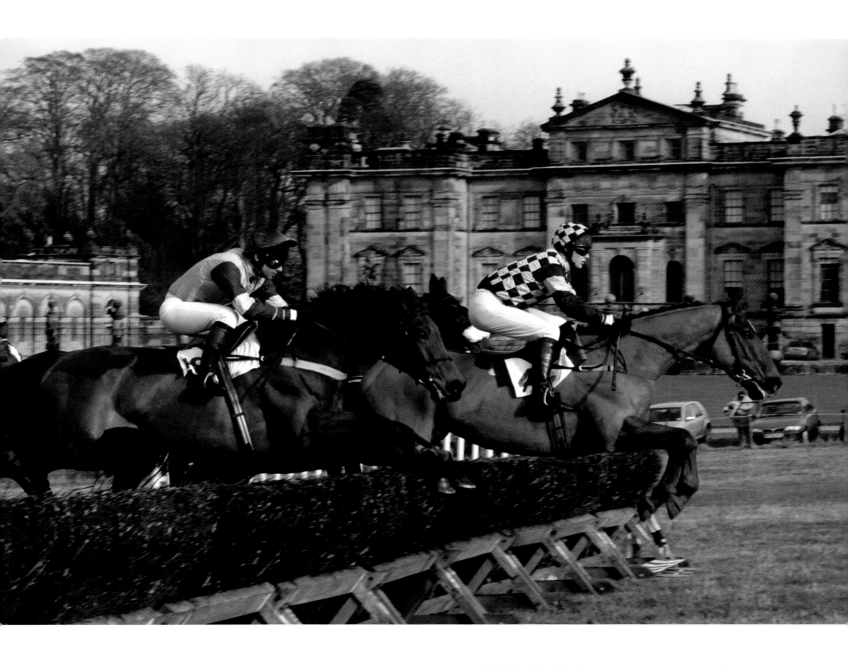

ABOVE: The Sinnington point-to-point meeting at Duncombe Park

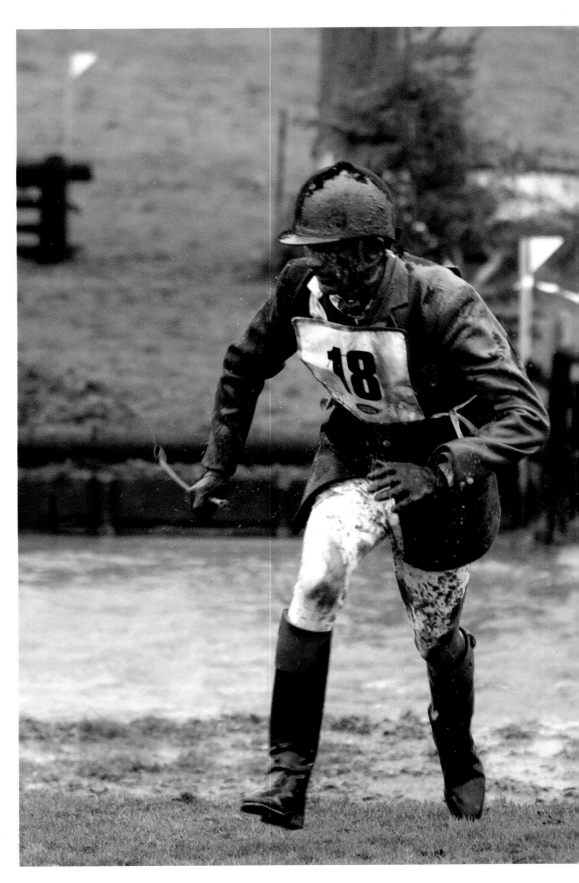

RIGHT: A muddy landing for a competitor in the Goring Hotels Natinal Team Championship, held over the Fernie course at Tur Langton in Leicestershire

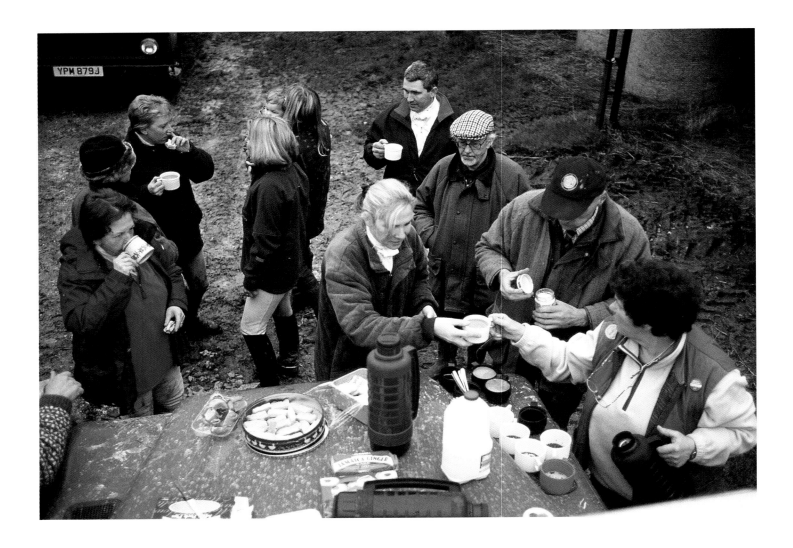

ABOVE: Hunt tea served off a Land Rover bonnet at
the end of a day with the Southdown & Eridge.

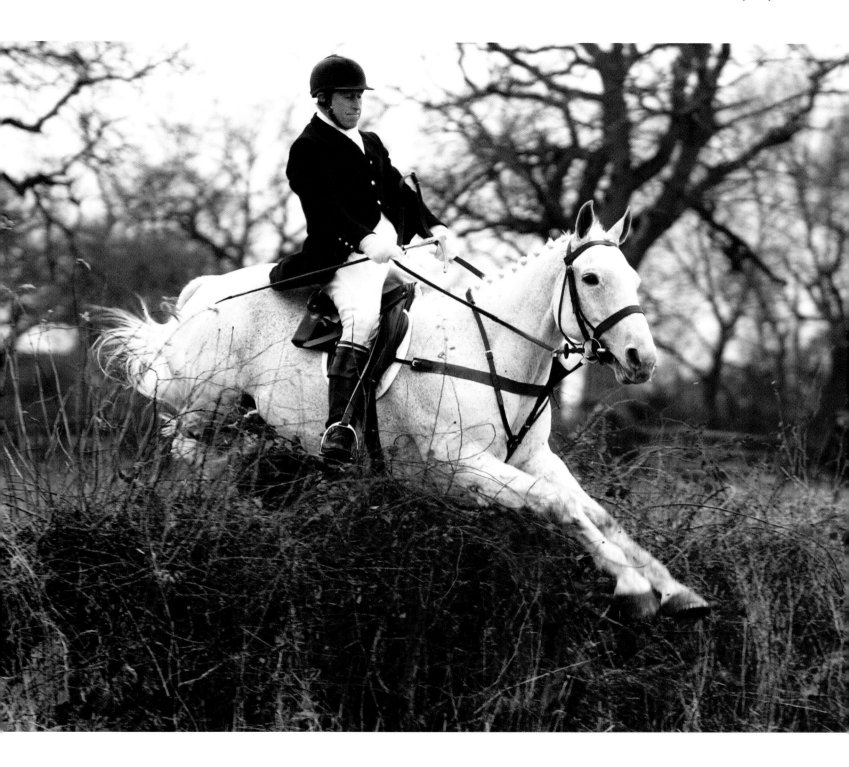

ABOVE: 'Be he stableman or lord....'. The Prince of
Wales enjoyed his hunting hugely before it became
too politically sensitive. Since the ban, the Royal
family has to remain impartial.

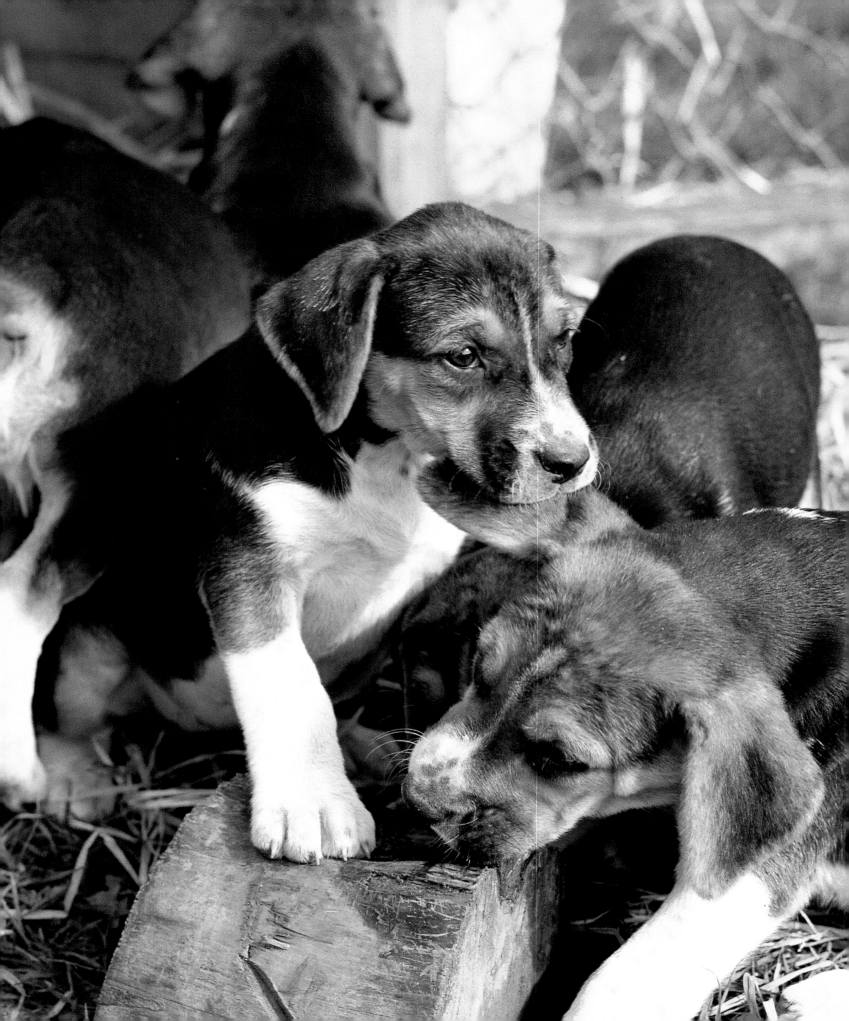

5 Hounds in Summer

'The bitch from the Belvoir, the dog from the Quorn,

The pick of their litter our puppy was born;

And the day he was entered he flew to the horn,

But rating and whipcord he treated with scorn.

Gently, Bachelor,

Have a care! Have a care!'

'The King of the Kennel', by Will H Ogilvie

MOST HUNTING PEOPLE ARE MORE INTERESTED to see hounds hunt than be shown. In truth, few can tell one hound apart from another anyway, and hound pedigrees tend to send all but the really dedicated to sleep. But without the science of hound breeding — the matching of useful working hounds with strong, athletic conformation — carried out assiduously by some masters, there would be no hunting. The hounds you see hunting today have bloodlines tracing back to 1800, which is from when the first annual *Foxhound Kennel Stud Book*, brought out annually by the Masters of Foxhounds Association, dates.

The anti-hunting faction simply does not comprehend — nor wish to understand — the care and history that will have gone into breeding a pack of Foxhounds, and therefore the reluctance of those responsible to allow this science to fade.

The Foxhound is a pack animal, bred for sole purpose — to hunt. The Foxhound lives to hunt, and thrives on communal living. The single Foxhound that becomes separated from the rest of its pack and feels lost can become a pitiful, bewildered creature. For this reason they rarely make suitable domestic pets – a fact that is little understood by hunting's opponents. A hound's job is to hunt; that's what they love

doing, what they look forward to, and what they thrive on.

The entire hunting ban debacle has perhaps had a more miserable and bewildering effect on the Foxhound, who cannot defend himself, than on any other element of the hunt.

The yearly puppy show is a traditional way of saying thank you, to subscribers for their continuing support, to the long-suffering farmers whose land has been hunted over in winter, and to the puppy walkers — again, often farmers. In between weaning and being introduced to hunting, hound puppies are 'walked' — ie, looked after for about six months during that babyish, naughty period between being tiny puppies and working dogs. The hound puppy will muck in with the sheepdogs, terriers and gundogs already around on the farm before returning to kennels.

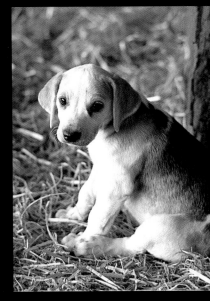

The puppy show involves hunt staff in a massive annual sprucing up operation in kennel - as in any job involving animals, it's an all-year occupation — and the ladies of the hunt in producing a traditionally large and lavish tea.

Hound shows provide important opportunities for professional hunt staff to meet one another in summertime and are a great gathering of hunting folk in the off-season. Not all hunts are interested in sending hounds to the big hound shows, but the packs that do make the effort, and who win prizes, are often coincidentally the packs that show some of the best sport. Under the genteel, bowler-hatted atmosphere of the occasion, however, there lies a fiercely competitive undercurrent.

LEFT: Belvoir hound puppies.
RIGHT: A Pytchley puppy.

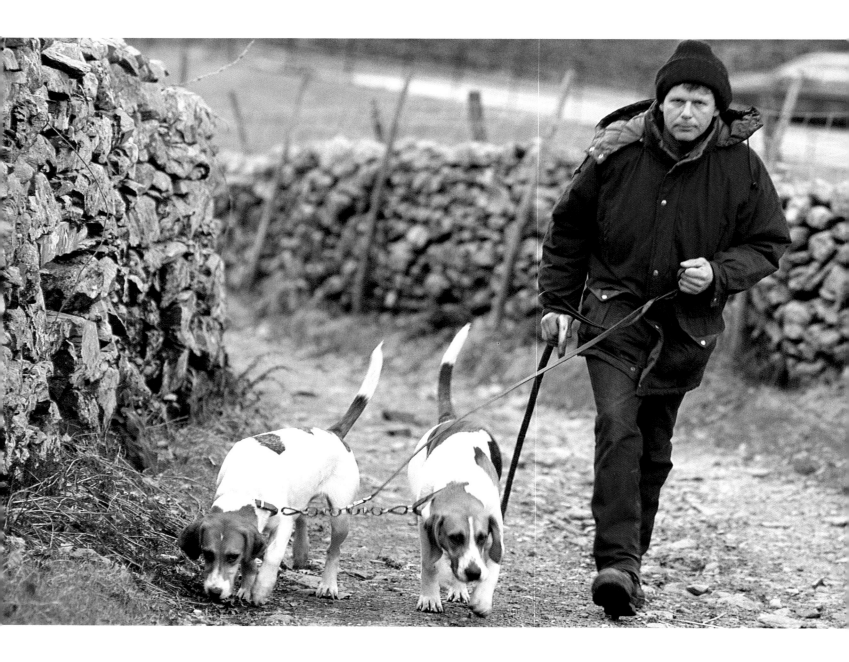

ABOVE: Peter Whitehead walking the Coniston
puppies Moment and Marmite.

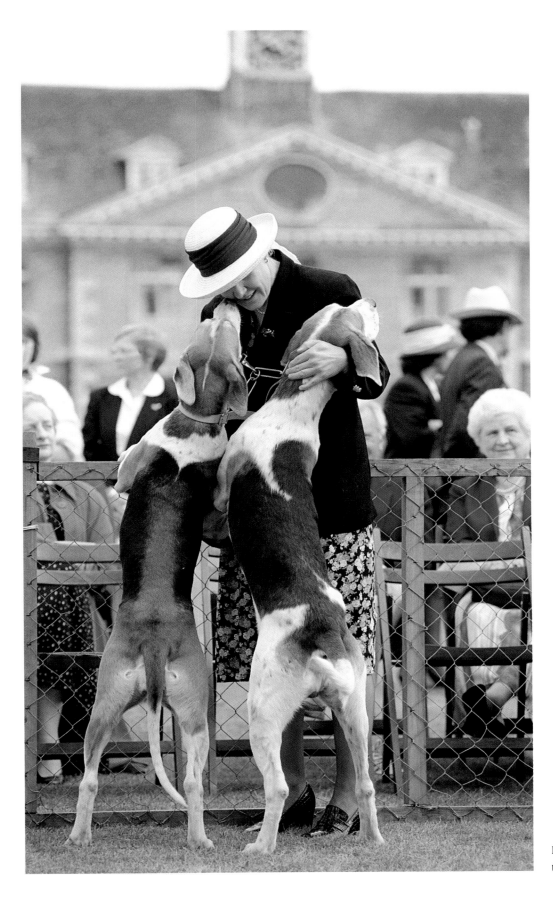

LEFT: Hounds joyfully recognising
their walker at the puppy show.

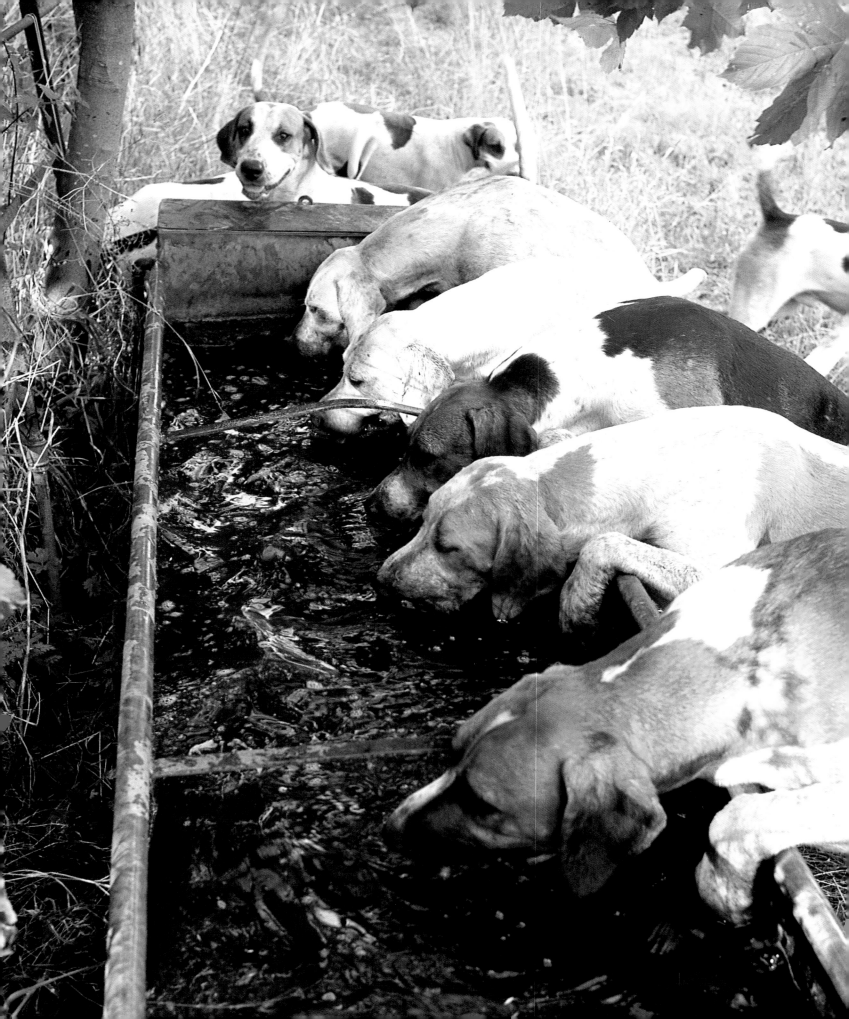

LEFT: The Grafton hounds.

RIGHT: A Welsh "woolly" from the Pembrokeshire.

OVER PAGE: The Mid Devon hounds doing what hounds do best — hunting.

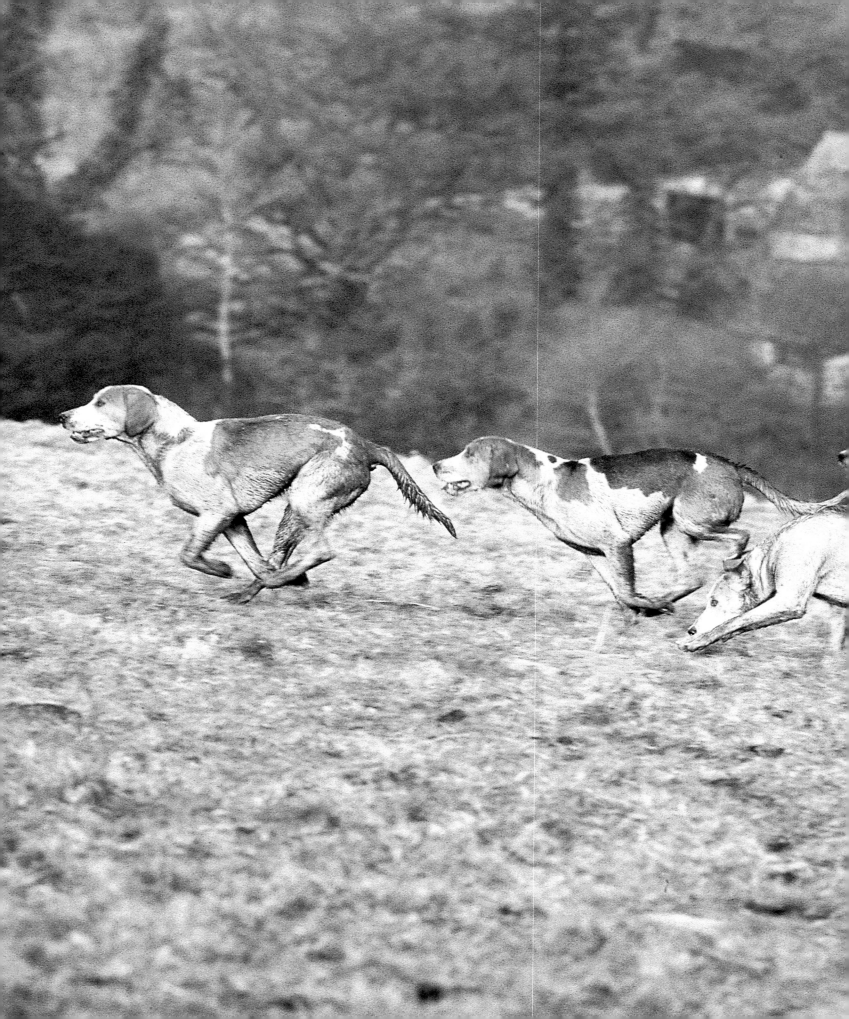

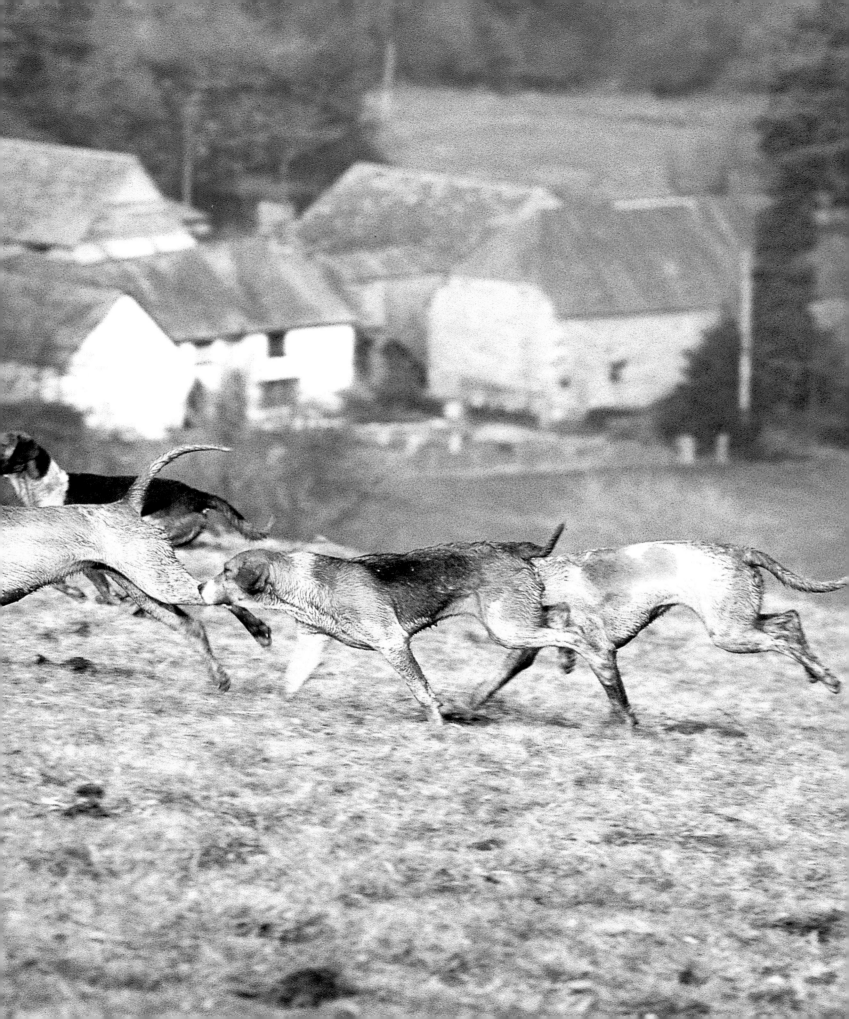

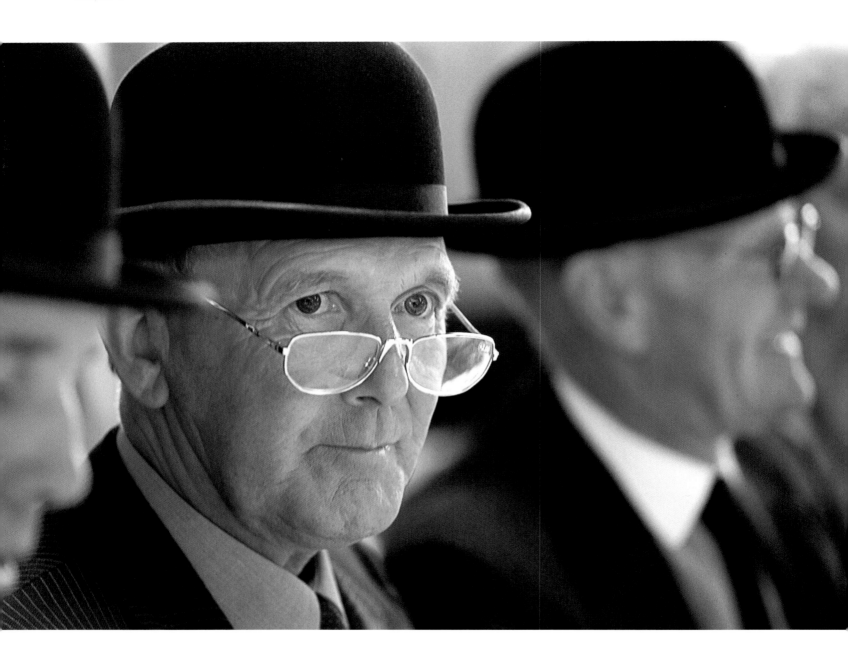

ABOVE: Peter Jones, former Pytchley huntsman, with fellow hunt staff at the Royal Peterborough Foxhound Show.

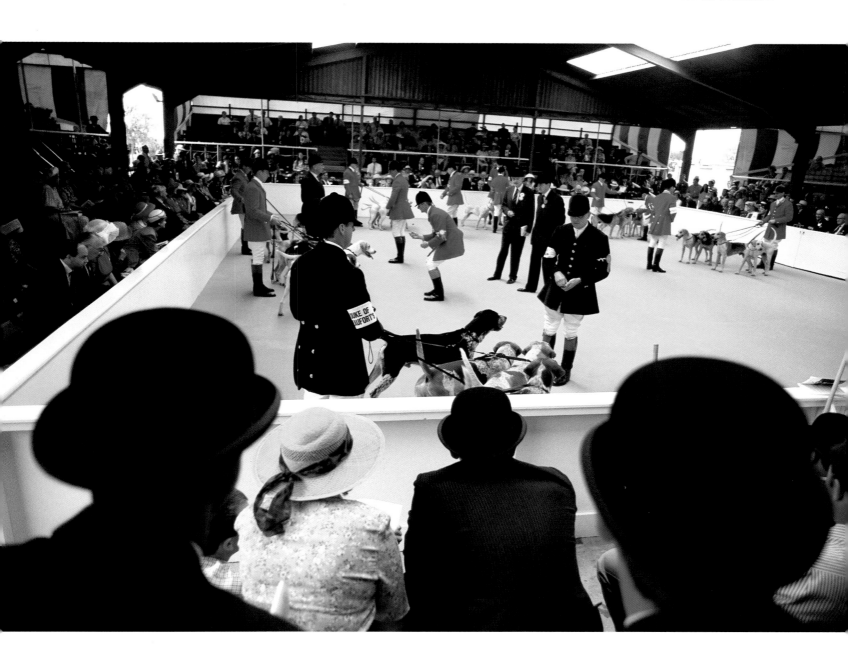

ABOVE: Judging the two couple bitch hound class at the Royal Peterborough Foxhound Show.

OVER PAGE: The hallowed arena at Peterborough, an annual Mecca for the great and the good in foxhunting.

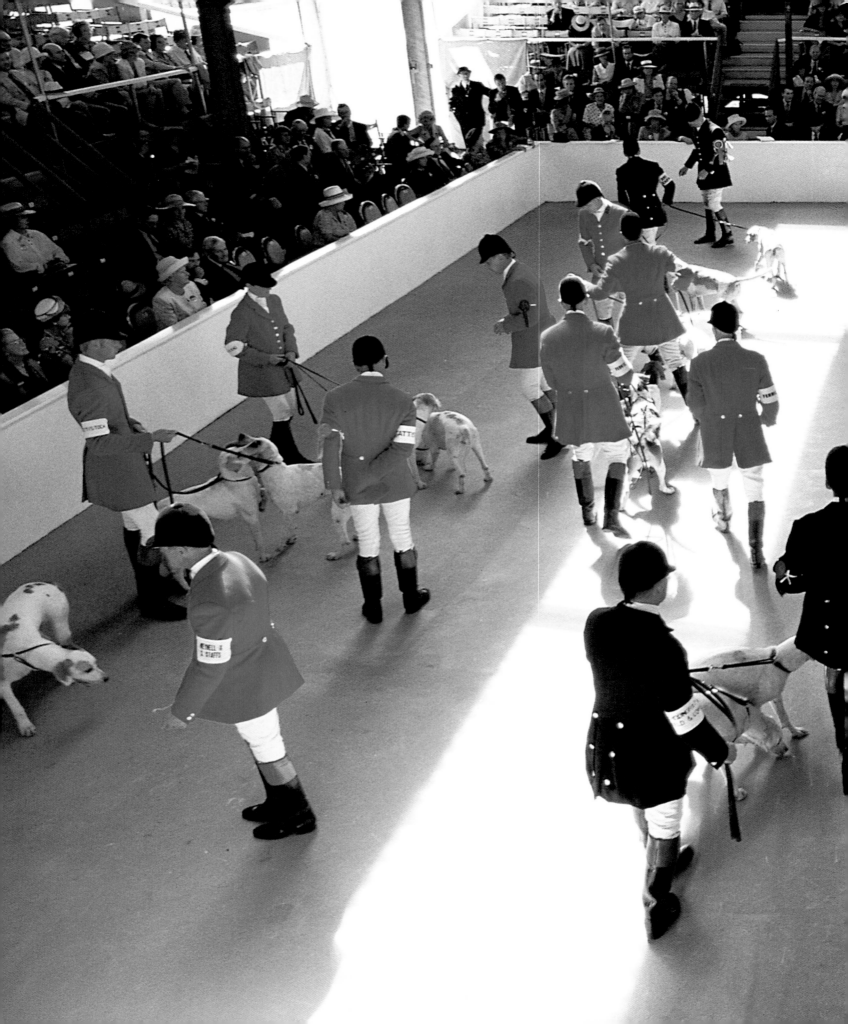

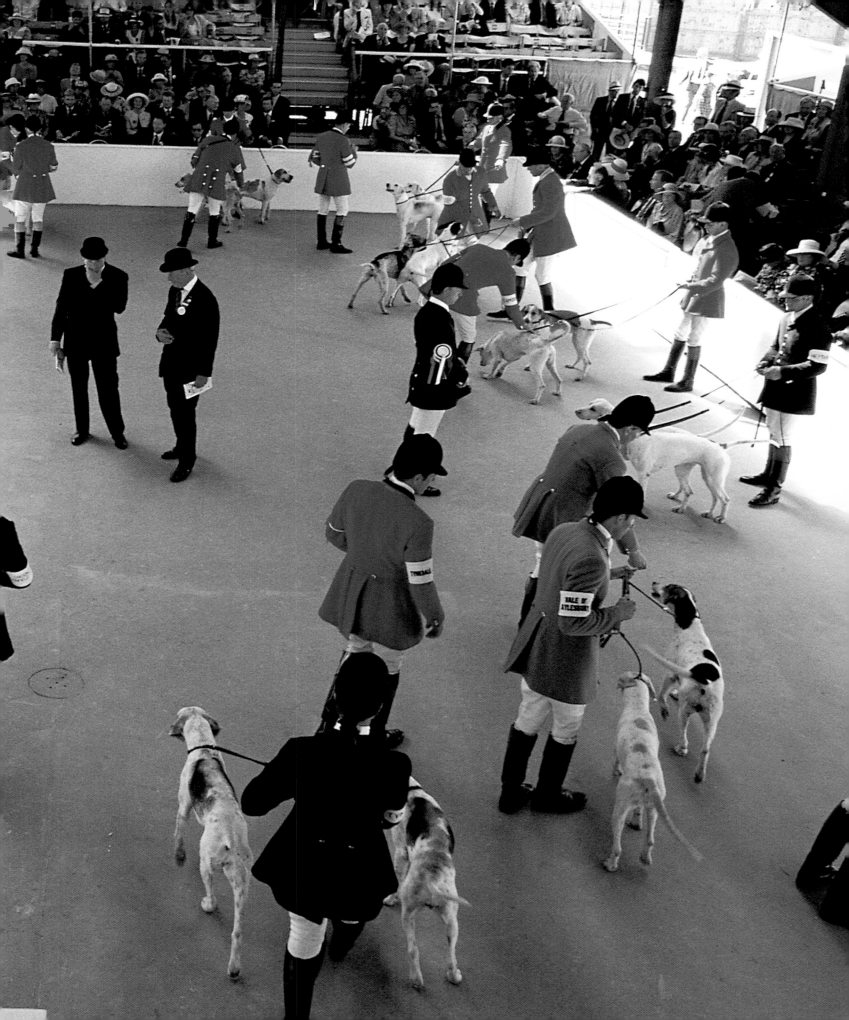

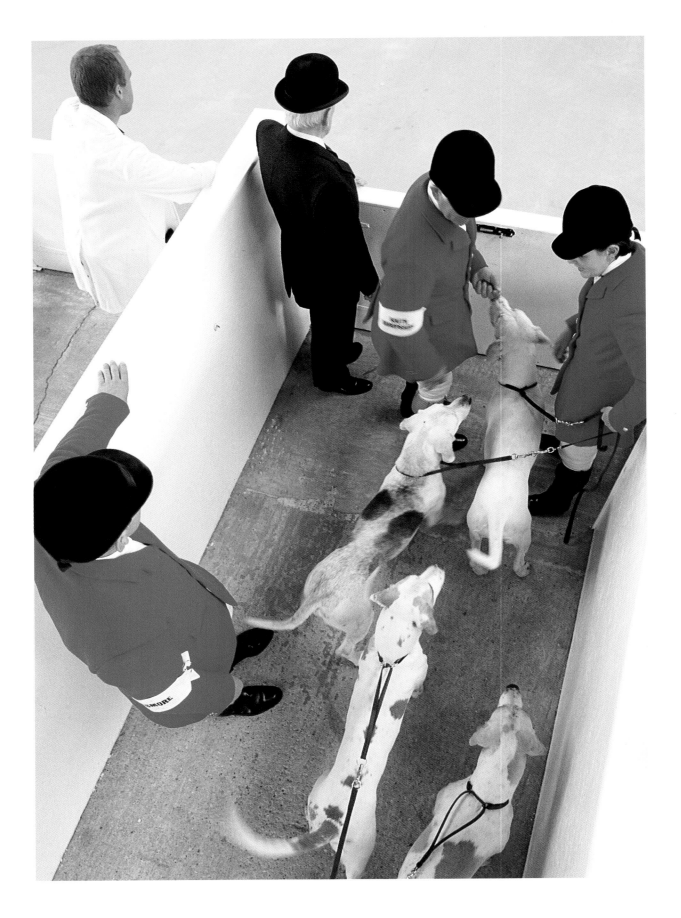

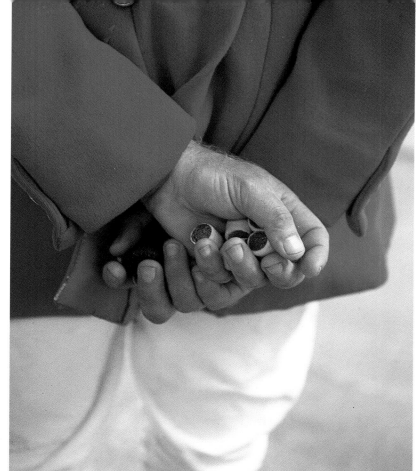

ABOVE: The late Betty Gingell, master and huntsman of the Cambridgeshire Harriers and a knowledgeable hound judge and breeder.

ABOVE RIGHT: Biscuit concealed in hand.

LEFT: Michael Rawson, former South Shropshire huntsman, waiting in the slip to show his hounds.

RIGHT: Charlie Watts, Cattistock huntsman.

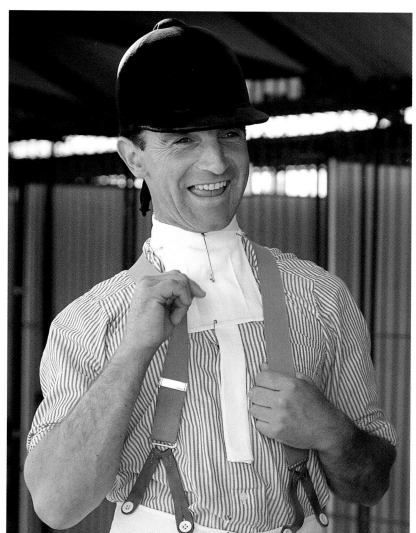

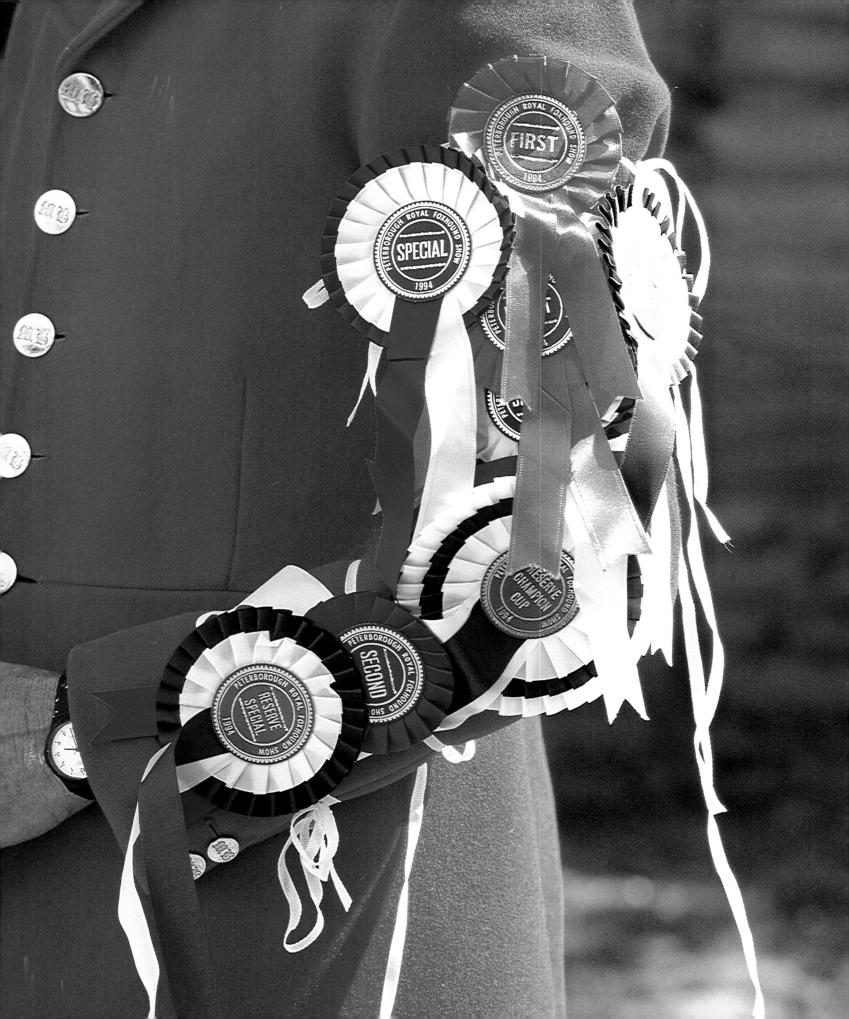

LEFT: A successful day.

BELOW: Alastair Jackson, director
of the Masters of Foxhounds
Association, and Nigel Peel, joint-
master and huntsman of the
North Cotswold.

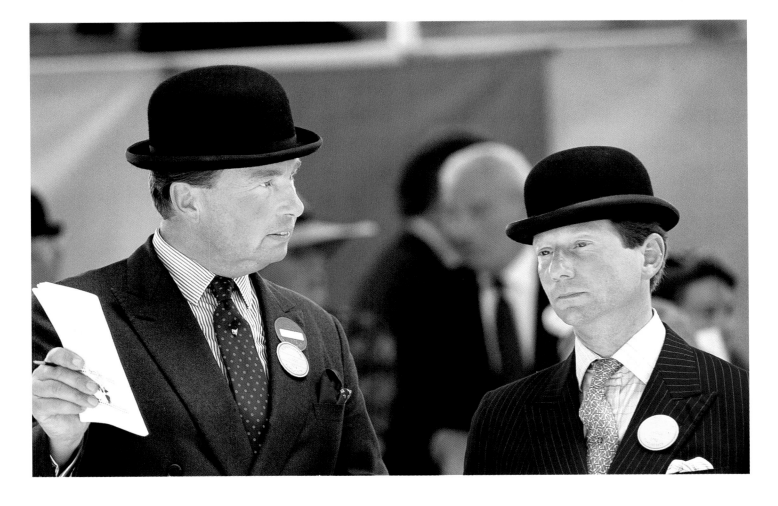

ABOVE: Not everyone was concentrating on the judging.

ABOVE: An affectionate moment between hound and walker.

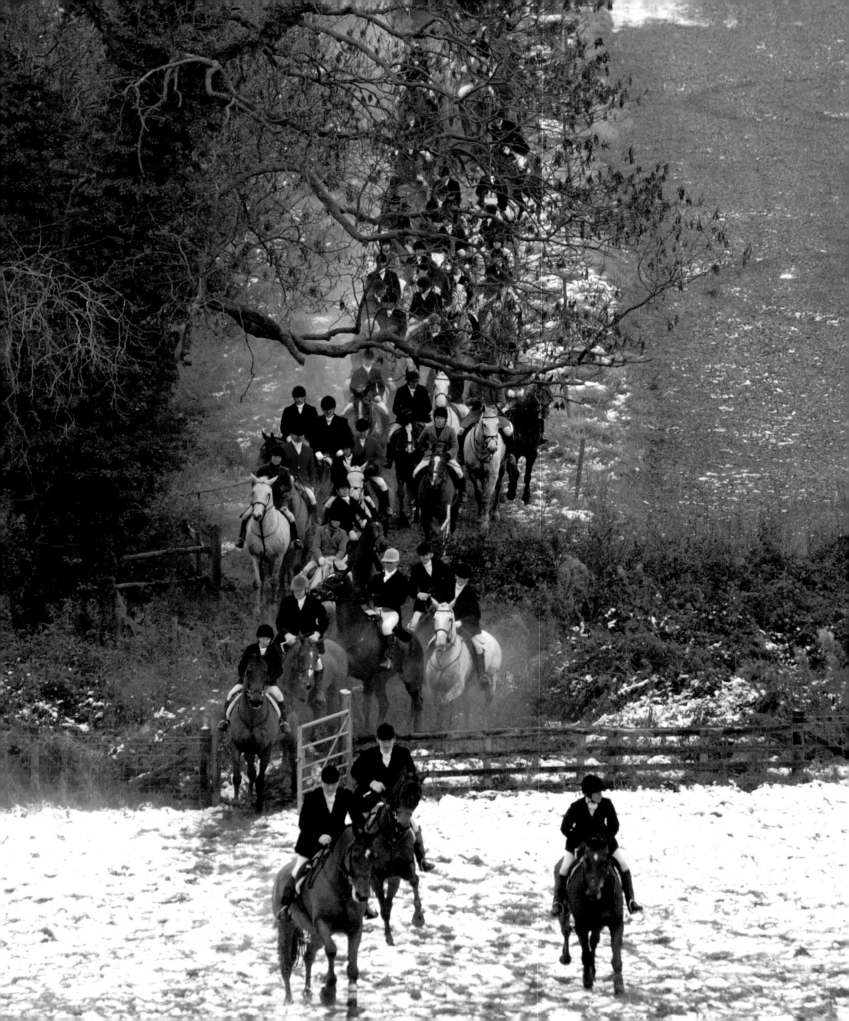

6 The Golden Hours

'The happiest man in England rose
An hour before the dawn.
The stars were in the purple
And the dew was on the lawn;
He sang from bed to bathroom -
He could only sing *John Peel;*
He donned his boots and breeches
And he buckled on his steel.'

from 'The Galloping O'er the Grass' by Will H Ogilvie

N
O SOONER DOES ONE SEASON END in the spring, than another
starts; there is no rest for hunt staff. During the summer,
hounds must still be exercised, even if no horses are in work,
and kennels kept immaculate for the puppy show and in the
event of visitors. Young hounds will be learning discipline, ready
for the start of their first season and new masters – masterships
traditionally begin and end on 1 May – should be visiting
kennels, learning about the hounds and how the country works.

Hunting people are still in a unique position to observe the
changing seasons in the countryside. The first of November
heralds the start of the hunting season proper, with the 'opening
meet', a nerve-racking day for hunt staff in which they are
expected to provide top sport for a large – and sometimes critical
– field, a few of whom may not bother to be seen again all
season. Sometimes the expectation can be too much, and many
an opening meet has been a complete dud in hunting terms.
There may be a plethora of nervous skittish horses to avoid –
especially racehorses who are supposed to have six proper days'
hunting in order to be allowed a master's qualifying certificate to
run in point-to-points – not to mention their equally
apprehensive riders. It is not known how traditional autumn
hunting will be affected as a result of the Hunting Act, but it
would be a tragedy if the magic of those expectant early
mornings, so eloquently illustrated in the old poem above, were
lost.

The Christmas holidays bring the traditional Boxing Day
meet, often held in a town centre, which is more about public

relations than a meaningful day's sport; and the Pony Club or
children's meet. The latter is a big day for young people when
it is traditional for individuals to be singled out to accompany
hunt staff. There will also be lectures on hunting etiquette —
always greet the master and hunt staff with 'good morning';
turn your pony's head towards hounds so it cannot kick them;
remember courtesy to the farmers on whose land you are
riding; always shut the gate, and do not disturb stock.

Hunting generally begins to wind down from mid-February
onwards, depending on the country and its farming patterns.
The most fortunate packs are those who always have some
high country to hunt, no matter how wet the going underfoot,
and who can keep therefor going, as in the West Country, to 1
May. Lambing can preclude hunting in some areas, but other
parts, like the moorland areas, will be desperate for a pest
control service to be performed while the lambs are out,
unprotected, on the moor. Spring hunting, with that sociable
'winding down' feeling, has a charm of its own, even though it
means the summer break is looming.

But in the wake of the Hunting Act, how many seasons are
left? How many more 'golden hours', as described in Will H
Ogilvie's poem below? How long can hunting people's faith and
energy be sustained?

During my childhood, every meal with a particular elderly
family friend began with the toast: 'Foxhunting for ever!' It
still rings in my ears, but sometimes with a hollow tone; those
pivotal hunting characters of the past would surely have
squared up to and entered into the current-day battle for
hunting's survival along with everyone else. But perhaps they
are lucky not to be facing the dire threat of extinction which
hovers over that most glorious sight in the British landscape.

'Their greetings we recapture,
Their voices yet we hear,
Wind-borne and clarion-clear,
Those men who shared the rapture
Of many a bygone year.'

from 'The Golden Hours' by Will H Ogilvie

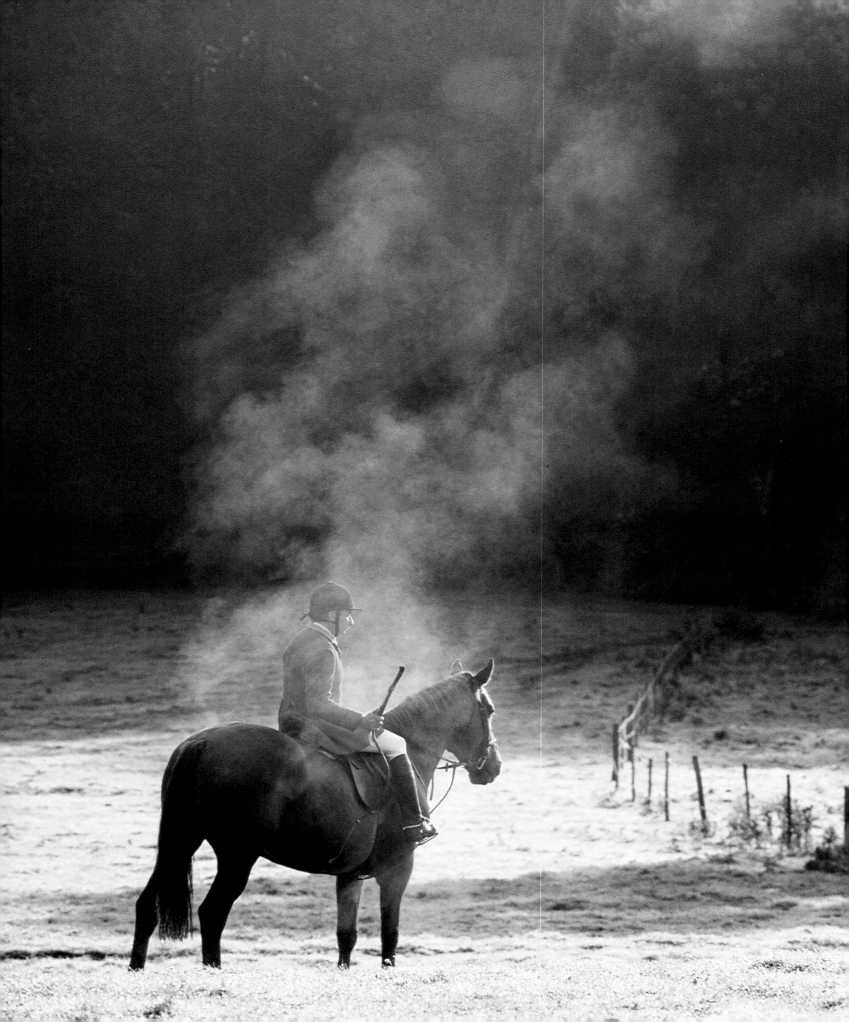

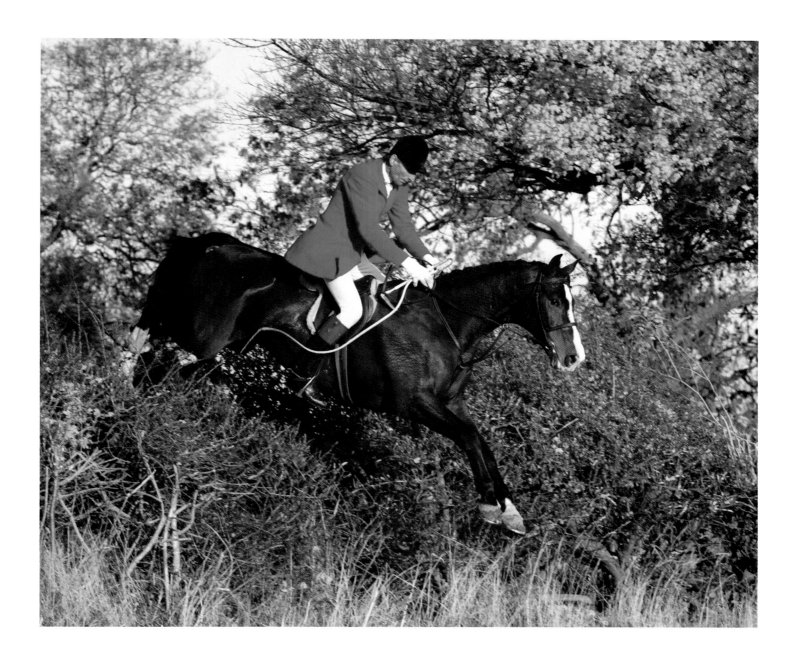

ABOVE: Joss Hanbury, joint-master of the Quorn and a crack horseman, against an autumnal backdrop.

PREVIOUS PAGE: The Fernie, with light November snow lying on the ground.

LEFT: Seavington whipper-in Chris Rabbetts in the steam of an early autumn morning.

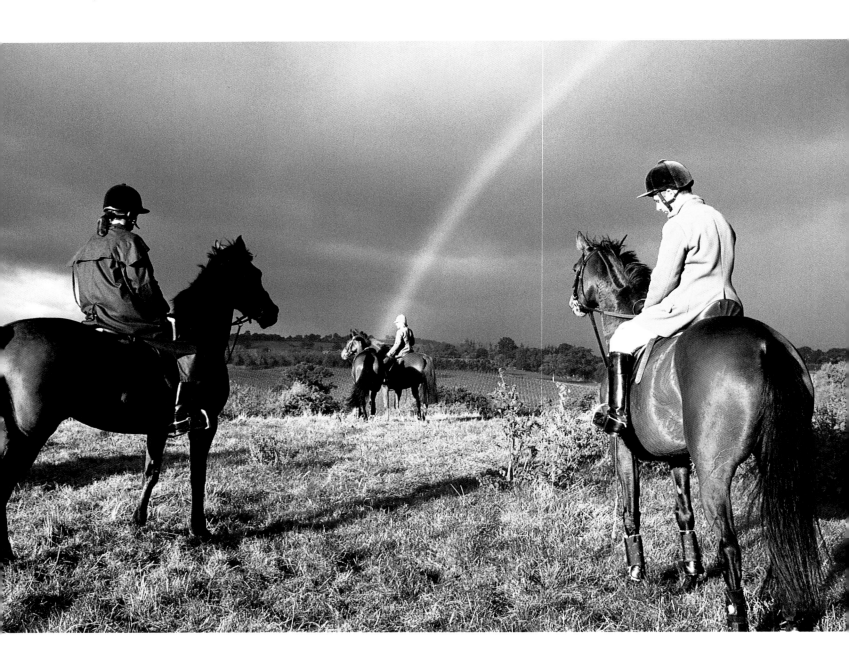

ABOVE: A rainbow over the Ludlow country.

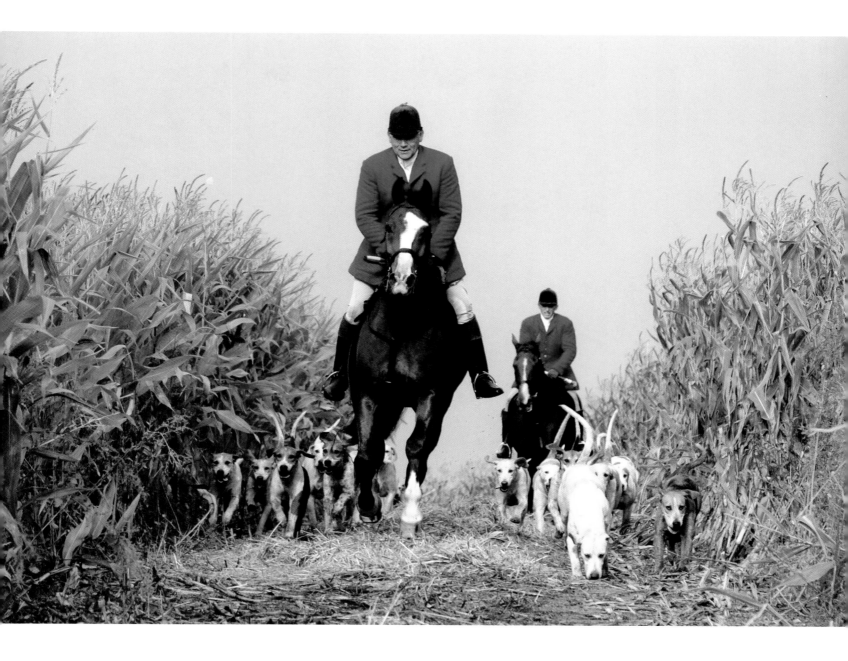

ABOVE: Cottesmore huntsman Neil Coleman with hounds in the maize on the Exton Estate on a September morning.

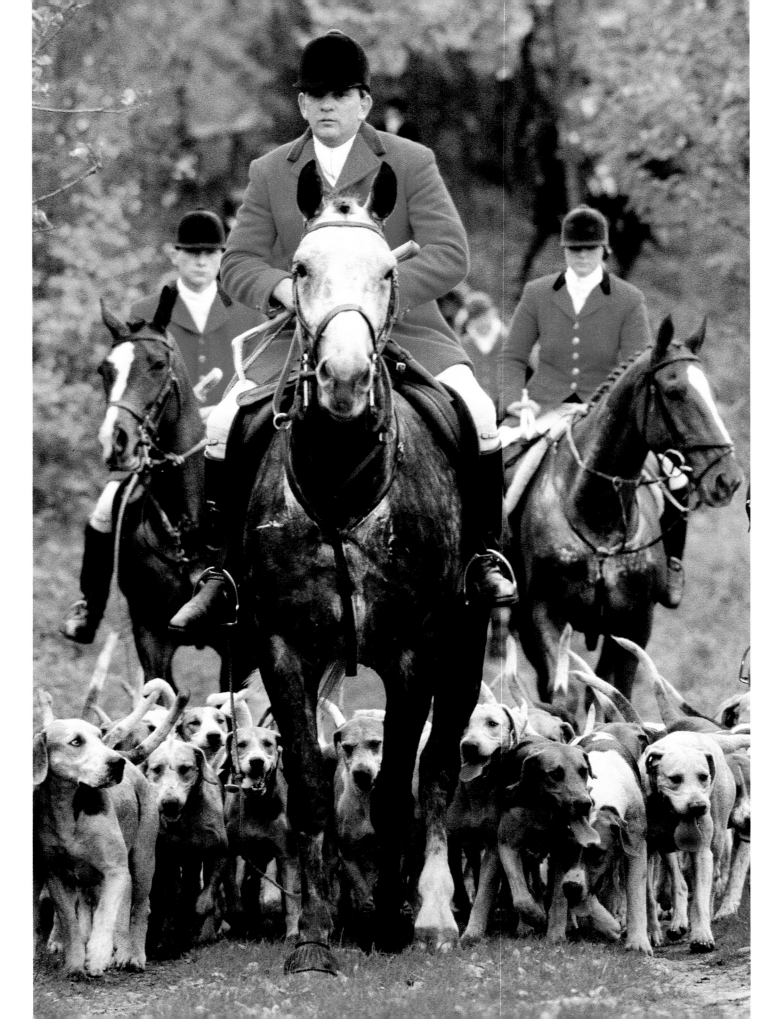

ABOVE: Hospitality at a South Dorset lawn meet.

LEFT: Ken Hand, huntsman, with the Essex &
Suffolk hounds on opening meet day — 1 November.

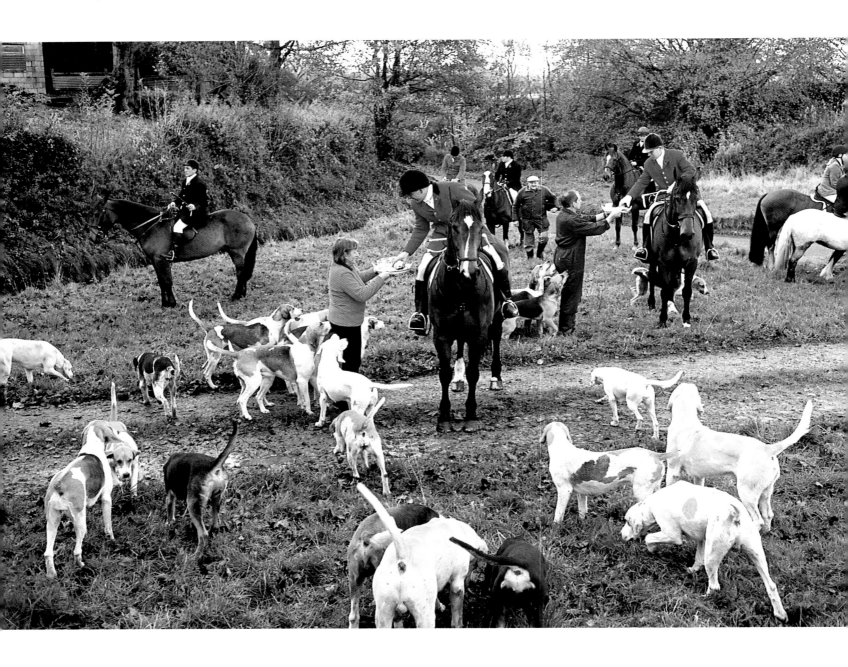

ABOVE: Lawn meet at a farm for the Saltersgate
Farmers.

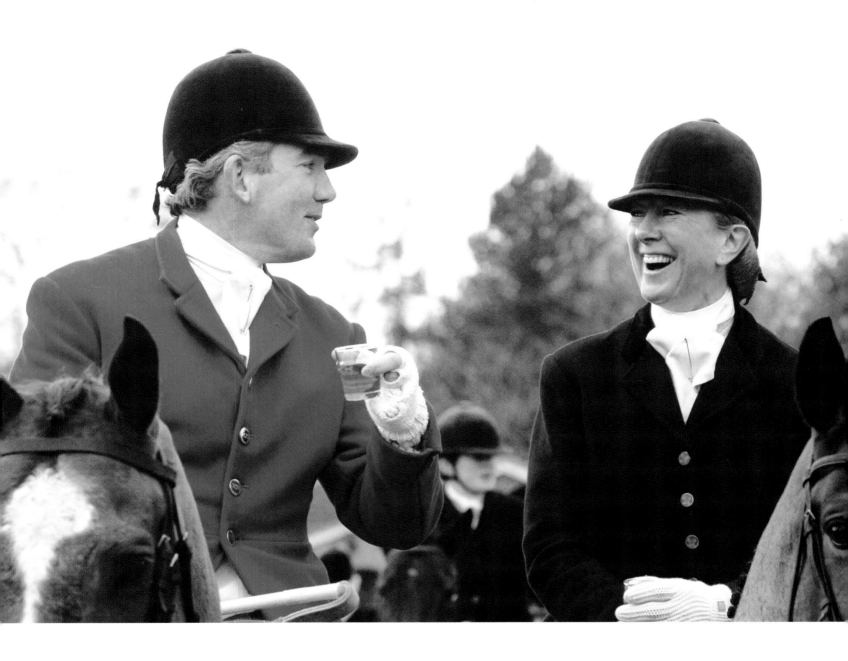

ABOVE: Bedale joint-masters Andrew Osborne and Mary Tweddle exchange greetings at a February meet.

RIGHT: A hound's eye view — the Duke of Beaufort's.

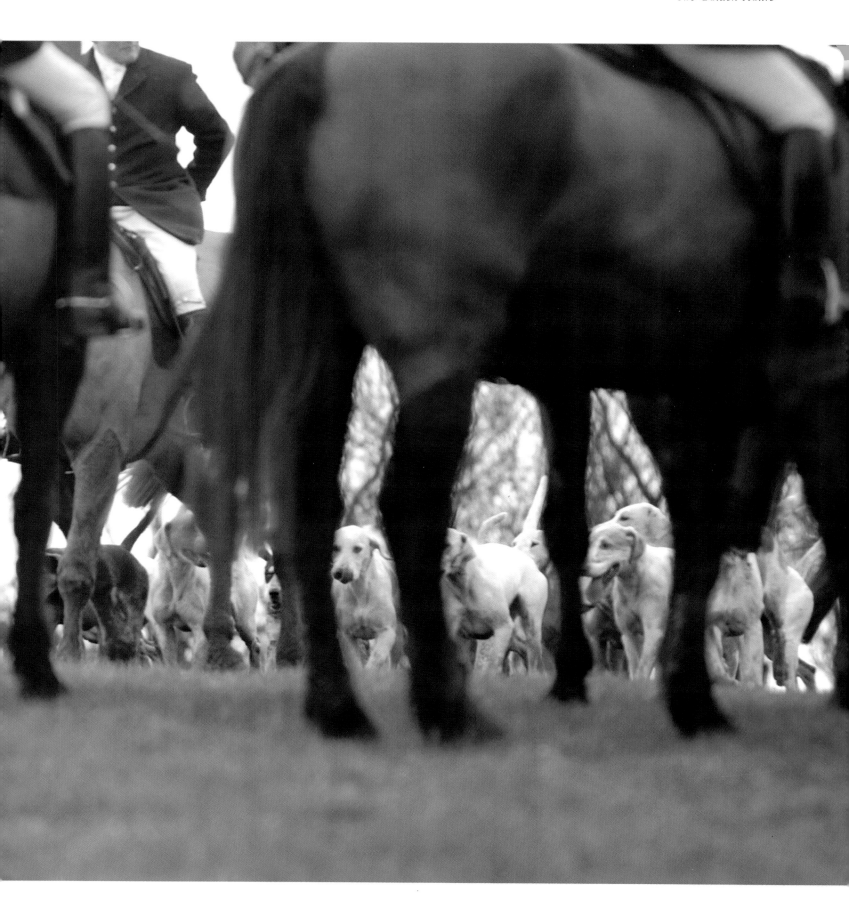

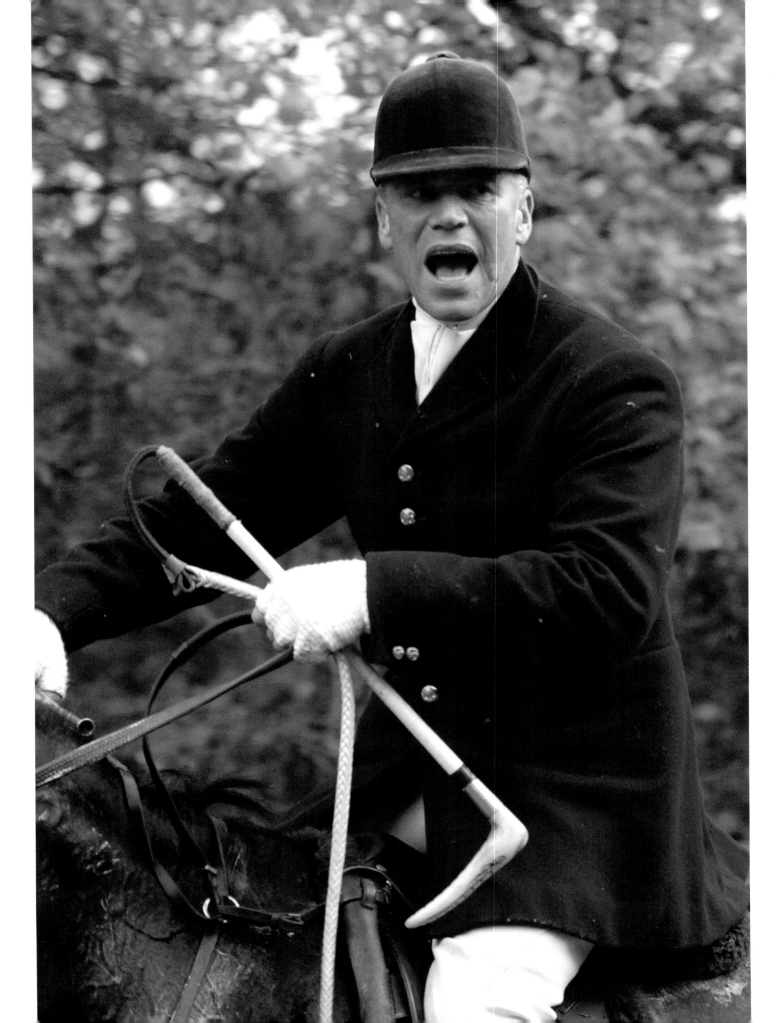

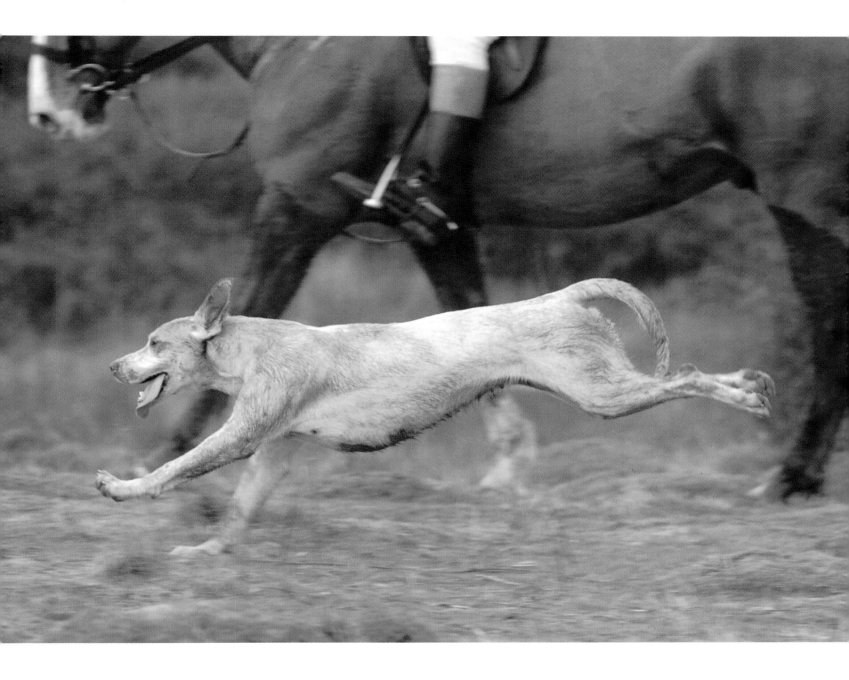

LEFT: Adrian 'Sage' Thompson, huntsman of the Chiddingfold, Leconfield and Cowdray.

ABOVE: The Ludlow — hound and huntsman.

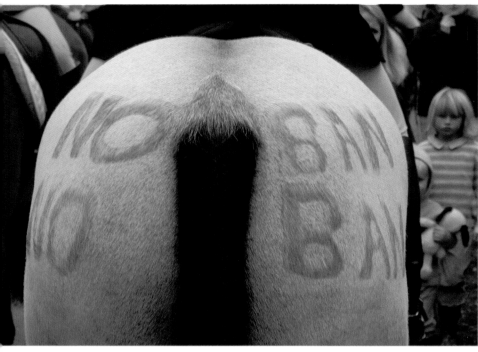

ABOVE: An unequivocal message from a Golden Valley follower.

RIGHT: Martin Letts, long-time joint-master and former huntsman of the College Valley & North Northumberland, with hounds at the end of the day.

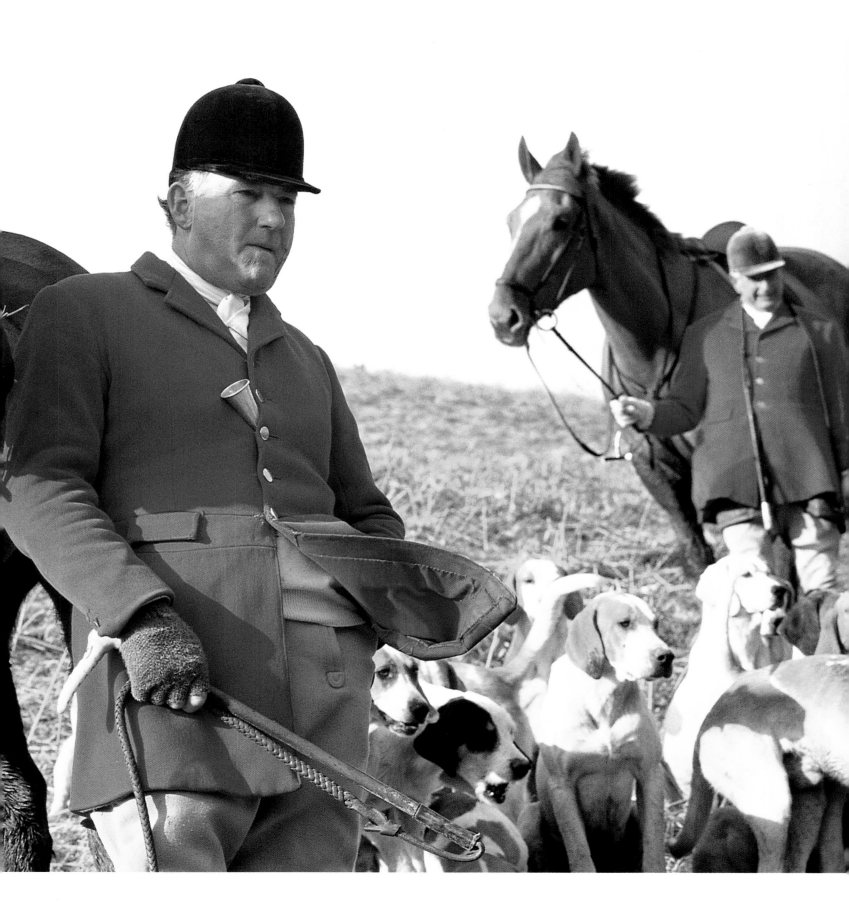

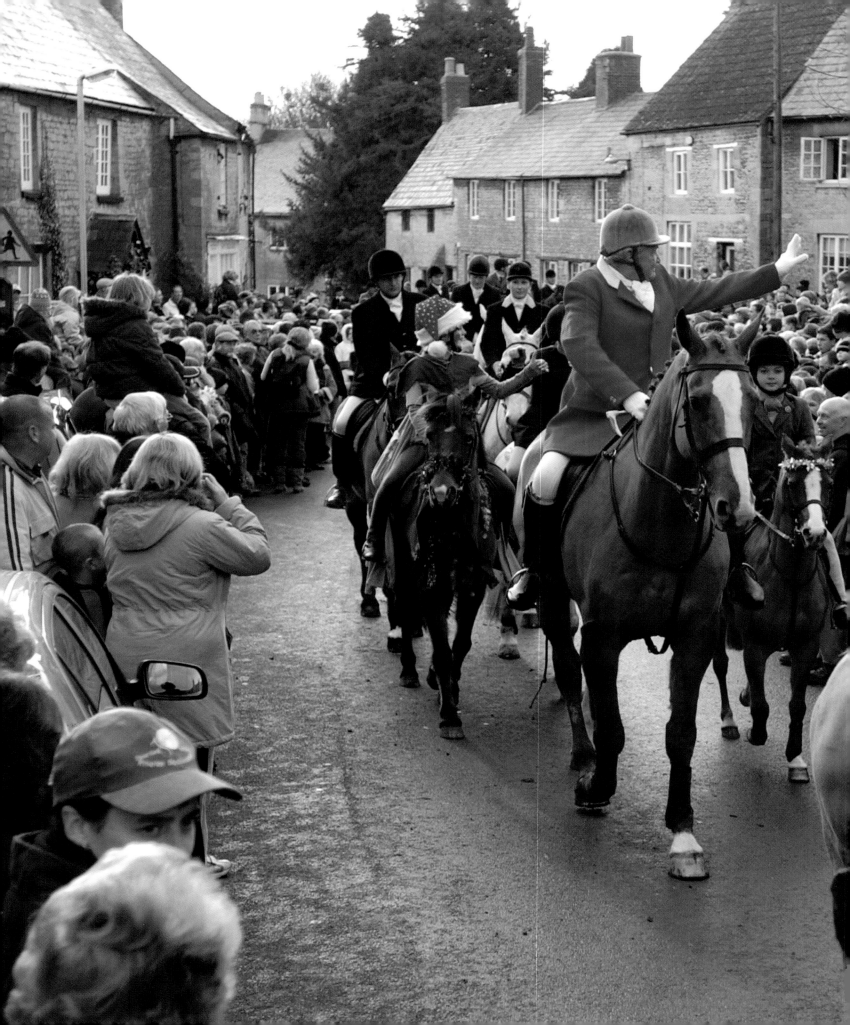

LEFT: Crowds throng the village of Brigstock to greet the Woodland Pytchley on Boxing Day morning.

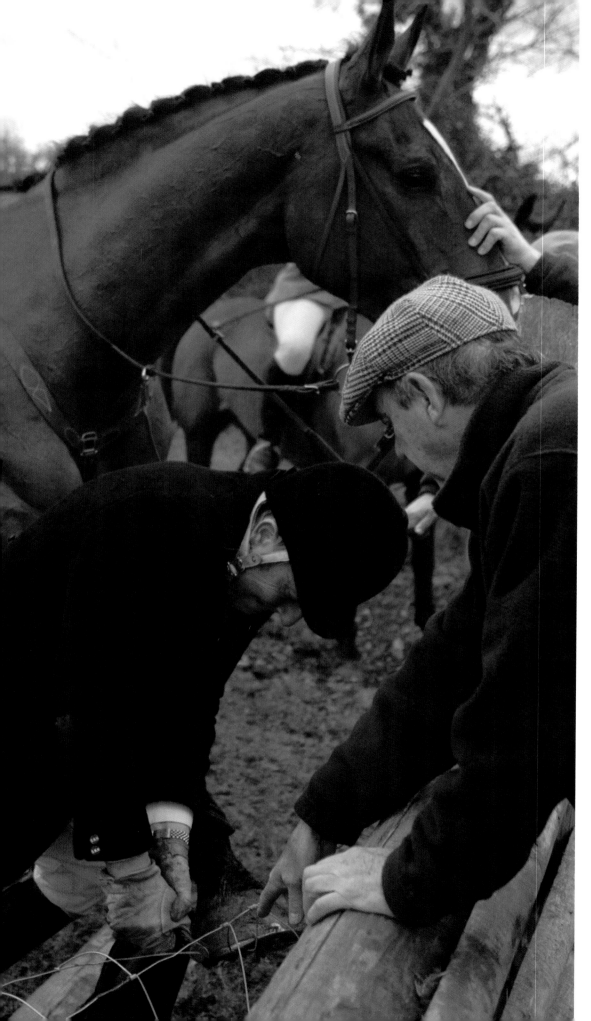

LEFT: Emergency rescue with wire-cutters out with the South Notts.

RIGHT: Immaculate unison jumping over a decent hedge in the Crawley & Horsham country.

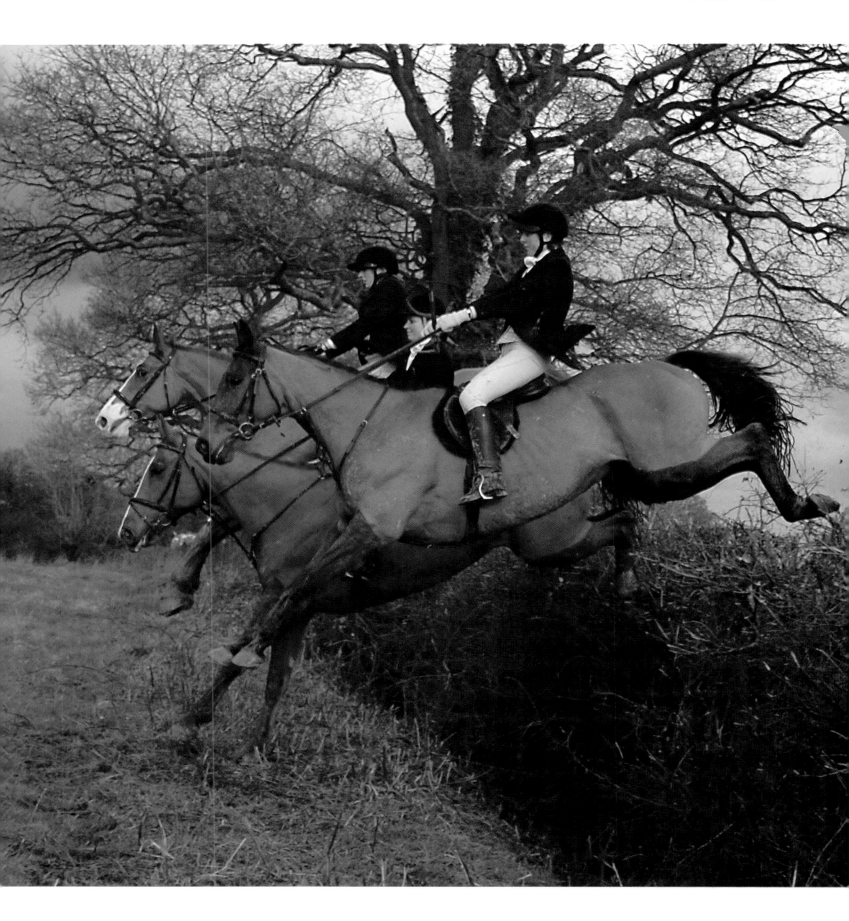

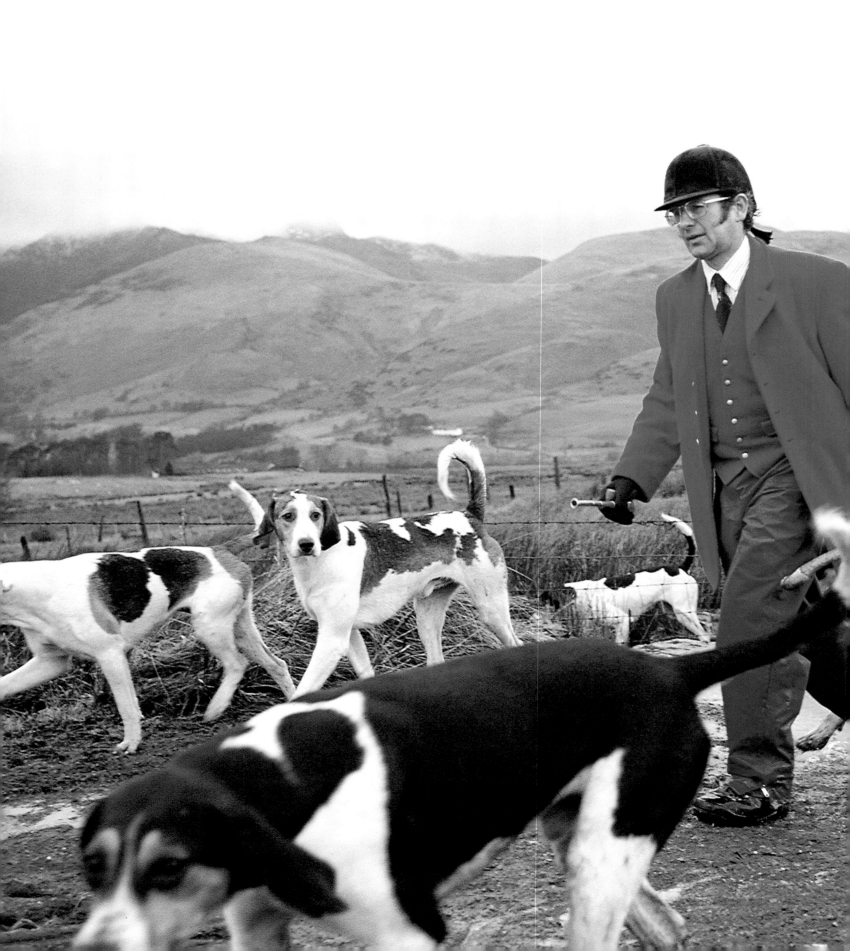

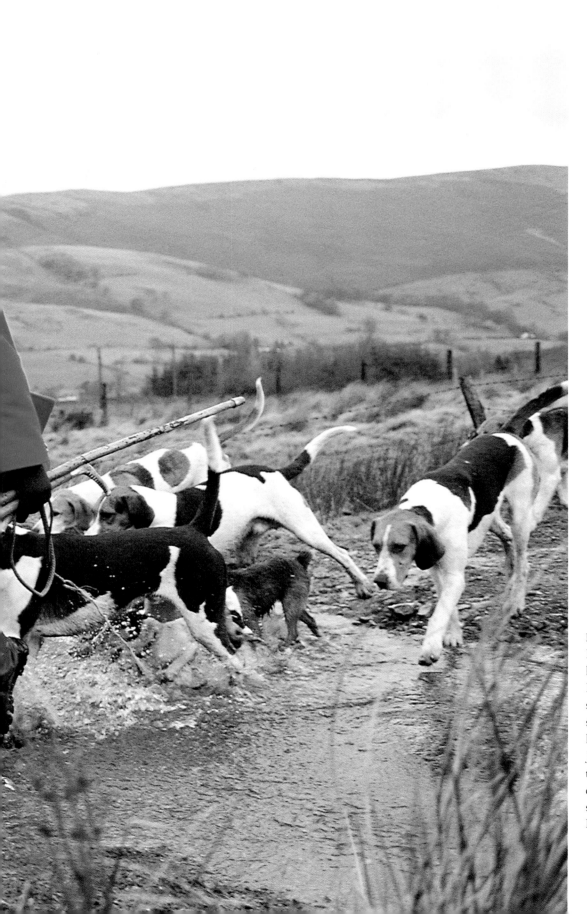

LEFT: The appropriately-named Barry Todhunter, famous huntsman since 1988 of the Blencathra and a brilliant spokesman in hunting's political struggle. The pack traces back to hounds hunted by the legendary John Peel — he of the song — in the 19th century and provides an essential fox control service to sheep farmers in the heart of the Lake District.

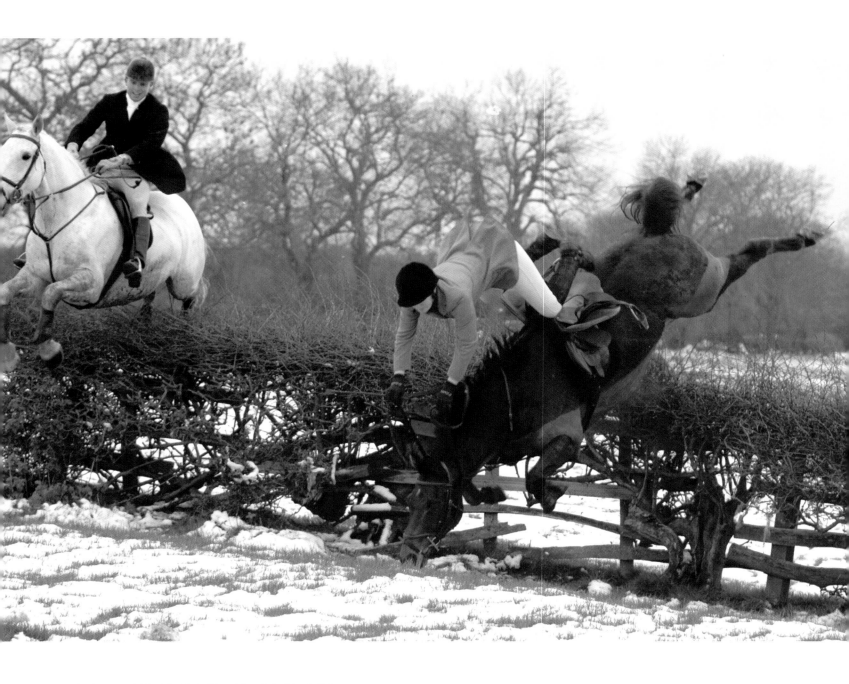

ABOVE & RIGHT: 'A fall's a h'awful thing' (Mr Jorrocks) — biting the dust with the Fernie (above) and the Surrey Union (right).

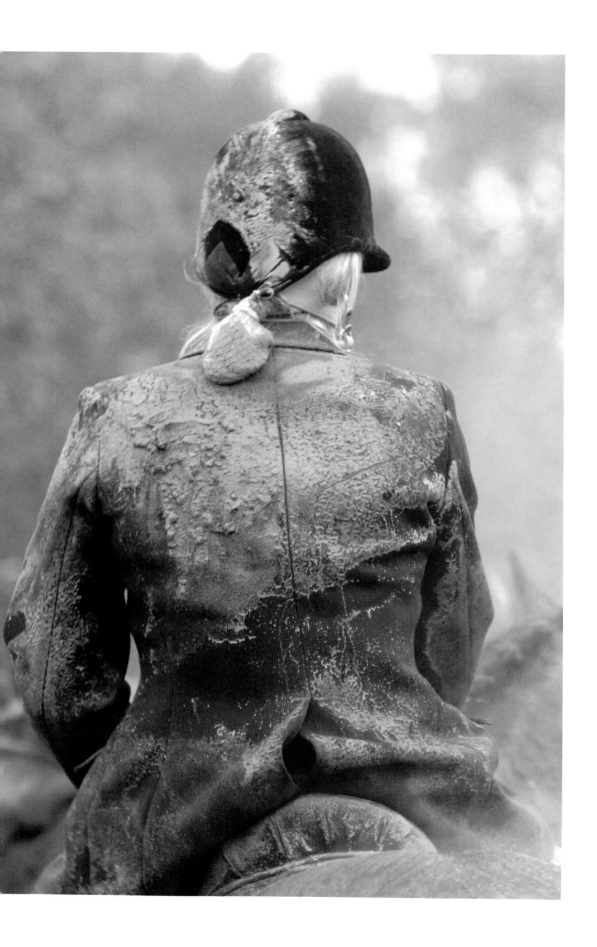

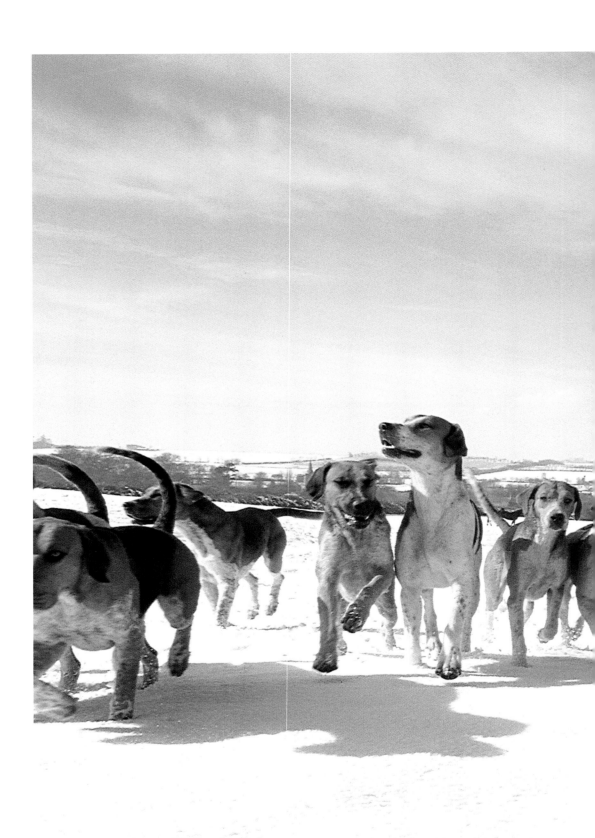

RIGHT: Huntsman Paul Bellamy hunts the Oakley hounds on foot when conditions are too snowy for horses.

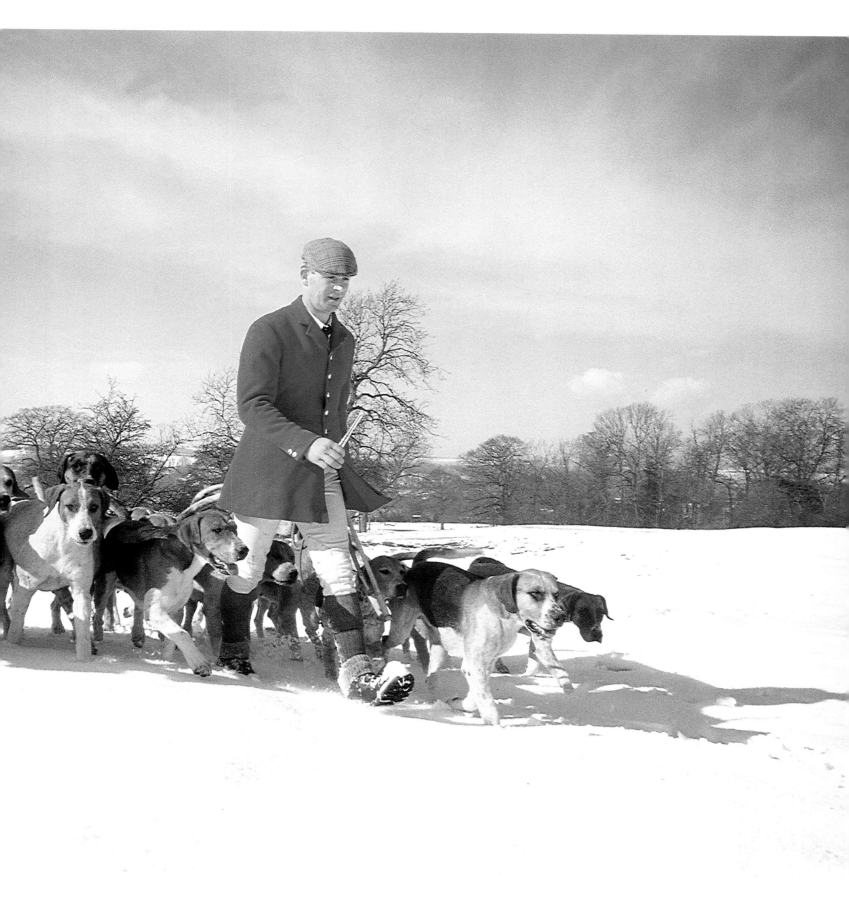

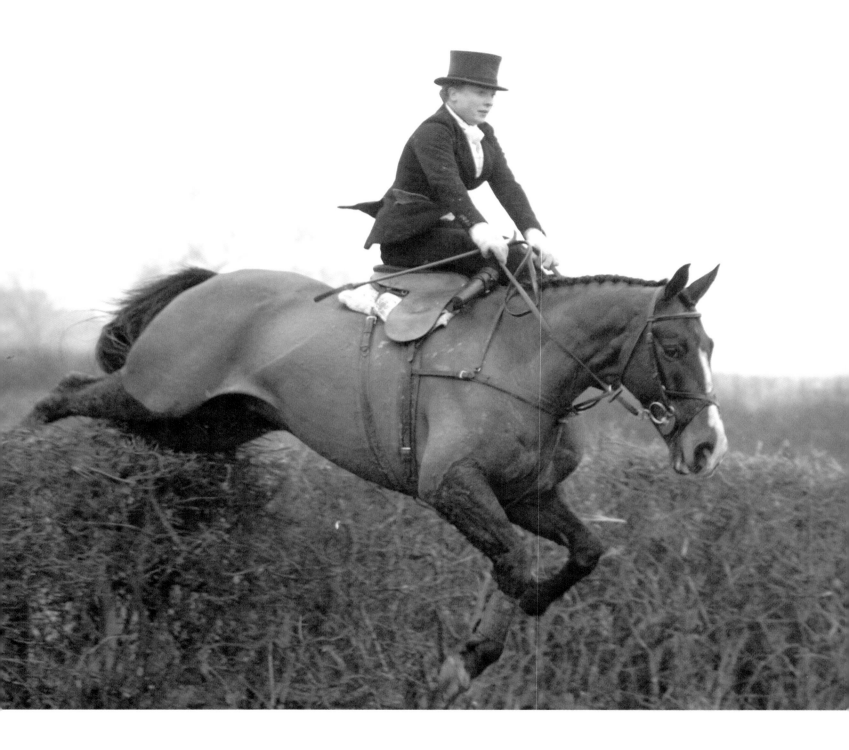

ABOVE: The elusive art of looking effortlessly elegant
— Frances Elton rides side-saddle with the Belvoir.

ABOVE: A pair of Morpeth gloves that have seen better days.

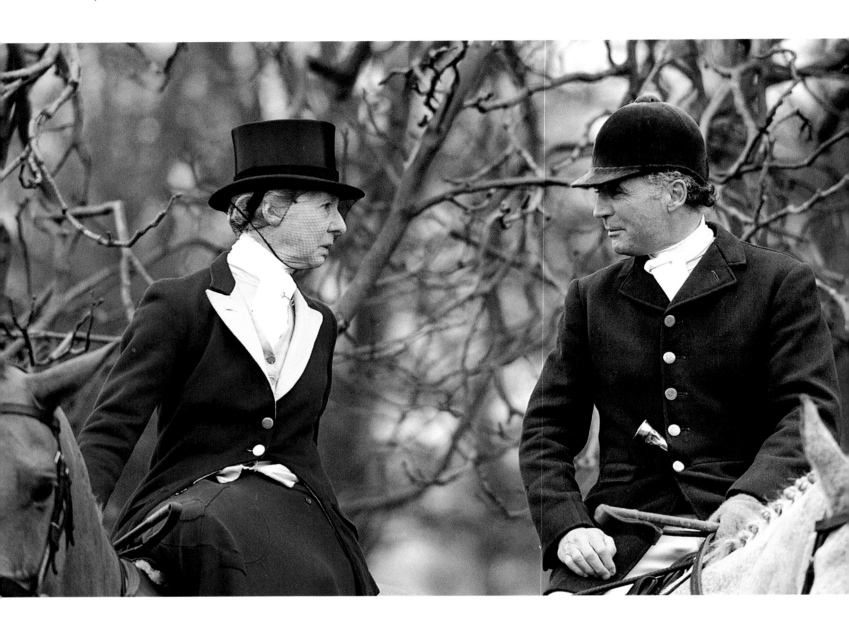

ABOVE: Elegance again — Mrs Pope and Ian
Farquhar, joint-master and huntsman of the Duke of
Beaufort's.

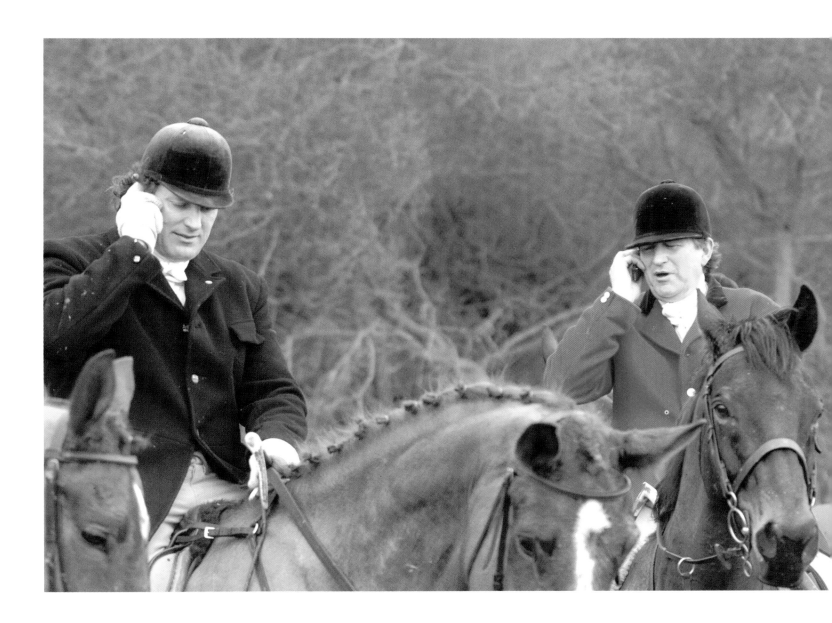

ABOVE: 'Can you hear the hounds?' 'No'. A sign of the times — these South Durham followers wouldn't earn universal approval from the purists!

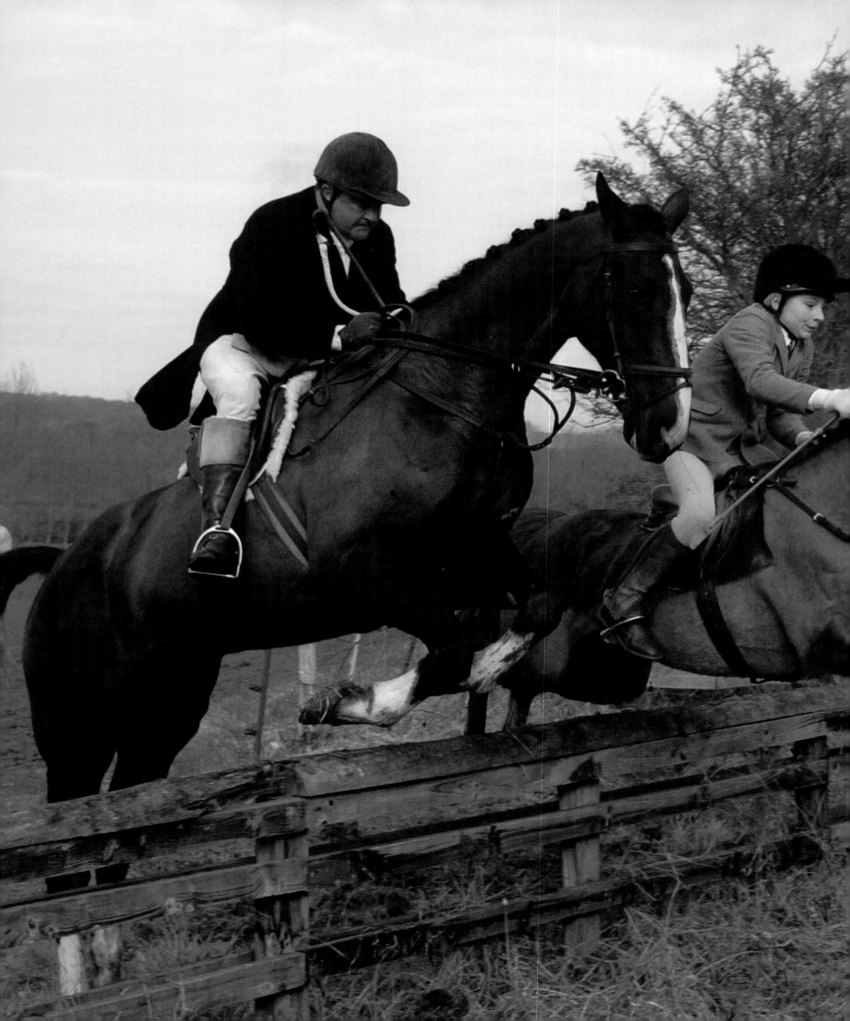

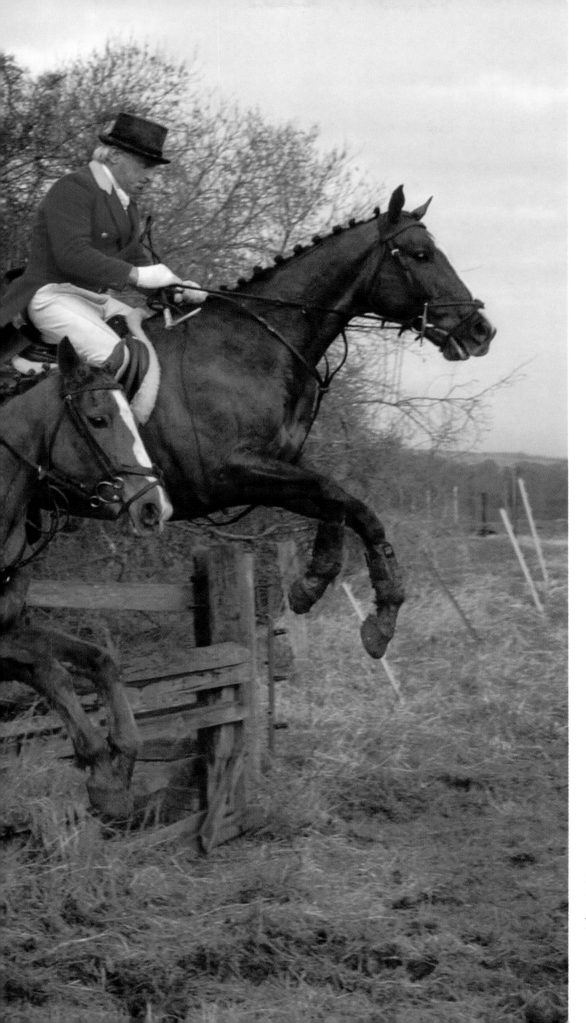

LEFT: Three generations out with the Pytchley — hunt chairman James Mackaness, Sasha Holt and treasurer John Stephenson.

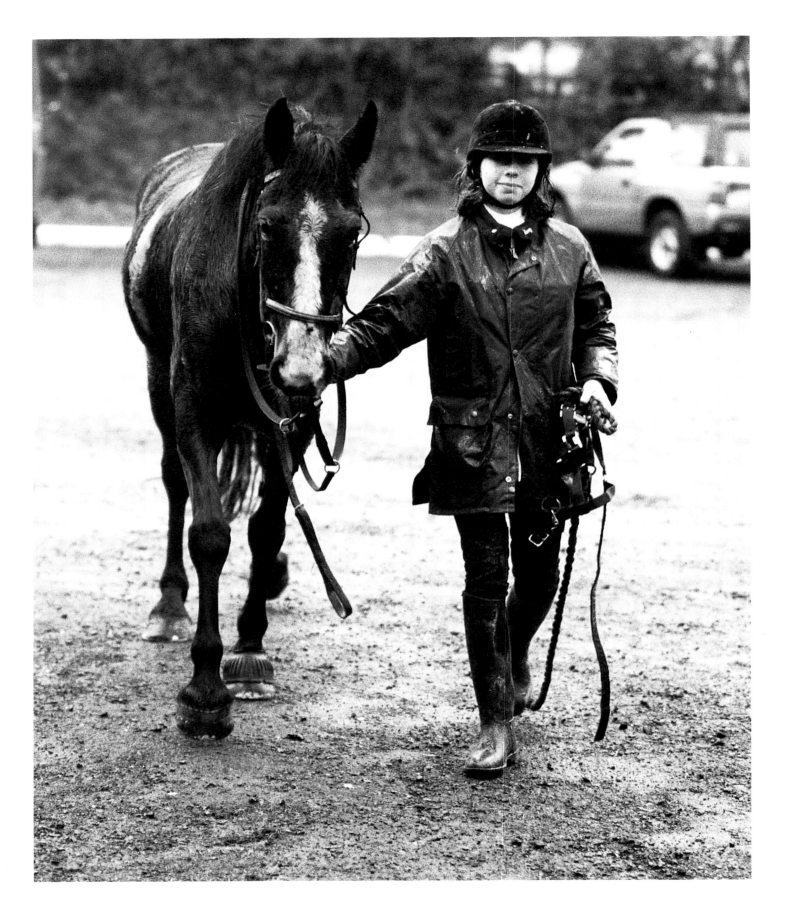

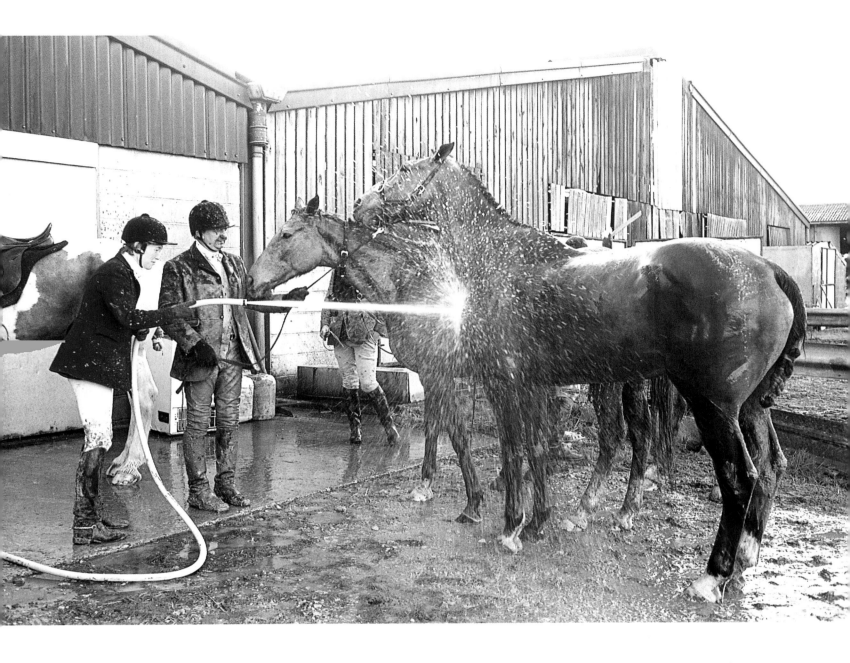

LEFT: Nina Musgrave, tired but happy after her first ever day's hunting, with the Duhallow in Ireland.

ABOVE: Janet Tory washing off at the end of a muddy vale day with the Portman.

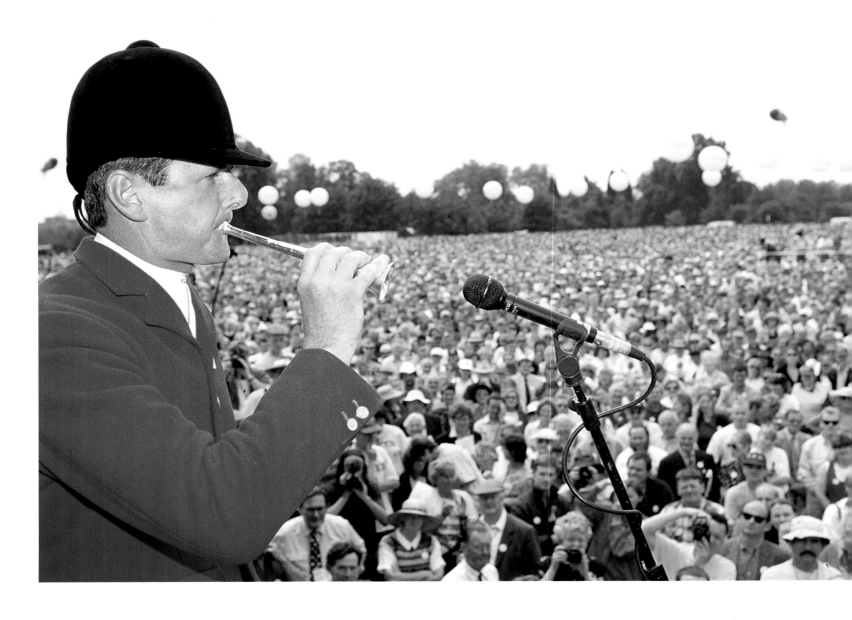

ABOVE: The rally in Hyde Park in July 1997 was hunting's first really serious major demonstration of modern times and proved the genuine strength of feeling against government legislation on hunting. It was an amazing, emotional occasion, as London welcomed — and treated with enormous courtesy — the hordes of peaceful, visiting demonstrators who clogged its underground and filled every inch of grass in its most famous park to protest passionately, yet peacefully. Pictured here among them is Patrick Martin, huntsman of the Bicester with Whaddon Chase.

RIGHT: The Countryside March of September 2002 was an equally courteous, but perhaps more insistent affair, the biggest demonstration seen in London since the Poll Tax riots. An estimated half a million people travelled to London to demonstrate peacefully against the government's perceived lack of interest in the countryside. The march was brilliantly organised, hugely impressive and well supported by the media but, ultimately, it failed to move a tranche of Labour MPs hell-bent on gaining some sort of victory in the House of Commons.

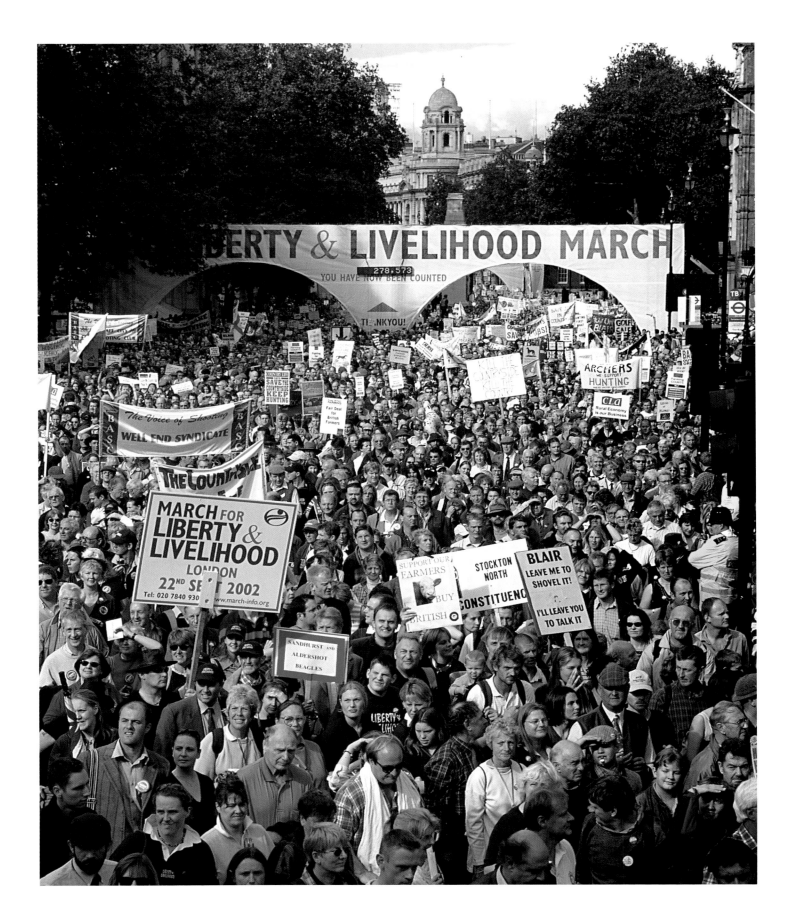

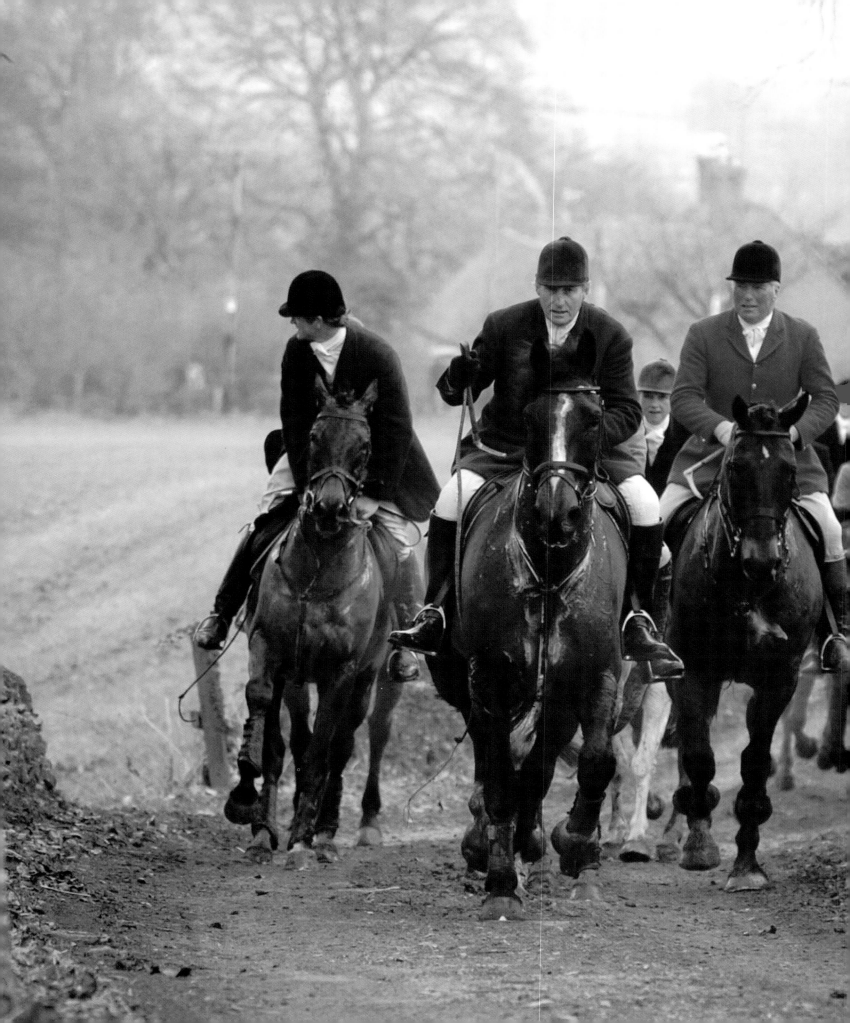

LEFT: Heythrop joint-masters
Richard Sumner and Oliver
Langdale at the head of the field.

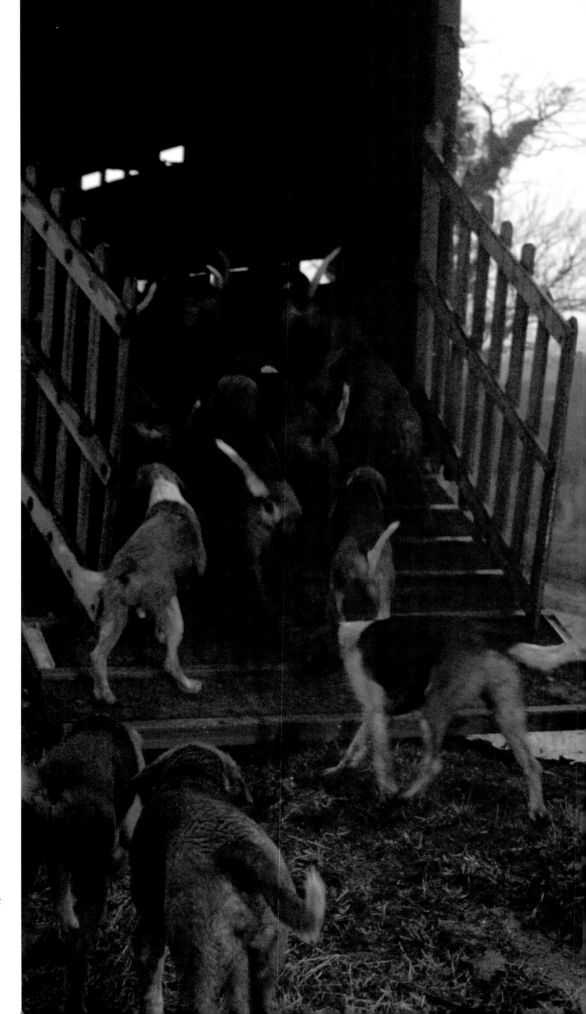

RIGHT: A dreadful day in history — Belvoir huntsman Martin Thornton loads hounds up at the end of the day on 17 February 2005, on the eve of the passing of the Hunting Act.

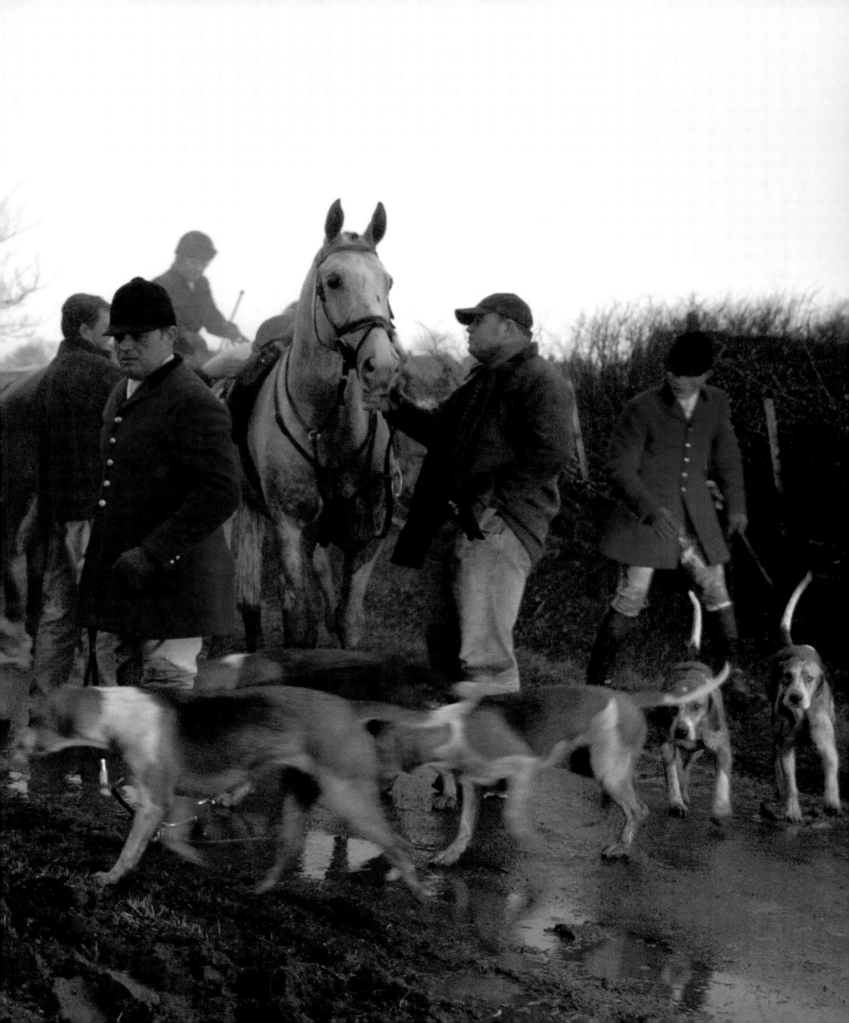

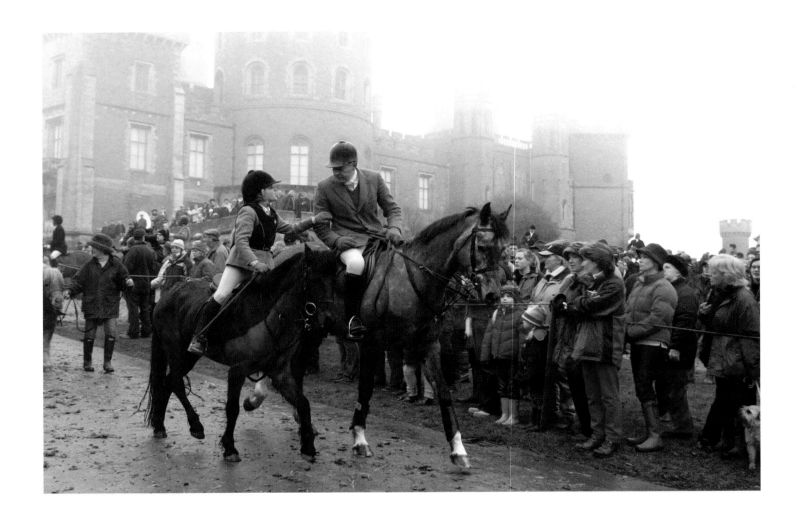

ABOVE: Crowds flock to the last 'real' day's foxhunting, at Belvoir Castle.

'Deep in our hearts enfolden
For ever shall be found
With dearest memories crowned
Those glorious days and golden
We spent with horse and hound.

...But this dear love we cherish,
Not Time itself devours;
In sunlight, mist, and showers
The years may pass and perish,
But not those golden hours.'

from 'The Golden Hours', Will H Ogilvie